THE A. W. MELLON LECTURES IN THE FINE ARTS

DELIVERED AT THE NATIONAL GALLERY OF ART

WASHINGTON, D. C.

1952. CREATIVE INTUITION IN ART AND POETRY by Jacques Maritain

1953. THE NUDE: A STUDY IN IDEAL FORM by Kenneth Clark

1954. THE ART OF SCULPTURE by Herbert Read

1955. PAINTING AND REALITY by Etienne Gilson

1956. ART AND ILLUSION: A STUDY IN THE PSYCHOLOGY OF PICTORIAL REPRE-
SENTATION by E. H. Gombrich

1957. THE ETERNAL PRESENT: I. THE BEGINNINGS OF ART
II. THE BEGINNINGS OF ARCHITECTURE by S. Giedion

1958. NICOLAS POUSSIN by Anthony Blunt

1959. OF DIVERS ARTS by Naum Gabo

1960. HORACE WALPOLE by Wilmarth Sheldon Lewis

1961. CHRISTIAN ICONOGRAPHY: A STUDY OF ITS ORIGINS by André Grabar

1962. BLAKE AND TRADITION by Kathleen Raine

1963. THE PORTRAIT IN THE RENAISSANCE by John Pope-Hennessy

1964. ON QUALITY IN ART by Jakob Rosenberg

1965. THE ORIGINS OF ROMANTICISM by Isaiah Berlin

1966. VISIONARY AND DREAMER: TWO POETIC PAINTERS, SAMUEL PALMER AND
EDWARD BURNE-JONES by David Cecil

1967. MNEMOSYNE: THE PARALLEL BETWEEN LITERATURE AND THE VISUAL
ARTS by Mario Praz

1968. IMAGINATIVE LITERATURE AND PAINTINGS by Stephen Spender

1969. ART AS A MODE OF KNOWLEDGE by Jacob Bronowski

BOLLINGEN SERIES XXXV · 15

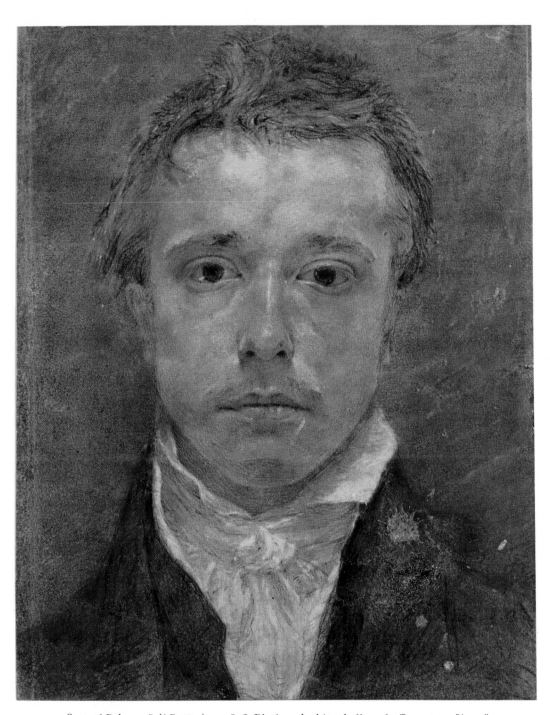

Samuel Palmer. *Self-Portrait.* c. 1826. Black and white chalk on buff paper, 11⅝ x 9″

DAVID CECIL

Visionary and Dreamer

TWO POETIC PAINTERS:

Samuel Palmer

and Edward Burne-Jones

THE A. W. MELLON LECTURES IN THE FINE ARTS · 1966

THE NATIONAL GALLERY OF ART

WASHINGTON, D.C.

BOLLINGEN SERIES XXXV · 15

PRINCETON UNIVERSITY PRESS

THIS IS THE FIFTEENTH VOLUME OF THE
A. W. MELLON LECTURES IN THE FINE ARTS,
WHICH ARE DELIVERED ANNUALLY AT
THE NATIONAL GALLERY OF ART, WASHINGTON.
THE VOLUMES OF LECTURES CONSTITUTE
NUMBER XXXV IN BOLLINGEN SERIES,
SPONSORED BY BOLLINGEN FOUNDATION

Library of Congress catalogue card No. 68-57088
SBN 691-09853-0
Designed by P. J. Conkwright
Printed by Princeton University Press
Plates printed by
Meriden Gravure Company

I rest not from my great task
To open the Eternal Worlds, to open the immortal Eyes
Of man inwards . . .

WILLIAM BLAKE

PREFATORY NOTE

THE Andrew Mellon Lecturer is supposed to speak about the Fine Arts. I hope I shall be forgiven for choosing rather to speak about artists. The Fine Arts are the province of the art critic and the art historian; a dangerous and disturbed territory on which it was clearly unwise for a literary biographer like myself to trespass. But I thought it might be of interest to make a virtue of my limitations and to consider the practitioners of Fine Art from a literary and biographical point of view. I therefore decided in the first place to choose for my subject the life stories of two painters; and in each story to make my theme the man rather than the artist. In the event, the two could not be separated, since for most artists their art is the center of existence and the means by which they most fully express their natures. When I came to tell the stories of Palmer and Burne-Jones, I found myself talking about their painting. But I took care to do so only in so far as it shaped the course of their lives and threw light on their characters and opinions. My lectures were intended to be portraits in words, not essays in criticism.

Secondly, the painters I chose are largely and confessedly literary in their inspiration. I am better equipped to understand such painters, and I was curious to investigate the process by which literature fertilized painting and to see whether there was anything in the artists' circumstances, historical and intellectual, that encouraged such a process. I discovered that there was. This meant that I had to give some consideration to the mental and spiritual climate of that nineteenth century in which my two heroes lived.

A great deal of matter, it may be thought, for so short a book! But my space was limited by the appointed length of my lecture course. In consequence my portraits are better described as portrait sketches, and my comments are at best suggestive rather than conclusive. I doubt if either is the worse for this. Few books are the worse for being short. To be limited in space forces the writer to concentrate on what is sig-

nificant in his subject: and it gives him less time to bore his readers.

I hope I shall not bore mine: though even if I did, I cannot regret having given these lectures. For they were the occasion of a seven weeks' stay in Washington, which was one of the most delightful episodes of my life. High among the things that made it delightful was the extraordinary help and kindness given me in my work by Mr. John Walker and his staff at the National Gallery, and the interest and pleasure I found in their company. May I take this opportunity of thanking them.

I must also express my gratitude to the Southampton Art Gallery, the Ashmolean Museum, Oxford, the Hon. Mrs. Raymond Asquith, the Birmingham Art Gallery, the British Museum, Sir Kenneth Clark, Lord Faringdon, the Fitzwilliam Museum, Cambridge, the Fogg Art Museum, Cambridge, Massachusetts, the Hon. Mrs. Patrick Gibson, the Gulbenkian Foundation, Lisbon, Miss Joan Linnell Ivimy, Sir Geoffrey Keynes, Mrs. Raymond Lister, the Lady Lever Art Gallery, Port Sunlight, the Maas Gallery, the Manchester Art Gallery, the National Portrait Gallery, Mr. Graham McInnes and Mr. Lance Thirkell (great-grandsons of Sir Edward Burne-Jones), the Tate Gallery, the Victoria and Albert Museum, and the Walker Art Gallery, Liverpool, for allowing me to reproduce pictures in their possession; to the Hon. Mrs. Raymond Asquith, Mrs. F. L. Griggs, Mrs. Martin Hardie, Mr. Theodore Hofman, Miss Joan Linnell Ivimy, Mr. Anthony Richmond, and Mr. John Samuels for allowing me to make use of papers belonging to them; and to Mrs. Helen Rossetti Angeli, the Hon. Mrs. Raymond Asquith, Earl Baldwin of Bewdley, Mr. Francis Cassavetti, Professor Oswald Doughty, Mr. Geoffrey Grigson, Mr. Philip Henderson, Mr. Denis Mackail, Lady Mander, Dr. Eric Miller, Mr. Simmins of the Vancouver Art Gallery, Mrs. Surtees, Mrs. Troxall, and Mrs. George Wansborough for information and advice.

I must add a special word of thanks to Mr. David Gould for his learned and untiring help in drawing up the List of Illustrations and the captions.

David Cecil

CONTENTS

LIST OF ILLUSTRATIONS

An asterisk indicates a color plate.
In general, photographs have been supplied by the respective institution or collection, unless otherwise indicated.

Plates: Samuel Palmer

15 *Margate, with Part of the Pier and Harbour after Sunset.* 1819. Water color, 4⅞₆ x 7″. British Museum, London.

PAGES FROM THE "IVIMY" SKETCHBOOK, 1824.
Each 4¾₆ x 7⁷₆″. British Museum.
From the facsimile edition, Trianon Press, London, 1962;
comments from the same source.

16 *Animal* (p. 37). Pencil underdrawing, India ink with blue water color.

17 *Study for a Crucifixion scene: Bad Thief* (p. 71). India ink.

18 *Study for a Resurrection scene* (p. 66). India ink. "Horrific overtones . . . the terrifying Fuseli-like figure with its scaly body."

19 *Cats* (p. 52). Pencil (small cats); pen and India ink (large cat).

20 *Study for a large Creation scene* (p. 61). India ink. Left-hand side of a polyptych inscribed "He made great lights."

21 *Study of a tree trunk* (p. 42). Pen and India ink with blue water color. Apparently made on the spot and given a landscape setting in the studio.

22 *Moonlit scene* (p. 172). Sepia. The earliest surviving example of Palmer's use of heavy sepia washes to depict a moonlit scene.

23 *The Rest on the Flight.* c. 1824–25. Oil and tempera on panel, 12³₆ x 15⁵₆″. Ashmolean Museum, Oxford.

24 *Late Twilight.* 1825. Pen and brush in sepia mixed with gum and varnished, 7¹₆ x 9⅜″. Ashmolean Museum, Oxford.

25 *Early Morning.* 1825. Pen and brush in sepia mixed with gum and varnished, 7¹₆ x 9¾₆″. Ashmolean Museum, Oxford.

26 *The Skirts of a Wood.* 1825. Pen and brush in sepia mixed with gum and varnished, 6¹³₆ x 10⅞″. Ashmolean Museum, Oxford.

27 *The Valley Thick with Corn.* 1825. Pen and brush in sepia mixed with gum and varnished, 7⅛ x 10⅞″. Ashmolean Museum, Oxford.

28 *The Valley with a Bright Cloud.* 1825. Pen and brush in sepia mixed with gum and varnished, 7⅛ x 10¹⁵₆″. Ashmolean Museum, Oxford.

ETCHINGS

M.F.A. = Museum of Fine Arts, Boston.
References are given to the states in Alexander's *Catalogue;*
see the Bibliographical Note.

Plates: Edward Burne-Jones

64 *Going into Battle.* 1859. Pen and ink on vellum, 8⅞ x 7¹¹⁄₁₆″. Fitzwilliam Museum, Cambridge. P: Stearn & Sons.

*65 *Merlin and Nimue.* 1861. Water color, 25¼ x 20½″. Victoria and Albert Museum, London. P: Rodney Todd-White.

> The following passage from Malory's *Morte d'Arthur,* Chapter 60, is inscribed on the original oak-gilt frame:
> "And always Merlin lay about the lady for to have her to himself, and she was ever passing weary of him and fain would have been delivered of him, for she was afraid / of him, because he was a devil's son and she could not put him away by no means. And upon a time it happened that Merlin showed to her where was / a great wonder, wrought by enchantment, which went under a stone. So, by her subtle craft, and working she made Merlin to go under that stone / to let her wit of the marvels there, but she wrought so for him that he came never out for all the craft that he could do."

66 *Wine of Circe.* 1863–69. Water color, 27½ x 40″. Private collection (England). P: Courtauld Institute of Art, London.

67 *Cupid Delivering Psyche.* 1867. Water color, 31½ x 36″. Borough of Hammersmith Public Libraries, London. P: Courtauld Institute of Art, London.

> The verses are from the story of Cupid and Psyche in William Morris, *The Earthly Paradise,* written the same year.

*68 *Pygmalion and the Image: The Heart Desires.* 1868–70. Oil on canvas, 38½ x 29½″. City Museum and Art Gallery, Birmingham. P: Rodney Todd-White.

*69 *Pygmalion and the Image: The Soul Attains.* 1868–79. Oil on canvas, 38½ x 29½″. City Museum and Art Gallery, Birmingham. P: Rodney Todd-White.

> From William Morris, *The Earthly Paradise,* epigraph to "Pygmalion and the Image": "A man of Cyprus, a sculptor named Pygmalion, made an image of a woman, fairer than any that had yet been seen, and in the end came to love his own handwork as though it had been alive: wherefore, praying to Venus for help, he obtained his end, for she made the image alive indeed, and a woman, and Pygmalion wedded her."

PROLOGUE

LITERARY PAINTING is out of fashion nowadays. Modern artists do not depict scenes from Shakespeare's plays or Milton's poems: modern critics would be surprised if they did. I am not clear about the reason for this. It cannot be due to the prevailing aesthetic doctrine of the age; for if it were, the same thing would be true of music. Yet Mr. Benjamin Britten makes an opera out of *A Midsummer Night's Dream* and sets to music the lyrics of Wilfred Owen, and does so with the full approval of his critics. Apparently they think that Shakespeare and Owen provide the right nourishment for Mr. Britten's muse. It may be that modern painting would also be enriched if it sought inspiration from poetry. Certainly it was so enriched in the past. In the past English poetry and English painting were often and closely connected with each other. Some of our distinguished artists actually wrote poems; good poems like Blake's, bad poems like Turner's. More often our distinguished poets inspired our distinguished painters. Milton and Shakespeare and Keats and Pope provided subject matter for Palmer and Calvert, Rossetti and Millais, Burne-Jones and—if a black and white artist may be admitted to the list—for Aubrey Beardsley.

It will be noted that all these artists lived in the nineteenth century. The poet-painter flourished more then than at any other time. There is a reason for this. The nineteenth century was the century of the Romantic Movement and the poet-painter is a romantic phenomenon. Eighteenth-century painting was social and extroverted: Hogarth and Gainsborough were concerned to depict the contemporary scene. The Romantic Movement—this is its distinguishing characteristic, so far as England was concerned—turned the eyes of the artist inwards. Its subject is the inner life, the raptures and fears and aspirations and fantasies of the soul in solitude. Its greatest poem, Wordsworth's *Prelude,* bore as its second title *The Growth of a Poet's Mind;* Coleridge describes the conflict of good and evil in the human soul in terms of a wild dream fantasy about an ancient mariner; the song of a nightingale and the sight of a Grecian urn stirred Keats to passionate meditations on his individual sense of beauty and sense of death. As with poets, so with painters. In symbolic form, they too were concerned with the inner life. Blake

3

paints the same mystical visions that he writes about: Turner's pictures of storms and sunsets, like Wordsworth's poems about them, are descriptions of memorable spiritual experiences. Blake's followers and the Pre-Raphaelites studied past poets as much as they studied past painters. They regarded their aims and functions as similar. The Romantic painter strove to make his pictures the pictorial equivalent of the works of the Romantic poets. To him the difference between a poem and a picture was one of form only. "Nowadays," said Rossetti, "the man who has any poetry in him, ought to paint it: the next Keats ought to be a painter."

This race of poet-painters did not survive the nineteenth century. But while they lasted, they produced some curious and fascinating work. They themselves, too, were often curious and fascinating personalities. Among the most fascinating were Samuel Palmer and Edward Burne-Jones. They and their life stories are the subject of these pages.

Samuel Palmer

Genius is the unreserved devotion of the whole soul to the divine, poetic arts, and through them to God; deeming all else, even to our daily bread, only valuable as it helps us to unveil the heavenly face of Beauty.

❖

The visions of the soul, being perfect, are the only true standard by which nature must be tried.

❖

We are like the chrysalis, asleep, and dreaming of its wings.

SAMUEL PALMER

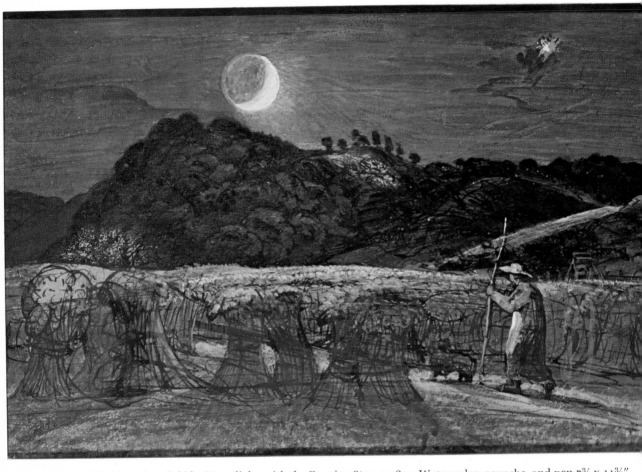

1 Samuel Palmer. *Cornfield by Moonlight, with the Evening Star.* c. 1830. Water color, gouache, and pen 7¾ x 11¾″

SAMUEL PALMER's sketch of a cornfield by moonlight is one of his most typical productions. As such it makes on the beholder a strange and twofold impression. On the one hand it seems rooted in reality. Only a man who had looked long and closely at the landscape of southern England could so intimately have evoked its spirit, so accurately have indicated its characteristic features; the leaning stooks, the gently sloping tree-muffled hills, the soft humid atmosphere suffusing all. But the picture also takes us away from the world we know. The scene shimmers with a mysterious radiance: moon and stars show much larger than they would in life; the figure of the countryman, drawn in a stylized and archaic convention, looms before us with a biblical grandeur. All is intensified, spiritualized, transfigured. Earthly appearances are used to convey an unearthly vision.

In this the picture is the image of the artist who created it. Palmer's spirit was marked by two distinguishing characteristics: responsiveness to visible nature and a strong religious sense. The combination of the two gives its individual character to his genius. It is also the chief factor in his life story. The course of Palmer's career was determined by his desire to fuse in his art the two dominant strains in his nature. Circumstances worked against his achieving his aim: poverty, home difficulties, and the mental climate of a period that neither understood nor sympathized with him; with the result that the course of his life was obscure and troubled, and that he died virtually unrecognized. Now, eighty-odd years after his death, he has come to be regarded as one of the greatest of English artists.

Oddly enough, he was not a countryman by birth. Born in 1805, he was the elder son of Samuel Palmer, a man who strove to earn a modest living, first as a coal merchant and then as a bookseller in Walworth, on the outskirts of London. There, and elsewhere in the London district, his son spent the first twenty years of his life. But, it need hardly be said, London in 1805 was not like London today. England was predominantly agricultural and the country came up to the very edges of the town. Palmer's home—Georgian and with delicate iron-work gates— looked out over a landscape that stretched to reveal the trees of rustic

7

Dulwich. He woke to the sound of singing birds and rustling leaves. From his nursery window he watched the farm-carts lumbering by, laden with fruit for the town; two or three miles' walk took him through fresh-smelling meadows into the deep country. The England that met Palmer's infant gaze still looked more like Elizabethan than Victorian England.

The Palmer family too were old-fashioned people; even in 1805 they seemed, to an up-to-date eye, quaint and archaic—incongruous contemporaries for Byron and Jane Austen. His father especially: the Palmers were descended from an ancient well-connected family, their forebears included squires, parsons, and even a bishop. Since then, they had gone down in the world and been forced to take to trade. But Palmer's father still looked back with pride to his ancestors: he counted among his most precious treasures a seal ring engraved with the family arms. He was the more attached to the past because he had little in common with the living members of his family. His brothers were go-ahead, philistine men of business. He himself was gentle, unambitious, contemplative, methodical in small things but with little grasp of practical affairs. He failed as a coal-merchant; as a bookseller, he showed himself better at reading than at selling books. From time to time he was forced to seek help from his brothers, who gave it with growing reluctance. Whether they helped him or not, Samuel Palmer remained poor. But he did not mind so long as he could live the kind of life he wanted: tranquil and simple and with time to devote himself to his two favorite activities. These were literature and religious observance. As was to be expected, both were of an old-fashioned type. Palmer's father was a man of learning in a seventeenth-century mode. His letters read like those of some contemporary of George Herbert, naïve, formal, and poetical, full of scriptural allusions and biblical phrases and references to angels and special providences, and with a florid Jacobean poetry about them. Samuel Palmer was bred as a member of the Church of England. But he was converted on his marriage to the Baptist faith. His wife, Martha Giles, was the daughter of William Giles, a banker, with strong Baptist convictions, and Samuel

8

Palmer was impressed enough by these to fall in with them. He revered his father-in-law not only for his piety, also for his culture: William Giles was friendly with artists and, in his spare time, dabbled in literature. He wrote improving books with such titles as *Treatise on Marriage* and *A Guide to Domestic Happiness*. One of these had a frontispiece by Stothard, for which Martha Palmer had sat as a model enclosed in a bower of roses and with a tulip in her hand. We know little else about her, except that she was pious and emotional, tenderly maternal to her son, and ready to sympathize with her husband's dislike of the go-ahead nineteenth century. Together, she and he turned their backs on the age they lived in and sought spiritual sanctuary in an idyllic and antiquated mode of living of their own creation.

It suited them, and it suited their little son. He was a soft-eyed, fragile-looking child, shrinking instinctively from anything harsh, but gaily responsive to anything that pleased him. Especially he delighted in being taken into the country, in the sights and sound and smells of nature. He said in later life, "I distinctly remember that I felt the finest scenery and the country in general with a very strong and pure feeling." Young Samuel especially enjoyed hearing of anything magical or supernatural: he loved tales of fairies and goblins and witches and ghosts; also angels and devils. This taste disposed him to take pleasure in the religious teaching he got at home. Luckily; for there was a great deal of it. The atmosphere was soaked in religion. Samuel was very ready to be soaked. He was a Wordsworthian child, trailing clouds of glory, glowing with intimations of immortality.

Nor does he seem to have been bored by the heavy diet of religious practices on which he was brought up, the steady round of praying, chapel-going, hymn-singing, and Bible-reading. He liked ritual; more-over, he knew his parents believed in these practices and he loved his parents deeply. So did another person whom he loved almost as much: his nurse, Mary Ward. She was a remarkable woman, and a living proof that we have not advanced so far beyond our eighteenth-century forebears as our efforts to do so might lead us to hope. Education was harder to come by for them, but there was a more widespread feeling for

9

true culture. Mary Ward came from a poor working-class home and never had any formal education. But she was born unusually intelligent with a keen sense of beauty; and, though a hard-worked domestic servant, she found it possible to pick up enough learning to become an ardent and discriminating lover of poetry. She communicated her love to little Samuel. Indeed, she was to be responsible for a crucial event in his imaginative development. It happened one night when he was three years old. He was standing with her looking out of the window. The moon, rising behind them, cast the shadows of an elm tree and its branches on the white wall opposite. As the shadows shifted in the night breeze, Mary Ward repeated a couplet by the poet Edward Young:

> *Fond man, the vision of a moment made,*
> *Dream of a dream, and shadow of a shade.*

The episode made an extraordinary impression on the little boy. He responded both to the spectacle and to the words, with the result that for the first time the two strains in his imaginative make-up associated themselves with each other in a single experience. He recognized the visual beauty that enraptured him as charged with a spiritual and moral significance. This recognition was to exercise an influence on him for the rest of his life. His memory of the moon and its shadows sank down to the deepest level of his consciousness, to abide there, a permanent and living symbol of spiritual glory. As a child, he was always drawing shadows; in maturity they were to be the subjects of his most characteristic masterpieces. He wrote, seventy years later, "I never forgot those shadows, and am often trying to paint them." Thus, the lines within which Palmer's genius was to function were laid down before he was four years old. The rest of his childhood was spent in developing it.

His home provided the ideal environment for this purpose: it managed to combine two very different merits. Life there was at once sheltered and uninhibited. Palmer needed shelter; his sensitive spirit could only flower in a gentle climate. His home was a shelter gently warmed by love. His parents doted on him and showed it. Strict moral principles did not make them strict parents. Once, when he had been

unusually naughty, Mr. Palmer proposed giving him a beating. "Oh, don't let us talk of anything so unpleasant!" cried little Samuel. His father never mentioned the subject again. As the result of this humane treatment, Palmer's capacity for feeling never ran the risk of being chilled. His warm artist's temperament bloomed, confident, unself-conscious, spontaneous.

Yet, though emotionally sheltered, he was spiritually free. There was no question of his having to conform to a pattern. On the contrary, his father made it a principle to reject conformity. Every day, after his scripture lesson, Samuel Palmer had to repeat, "Custom is the plague of wise men and the idol of fools." These words left a deep impression on him, and the thought inspiring them became an integral part of his outlook on life. Many years later he said to his own son, "If we merely ask ourselves, 'what will people say of us?' we are rotten at the core."

His upbringing allowed him to be emotionally uninhibited too. Wisely; for he had a highly charged unreserved temperament, given to demonstrative caresses and intimate confidences, fits of wild fun and tears of grief or joy. Years later, he told his son that one of his chief pleasures as a child was shedding "delicious tears" when listening to the organ. The son was shocked to hear of these unmanly exhibitions, and blamed his grandparents for not discouraging them. In fact, they were evidence of Samuel Palmer's unusual sensibility; and it was a good thing for him that he was able to indulge them unreproved.

More important, the life Palmer lived at home gave a chance for the free play of his imagination. With no other children to distract him—for his only brother seems to have played little part in his life—he had to find his own satisfactions. This was no difficulty to him. Though not a solemn child—he had a lot of boyish exuberance—he was not boyishly gregarious. His happiest moments were spent weaving fantasies and ob-serving the world of nature. Both of these activities were best practiced alone. Alone, then, he spent his days in the garden, gazing with curiosity and pleasure at tree and flower and moving cloud and slow-sliding brook; or indoors, turning over picture books, listening to music, es-pecially if it came from the tear-compelling organ, scribbling in a

drawing book, listening to Mary Ward's stories, and incessantly reading. Hour after hour, he would sit curled up in a corner, with his cat, Watch, on his knee, and a glass of homemade wine in his hand, lost in a favorite book.

He learnt to read early and at home. He was not sent to school, and his father made himself responsible for his lessons. These were not an unmixed pleasure. Palmer disliked grammar and mathematics. Neither appealed to his imagination; and he went so far as to say that, temporarily at least, studying them destroyed his taste for all learning. This is unlikely, for grammar and mathematics could not have taken much of his time; they did not interest his father either. He concentrated rather on literary subjects, and taught Samuel a little Greek and enough Latin to enable him to share his pleasure in Virgil. He also read a great deal of English poetry with him, especially the works of Spenser and Milton. Samuel was soon reading these on his own. As might be expected, he liked poetry better than prose, especially if it described the country, or told a romantic tale set in the medieval past.

For, in one respect, Palmer was a typical child of his time. During the last fifty years, the medieval past had been an object of imaginative sentiment. It had been the age of mock-Gothic and Strawberry Hill and *The Castle of Otranto*, of Percy's *Reliques* and Gray's *Bard*, of Ossian and Chatterton. Augustan culture, it seems, had grown so rational and lucid in the reign of good Queen Anne that imaginative spirits in succeeding generations had found its atmosphere intolerably stifling. They longed for mystery and romance, and looked for them in the ruins and castles and abbeys and cloisters surviving from the age of faith. Palmer liked ruins and castles very much, and abbeys and cloisters even better: "I had a passionate love (the expression is not too strong)," he said later, "for the traditions and monuments of the Church." He enjoyed reading about them too, and the legends connected with them. The Middle Ages joined with the classic myths and the English landscape to enrich and fertilize Palmer's imaginative life.

So even more did the Bible, the passages of scripture he learnt every day. The Bible stories were as picturesque and stimulating to the fancy

as poetry; but they were, so he was taught, also a part of the Divine truth by which man must live, if he was to be saved. His favorite among them—the histories of Ruth and Job and still more that of Christ, his Saviour as told in the Gospel—were there to explain to him the nature of his existence. This redoubled the force of their impact on him. The strongest influence on the development of Samuel Palmer's genius was always his religious education. It explained and sanctified the sense of glory stirred in him by the sight of the visible world. Since the visible world was the expression of the mind of its Divine Creator, this sense of glory was natural and right. To Palmer, as to his contemporary, Keats, truth was what the imagination declared to be beauty. For Palmer truth meant religious truth.

Fed by reading, fortified by faith, Palmer's imaginative life grew strong and began to seek active expression. Before thirteen, he had already started on his career as an artist. He had scribbled and dabbled in chalk and water color from early childhood. He showed a precocious talent and a characteristic choice of subject matter. Even as a child he drew landscapes, real or imaginary: his earliest known work depicts a windmill. He also drew pictures of scenes in his favorite stories and of those ancient church buildings—Gothic spires and sculptured moldering cloisters—that haunted his dreams. As he grew older, he copied engravings. Some of these were architectural, some were botanical. With vigilant care he guided his hand to follow the delicate irregular lines of leaf and bud and transparent petal.

I I

ORDERLY, dreamy, unchanging, the long days of childhood slipped by. Then in May, 1818, when Palmer was thirteen years old, this peace was suddenly broken. For some unrecorded reason, Samuel Palmer, reversing the policy of a lifetime, sent his son as a boarder to Merchant Taylors' School. It was a disaster. Boys' boarding schools in the early nineteenth century were rough

places. Samuel was peculiarly unfitted to stand the roughness. His up-bringing had made him mentally precocious, but otherwise childish; timid, dependent, and tearful. Moreover, Merchant Taylors' was a bleak barrack of a building, whose very appearance was enough to strike a chill into Samuel's beauty-loving eye. Steadily and completely miserable, he spent six or seven months there, bathed always in tears. Then his father, unable to bear the thought of his wretchedness, took him away. It was not the end of his misfortunes. Early in 1818, his mother suddenly died. He had loved her with a clinging affection, and he was at the worst age possible to suffer such a loss: old enough to realize it, but yet too young to be independent. He felt, he said, as if a sharp sword had gone through his body.

The effect of these two blows was powerful and permanent. Alas, Palmer's upbringing, so admirable for the artist in him, had not fitted him to live easily in the world! The first encounter with it at school had made him horrified by its cruelty. His mother's death inflicted a more serious wound: for it undermined his fundamental sense of security. School had taught him that the world outside home could be a dreadful place; his mother's death that even the sanctuary of home was not safe from disaster. At thirteen, Samuel Palmer was confronted with the fact that human life was a predicament, and often a tragic one. The outcome was that he became subject to fits of black melancholy, which were to recur throughout his life. Even when he was not melancholy, he never again felt fully safe. He had learnt that human life was incurably dangerous.

A distressing discovery! But not an altogether unfortunate one; for it made him turn from it to the non-human world whence his creative genius drew its nourishment, the world of natural beauty, the world of ballad and fairy tale, the world of Christ and His angels. Meanwhile, at home, life resumed something like its old course. In their different ways, Mary Ward and his father did all they could to make up for Samuel's loss of his mother. Mary Ward watched over his health and his comfort; Samuel Palmer sought to stir his son's interests and to cultivate his mind. Every evening, he used to take him for walks in the

14

neighboring fields. If the conversation flagged, Mr. Palmer would take a little vellum-bound book out of his waistcoat pocket and try to stir Samuel's interest by reading a poetical quotation or propounding an algebra problem which he had jotted down in it. More often, in quaint and scriptural phrase, he discoursed on religion or literature or life, on the glories of the heavenly vision, the insignificance of this world's prizes, the futility of custom or convention. It is improbable that Samuel much enjoyed the algebra problems. Otherwise, he delighted in his father's company and revered his wisdom. Later, he dedicated a piece of music to his father, because, he said, "not choosing to sacrifice me to Mammon . . . , with an affection rare in this day, he led my erring steps where Faith, Temperance, and Study evermore resort, and wait to take the hand of those who love their charming company." This quotation entertainingly illustrates the tone of talk in the Palmer home, with its blend of piety and naïveté and formal, old-fashioned rhetoric. Once more it is curious to think it was written by a contemporary of Byron and Jane Austen.

Samuel Palmer's unconventionality now showed itself in a more practical way. People grew up early in those days and his son was now thought old enough to start on what was to be his career. What form should it take? The Palmers were poor, and many fathers would have pressed a son to adopt a regular, reliable profession. Not so Samuel Palmer; he wanted his son to be a painter. He thought art a higher thing than business or law. He realized that it would be long before Samuel could earn his living, but he was willing to finance him meanwhile.

This fatherly confidence in his son was soon justified. After a few months under a professional master, Samuel had advanced enough to have three pictures accepted for exhibition at the Royal Academy and two at the British Institution. He got the news, so he said, on his fourteenth birthday that he had sold one of these last works for what was then the respectable sum of seven guineas. This should have been wonderfully encouraging. In fact, such records as we have of Palmer during the next few years give the impression he was not happy. His

15

melancholy fits recurred fairly frequently; and he was further disturbed by the unsettling influence of adolescence. Like other boys of his age, he began for the first time to question the beliefs he had been brought up on, especially the religious beliefs. For a time, even his enthusiasm for his art waned; when he might have been painting, he was reading and arguing about religion. By the time he was fifteen, he said later, he had discovered so many reasons for disbelief that he was a freethinker.

It was not for long. Palmer was a man of unquenchably religious temperament, and at eighteen he was back in the Christian fold again. No longer a Baptist, however; during these years, Palmer joined the Church of England. The English Baptist church in the early nineteenth century was not a congenial place for an artist, especially for one with a romantic sense of the past. It was too bleak, too puritan, too unfurnished with historical associations. The Church of England, on the other hand, was ancient and sacramental: its music and ceremonies and magnificent liturgy were the outward and visible signs of an inward and spiritual sense. Further, it was housed in those Gothic churches which stirred Palmer's imagination so deeply. Not that his Christianity was just an aesthetic affair, in which dogma or historical truth played little part: Palmer was interested in dogma. As he liked the concrete and definite in landscape so he liked it in religion. And his faith was rooted in historic fact. Like a distinguished poet of our own day, Mr. John Betjeman, he cared for Christianity because it taught definitely and specifically:

> *That God was Man in Palestine*
> *And lives today in Bread and Wine.*

The deity he prayed to was no featureless spirit, but a person; Jesus Christ, as revealed in the Gospel, wise, tender and compassionate, Jesus Christ who took the children up in His arms, and wept at the tomb of Lazarus and broke bread with His disciples at Emmaus. It was because Palmer loved Christ as Man that he worshipped Him as God: "I have," he wrote a few years later, "a slowly but steadily increasing conviction that the religion of Jesus Christ is perfectly divine; but it certainly was not only intended to be enthroned in the understanding,

16

but enshrined in the heart; for the personal love of Christ is its begin-
ning and end. . . ."

By eighteen years old, then, he was once more a confirmed believer,
who regularly prayed and read scripture and attended church and
partook of the Sacrament. Along with spiritual ardor came a renewed
ardor for his art. He wasted no more time in arguing and reading con-
troversial books. Instead, he worked; his talents rapidly matured.
Already he had produced some remarkable pictures for his age. But
they were not yet fully characteristic; Palmer had not yet found him-
self—or, rather, he had not yet discovered a mode of expression by
which his true self could be accurately conveyed. For how we express
ourselves is conditioned by the language we use: Palmer was still em-
ploying a pictorial language that, as it were, lacked the words needed
to express his meaning. It was what he called the style of "modern"
landscape painting: a blend of the classic tradition of Richard Wilson
with a more intimate realism derived from seventeenth-century Dutch
art. This style was admirably suited to express the feelings stirred in
most men by the English rural scene. But Palmer's country sentiment
was at once more passionate and more spiritual than theirs. So long as
he stuck to the conventional mode, he could not in pictorial terms
express what he felt. Obscurely, he realized this. Once Palmer did see
a work that seemed to suggest a way out of his difficulties. Walking
round the Academy, he came upon Turner's *Orange Merchantman*, and
stopped short in startled admiration. Here was a painter who did com-
bine an eye for nature with a power of spiritual vision! For while
Turner observed effects of light with unique subtlety and exactitude,
he used them to give a soul to his scene. He is the Shelley of painting,
dramatizing the struggles of the human spirit in terms of storm and
shifting cloud and radiant sun-shaft. Palmer responded to this drama;
for a time he fell under Turner's influence. But not for long: Turner's
treatment of nature was too impressionistic, the spirituality it embodied
too evanescent and indefinite truly to represent Palmer's vision. Like
Shelley's, Turner's art is an image of aspiration rather than of clear-cut
conviction.

If Turner helped Palmer little, other contemporary landscape painters helped him less. David Cox's work for instance, though pleasing enough, was superficial; nature, thought Palmer, had deeper qualities. For the time being, however, no new mode of conveying these suggested itself: Palmer plodded on in the "modern" style. Then, one day in 1823, there entered into his studio and his life a wiry, bright-eyed, bustling little man, who announced that his name was Linnell. He was one of the most dynamic personalities in the English art world of the early nineteenth century, and was to prove a figure of the first importance in Palmer's history. Born in 1792 of humble parentage, John Linnell was a self-made, forceful character, who had early evinced a talent for painting and a determination to make the best of it. He threw himself into the task with energy; and now, at twenty-six, he was already a successful painter, competent alike at portraits, landscapes, and subject pictures, and with a wide acquaintance among the important artists and literary people of the day. He was not completely successful, for in 1821 he had failed to get into the Royal Academy. This, he thought, was owing to the malignant machinations of no less a person than John Constable. More probably, it was due to his own difficulties of character. Linnell was domineering, grasping, and so convinced that he was right about everything that he was liable to be rude to anyone who disagreed with him. This often happened; for his opinions were cranky. Politically, he was an extreme radical, and in religion, though a Christian, violently hostile to every official Christian church. During his life he was to join the Baptists and the Plymouth Brethren, but soon left them on the ground that they required him to conform to the will of others in a way inconsistent with his dignity. He took a fleeting look at the Quakers; but even that pacific and liberal body was too authoritarian to suit Linnell. Instead, he evolved a version of Christianity the truth of which—a little inconsistently—he allowed no one to question in his presence. He also aggressively opposed Sunday observance, fox-hunting, marrying in church, and Christmas decorations. When a neighboring clergyman asked him for some holly out of his garden to ornament the church, Linnell sent a curt refusal, couched unexpectedly in rhyme:

Alas, alas how great the folly,
To substitute for Christ ivy and holly.

So far, Linnell seemed only another of those self-made, self-willed eccentrics which—till recently at any rate—have been a typical product of England. But he was more than that. He was a gifted painter with a true and individual feeling for the English landscape; and further he combined an enthusiastic love of art wherever found with a fresh sensibility and fearless trust in his own intuitive responses, in such a way as to make him a remarkable talent-spotter. It is his glory that, when still young, he was almost the only person to appreciate the genius of the aging Blake.

It was his talent-spotting strain that brought him to Palmer's studio. He had seen some of Palmer's work and liked it; he wanted to help the artist who had done it. The meeting was a success. The two men became friends. Soon, Linnell had constituted himself Palmer's mentor and guide in artistic matters. This was lucky, for he guided him away from the paths of "modern art." Linnell was up-to-date enough to have a taste for the Gothic and the medieval. He took Palmer to galleries and showed him engravings, and for the first time Palmer was made acquainted with the work of the German, Flemish, and early Italian artists, Lucas van Leyden, Fra Angelico, Bruegel, and, above all, Dürer. "Look at Albert Dürer!" Linnell admonished Palmer again and again.

A new world opened itself to Palmer's young eyes: and a world much more akin to that of his own private vision. These old artists observe nature closely: in exact detail they portray hills and cities and clouds. But they also wonderfully suggest the spiritual and the supernatural. The angels and saints in their pictures are more convincing than those of later artists; largely because they are drawn in a different pictorial convention, stylized and intensified, with pure colors and sharp outline. The firmness of their creators' faith was expressed in the firm outline with which they drew their figures. The impression made by them on Palmer can be imagined. Here at last was a means by which he might express his own vision. "It pleased God," he said, "to send me Mr. Linnell as a good angel from Heaven to pluck me from the pit of modern

19

art; and after struggling to get out for the space of a year and a half, I have just enough cleared my eyes from the slime of the pit to see what a miserable state I am now in." Besides clearing his eyes, Linnell helped him in other ways; gave him some lessons in oil painting and set him to study the human figure. Further, he introduced him to a wider circle of artists and fellow students. Enthusiastic and unselfconscious, Palmer responded to their company. They in their turn were attracted by him; it was now he made his first friends. The records of his life at this time disclose engaging glimpses of a group of excited naïve youths, engaged in endless enthralling talks in studio and art school, or visiting Mr. Ader's celebrated collection of old pictures, or off to the gallery at Dulwich, where Palmer stopped, lost in admiration before a so-called "Portrait by Leonardo da Vinci." The head was revealed against a background of pure pale sky—"The color of the soul, not vulgar paint!" exclaimed Palmer.

During these months, Palmer made two friends who were to play important roles in his life. They were a pair of fellow students, called George Richmond and Francis Finch. The three found themselves drawn to one another by the fact that they were all three pious, and all three felt romantic about the past and poetry. Both Finch and Richmond were unusually likable. Richmond was a handsome little man, lively and affectionate; Finch was eager and gentle, and so tender-hearted that at parties he danced only with plain girls, for fear that otherwise they would not get partners. Older and more thoughtful than his friends, Finch had already begun to evolve his artistic principles. These were founded on an unusually strong sensibility to the beautiful. "He had imagination," said Palmer, "that inner sense which receives impressions of beauty as simply and surely as we smell the sweetness of rosemary or woodbine," and he had come to the conclusion that it should be his artistic aim not merely to imitate nature, but to convey his sense of it to the beholder. Finch wanted his landscapes—for he too went in for landscape—to be like happy beautiful poems, and with something unearthly about them; scenes of river or pastoral slope, "seen as through a magic casement," he said. The phrase recalls Keats: Keats, hardly older than

the three friends, was one of their favorite poets. Finch's views helped to shape Palmer's development. As Linnell had influenced his mode of expression, so Finch influenced his ideal of what a picture should be.

He influenced his taste in other ways too. Palmer was fond of music and enjoyed singing and playing the fiddle. Finch, also musical, was more accomplished and had a knowledge unusual in those days of the older English composers, Tallis, Gibbons, Purcell. Of an evening, Palmer would sit listening to him singing their music in a clear soft tenor, accompanying himself on the piano. His performance, though amateurish, showed a sympathy with the composers' intention that, for Palmer, made it exquisitely moving. It did this all the more because these works were the musical counterpart of the painting and architecture he loved; like them, they were an expression of an age of faith: their ethereal minor-key poignancy conveyed intimations of another world. Here—though in a different art form—was another example to be followed. This old English music was one of the inspirations of Palmer's art, its spirit an ingredient in its peculiar flavor.

Literature was a stronger, more direct inspiration. He said himself that it was dreaming that inspired him and that it was poetry that set him dreaming. He read a great deal of it in these years, and of prose too. Now it was that his literary taste finally took shape. It was a development of his boyhood's taste, romantic and backward-looking. The devotional works he liked best were from the sixteenth and seventeenth centuries: and he preferred his history antique. It was at this period too that he learnt to enjoy medieval literature; Chaucer's writings and Lydgate's *The Flower and the Leaf*, and he delighted in the older ballads. The two poets, however, who still meant most to him were his first favorites, Milton and Virgil. Milton appealed to him on his two chief sides. He was the grandest of English religious poets: had he not, in *Paradise Lost*, dramatized the whole cosmic scheme as interpreted by Christianity? Yet the beauty his work revealed was not exclusively celestial. Vividly he evoked the natural scene and especially those aspects of it that appealed to Palmer: moonlight and twilight, leafy woods, gliding streams, tufted trees, rich and delicate contrasts of light and shadow, checkering the

landscape, as the massed clouds moved slowly over the sky. Again and again Palmer found in Milton a passage or phrase which put into words some natural effect he had noticed, and especially the effects of moonlight. He noted on the fly-leaf of his copy of Milton's works a list of phrases referring to the moon:

> The horned moon . . .
> Amongst her spangled sisters bright
> . . . the Moon rising in clouded majesty
>
> Full-orb'd the moon, and with more pleasing light
> Shadowy sets off the face of things. . . .

Line after line of Milton's stirred in Palmer a delighted sense of recognition:

> . . . there does a sable cloud
> Turn forth her silver lining on the night
> And casts a gleam over this tufted grove.
>
> While the ploughman near at hand,
> Whistles o'er the furrowed land,
> And the milkmaid singeth blithe,
> And the mower whets his scythe,
> And every shepherd tells his tale
> Under the hawthorn in the dale.

Or again:

> And missing thee, I walk unseen
> On the dry smooth-shaven green,
> To behold the wandering moon,
> Riding near her highest noon,
> Like one that had been led astray
> Through the Heaven's wide pathless way;
> And oft, as if her head she bowed,
> Stooping through a fleecy cloud.
> Oft on a plat of rising ground
> I hear the far-off curfew sound,

Over some wide-watered shore,
Swinging low with sullen roar.

. . . .

And when the sun begins to fling
His flaring beams me Goddess bring
To archëd walks of twilight groves,
And shadows brown that Sylvan loves,
Of pine or monumental oak,
Where the rude axe with heavëd stroke
Was never heard the nymphs to daunt,
Or fright them from their hallowed haunt.
There in close covert by some brook,
Where no profaner eye may look,
Hide me from Day's garish eye,
While the bee with honied thigh,
That at her flowery work doth sing,
And the waters murmuring,
With such consort as they keep,
Entice the dewy-feathered Sleep. . . .

These last two quotations are from *L'Allegro* and *Il Penseroso*. Palmer was later going to illustrate these: he had always had an especially soft spot in his heart for them. The lightest of Milton's poems, they were concerned mainly to present pleasant pictures to the mental eye. Yet they were not merely descriptive. The scenes they depict are transfigured by the light of the poetic imagination; they are touched by "the consecration and the poet's dream." Moreover, even though in them he is not overtly religious, Milton suggests the existence of an unseen and spiritual dimension:

And let some strange mysterious dream
Wave at his wings, in airy stream
Of lively portraiture displayed,
Softly on my eyelids laid.

23

And as I wake, sweet music breathe
Above, about, or underneath,
Sent by some spirit to mortals good,
Or the unseen Genius of the wood. . . .

To Palmer, Milton was not only a glorious poet, but a spiritual teacher. He was to write a few years later: ". . . among our poets, Milton is abstracted and eternal. That arch-alchemist, let him but touch a history, yea a dogma of the schools, or a technicality of science, and it becomes poetic gold. Has an old chronicle told perhaps marred an action? Six words from the blind old man reinvigorate it beyond the living fact; so that we may say the spectators themselves saw only the wrong side of the tapestry. If superior spirits could be fancied to enact a masque of one of the greatest of those events which have transpired on earth, it would resemble the historical hints and allusions of our bard. I must be called mad to say it but I do believe his stanzas will be read in Heaven. . . ."

Indeed Milton wrote two-and-a-half lines which more than any passage in scripture itself summed up and expressed what was for Palmer the supreme spiritual truth:

What if earth
Be but the shadow of Heaven, and things therein
Each to each other like, more than on earth is thought?

The other poet of the first importance to Palmer was Milton's master, Virgil. He had read his works too, again and again, from the time his father had taught him Latin as a little boy. The Virgil he loved was the author of the *Georgics* and *Eclogues*; the poet of farming and gardening and vine-growing and country life. He made those things poetic, and not by sentimentalizing or softening their more prosaic aspects. Country life, as depicted by Virgil, is both rough and humdrum; the *Georgics* is, among other things, a practical manual about how to plant and prune and dig and dung. The modern reader may find this disconcerting; but Palmer liked it very much. He said, "It invests familiar objects with meaning and beauty." Virgil's countryside is the real

24

countryside, not an escapist Arcadia. Yet it has its spiritual quality. Virgil, like Milton, was a religious poet. He felt the presence of the gods in stream and woodland. His rural poems resemble the pictures of Poussin, where behind shepherd and shepherdess move the mysterious figures of nymph and faun, and sometimes the great god Pan himself, guardian and genius of the place.

No other writers had an influence on Palmer comparable to Virgil's and Milton's. But there were two other books which did seem—to judge by results—to have also played a special role in fertilizing his imagination. The first was Bunyan's *Pilgrim's Progress*. Bunyan's vision also united the earthly and the heavenly, but in a very different fashion from Milton and Virgil. They painted in the grand manner: even when writing on prosaic subjects, their style was noble. Further, Virgil was an antique Roman and Milton the product of a classical and international culture. Not so Bunyan, the humble Bedfordshire tinker. His language was plain and colloquial: he put his allegory of man's search for heaven into a realistic, homely form, drawn direct from the contemporary England in which he lived. Indeed, his success came from the fact that he combined the spiritual and the realistic, and from the imaginative force by means of which he fused these two heterogeneous strains into one. Bunyan really does succeed in building a ladder between Heaven and Charing Cross: Hell and Paradise are all the more real to us because we are made to see them in terms of the streets and prisons and conventicles of Bedfordshire in 1678.

In all this, Palmer found himself close to Bunyan. He also was very English; and though he had become an Anglican, he had spent his childhood as a member of a small nonconformist sect, which, like Bunyan, visualized the spiritual in literal homely contemporary terms. This was to influence Palmer's work. He began to conceive of communicating religious experience, and religious truth, in the form of a simple English country scene of his own day. More specifically, Bunyan influenced Palmer's pastoral scenes, the pictures he drew of shepherds playing their pipes, or watching their flocks. The shepherd was a typical figure in Palmer's imaginative world. He had found him in Virgil,

25

where he stood representative of a simple and innocent existence lived close to nature. He was also a figure with specifically Christian associations; a symbol of Christ Himself ready to lay down His life for His sheep. In the *Pilgrim's Progress*, the two symbols—Virgilian and Christian—combined themselves for Palmer: in the wise shepherds of the Delectable Mountains, who instruct Christian in "things deep, things hid and that mysterious be," and in the exquisite passage about the shepherd boy, singing to himself in the Valley of Humiliation.

". . . Now as they were going along and talking, they espied a Boy feeding his Fathers Sheep. The Boy was in very mean Cloaths, but of a very fresh and well-favoured Countenance, and as he sate by himself he Sung. Hark, said Mr. *Great-heart*, to what the Shepherd Boy saith. So they hearkned, and he said,

> *He that is down, needs fear no fall,*
> *He that is low, no Pride:*
> *He that is humble, ever shall*
> *Have God to be his Guide.*
>
> *I am content with what I have,*
> *Little be it, or much:*
> *And, Lord, Contentment still I crave,*
> *Because thou savest such.*
>
> *Fulness to such a burden is*
> *That go on Pilgrimage:*
> *Here little, and hereafter Bliss,*
> *Is best from Age to Age.*

"Then said their *Guide,* Do you hear him? I will dare to say, that this Boy lives a merrier Life, and wears more of that Herb called *Hearts-ease* in his Bosom, than he that is clad in Silk and Velvet; . . ."

Humility was one of the virtues Palmer loved most and he loved this passage. His copy of the *Pilgrim's Progress* always fell open at the page on which it was printed.

The other work that made a special impression on Palmer was a play, *The Faithful Shepherdess*, by the Jacobean playwright John Fletcher.

It is an odd production. Its form is that of the classic pastoral, set in Thessaly and about characters with names such as Chloe and Corin who worship Pan and are looked after by a benevolent supernatural figure, a sort of good fairy in the form of a satyr. But this classical fable embodies a moral thesis, Christian and medieval, about the importance of the mystical virtue of chastity. The landscape too, though supposedly Greek, is clearly drawn from seventeenth-century England, with its oaks and hazels and daffodils. The general effect of the play is of some Elizabethan tapestry where classic gods and English flowers and Christian emblems are set naïvely side by side. It is a quaint mixture; and its quality is mixed too. On the one hand its characters are faceless puppets and its morality conventional and unconvincing. On the other, its poetry, effortless and lyrical, communicates an extroardinarily fresh and intimate sense of the English countryside.

> SATYR. *See, the day begins to break,*
> *And the light shoots like a streak*
> *Of subtle fire; the wind blows cold,*
> *Whilst the morning doth unfold;*
> *Now the birds begin to rouse,*
> *And the squirrel from the boughs*
> *Leaps, to get him nuts and fruit:*
> *The early lark, that erst was mute,*
> *Carols to the rising day*
> *Many a note and many a lay: . . .*

Such poetry enraptured Palmer. "It is pure gold," he said. ". . . When I found there, in black and white, all my dearest landscape longings embodied, my poor mind kicked out and turned two or three somersaults." For Fletcher manifested in yet another way how realism could blend with imagination. He gave the English landscape a soul, incarnate in the forms of wood nymphs and naiads and satyrs: he made Pan at home in Kent and Sussex. Palmer looked at Kent and Sussex through Fletcher's eyes and saw the divinities of rural Greece alive there. Their life was in the future to enrich his own art.

27

I I I

IN 1824, Palmer was nineteen years old. His formative years were
over. His character had matured; his opinions were established:
nurtured by the art and letters of the past, that vision of reality
which was to be the subject of his art had revealed itself: he was on the
way to discover the mode by which he was to give it expression. At last
his genius had broken free from its chrysalis and was poised for flight.
Before it takes wing, let us stop and look at him. What sort of young
man was Samuel Palmer at nineteen years old?

His appearance, without being strictly handsome, was unusual and
prepossessing. A broad-shouldered, stocky, but light-limbed figure was
surmounted by a boyish face with full-lipped sensitive mouth, high
forehead, and wavy auburn hair, beneath which the eyes looked out at
the world with rapt passionate secret gaze. His personality was as unusual
as his face. His upbringing had left him a mixture of genius and of child.
There was a lot of the child about him: a child's exuberance and delight
in fantasy and fun, a childish credulity—he still believed in ghosts and
witches—childish timidity and childish enjoyment of his food; he was
especially fond of goose. Above all, he had a childish spontaneity and
lack of selfconsciousness. As often as at ten years old, he would burst
into song, or melt into tears, or pour out confidences to strangers,
apparently unaware of the impression he might make. His clothes also
showed his unselfconsciousness. As quite a young man he exhibited a
streak of dandyism and was especially fond of sporting a pair of white
trousers. One day, however, he caught sight of himself in a shop window.
His effect displeased him. "No more finery for a gentleman as short as
you," he told himself. After this, he reacted to the other extreme and
appeared in wild bohemian disarray; though he still took a romantic
pride in wearing a seal ring engraved with the family arms which
indicated that he came of ancient lineage.

All this was liable to make people laugh at him. Palmer did not mind,
his thoughts were centered elsewhere; an intense imaginative life surged
and seethed within him, making the outside world insignificant. Did

other people realize it? Who can tell! Luckily, we have a record. Palmer kept sketchbooks in which he jotted down in sketch or word anything that was occupying his mind. One of these has survived. It is an enthralling document: a shabby, sheepskin-covered little volume, four by seven inches, scribbled over with entries in prose and verse. The prose entries include quotations from books that had especially struck him, ideas for pictures, observations of natural phenomena, notes on the technique of painting, poems by himself and others. But there is more drawing than writing in the book; careful studies from life, of flowers and leaves and trees and cats, and ideas for pictures. These are of landscapes, real or imaginary—domes and spires and cottages and cornfields—or they are religious figure compositions, illustrating either favorite scenes in scripture—Resurrection and Creation, Ruth, St. Christopher, Christ on the Cross—or mysterious subjects, scaly monsters under Gothic arches, an extraordinary sketch of a naked crowned figure—Satan and the bad thief of the Crucifixion combined, with his head bent back and a fiendish expression on his distorted features. Sometimes Palmer combines fantasy and reality. A carefully observed cornfield is lit up by a moon ten times the size of reality, or by a sun surrounded by rays drawn in the form of conventional flames. In this private work, done only for his own eye, Palmer does not bother to conform either to the rules of convention or to those of realism. He dashes down some notes for future work in a manner as stylized as if he were Chagall or Rouault; and the words scribbled round the drawings vary from unpunctuated abbreviations to a rich poetic phrase.

All the different entries unite to compose an image of his mind. It is a mind possessed by faith, soaked in religion. All his imaginings are concerned with religion; even his natural studies of oak or beech leaf seem obscurely to affirm some religious truth. They are never merely records of fact. Though a patient observation marks them, imagination has transfigured them. It also transfigures his written notes. Here are some characteristic examples:

"These leaves were a gothic window, but sometimes trees are seen as men. I saw one a princess walking stately and with a majestic train."

29

"Sometimes the rising moon seems to stand tiptoe on a green hill top to see if the day be going and if the time of her vice regency be come." "Remember the Dulwich sentiment at very late twilight time with the rising dews (perhaps the top of the hills quite clear) like a delicious dream." "A monastic figure with much background of Gothic cathedral, the time twilight. The pinnacles and enrichments in light painted with silver and toned down into the many gradations of colour and shadow. Warmish tones, and elaborate feeling of that time in summer evenings when those venerable buildings seem no longer to be brute matter but with a subdued solemn light which seems their own and not reflected send out a lustre into the heart of him who looks—a mystical and spiritual more than a material light. And with what a richness does it beam out from the neutral coolness of the quiet flat sky behind it. . . ."

Or stirred by a lyrical impulse, he uttered his thoughts and impressions in verse:

> *And now the trembling light*
> *Glimmers behind the little hills, and corn,*
> *Lingring as loth to part: yet part thou must*
> *And though than open day far pleasing more*
> *(Ere yet the fields and pearled cups of flowers*
> > *Twinkle in the parting light;)*
> *Thee night shall hide, sweet visionary gleam*
> *That softly lookest through the rising dew:*
> > *Till all like silver bright*
> > *The faithful Witness, pure, and white,*
> *Shall look o'er yonder grassy hill,*
> *At this village, safe, and still.*
> *All is safe, and all is still,*
> *Save what noise the watch-dog makes*
> *Or the shrill cock the silence breaks*
> > *—Now and then.—*
> > *And now and then—*
> > *Hark!—once again,*

30

The wether's bell
To us doth tell
Some little stirring in the fold.

Methinks the lingring, dying ray
Of twilight time, doth seem more fair,
And lights the soul up more than day,
When widespread, sultry sunshines are.
Yet all is right, and all most fair;
For Thou, dear God, hast formed all;
Thou deckest ev'ry little flower,
Thou girdest ev'ry planet ball—
And mark'st when sparrows fall.
Thou pourest out the golden day
On corn-fields rip'ning in the sun
Up the side of some great hill
Ere the sickle has begun. . . .

The natural world for Palmer revealed the divine world. This is what he wished to express in his art. One of his ideas for a picture is to show a cornfield, and behind it ". . . the hills of Dulwich or rather the visions of a better country which the Dulwich fields will shew to all true poets." It is significant that he chooses, as vehicle for his spiritual message, no sublime landscape of ocean or mountain, but the modest rural scene of Dulwich. Palmer was in strong reaction against the grand or heroic. "Whatever you do," he adjured himself, "guard against bleakness and grandeur—and try for the primitive cottage feeling." Like his contemporary Wordsworth, he believed that it was the humble man living in the country, occupied in the basic primitive activities necessary to life, and undisturbed by the false attractions of a sophisticated and urban world, who was likely to come closest to God. It was this conviction that made Palmer revere the life of the plowman and shepherd; this is why he loved pastoral poetry—that is, if he felt that it was about a genuine pastoral life, not that of some golden Arcadia that had never existed. Such a genuine life had once existed in Virgil's Italy; and also in

England, so he understood. Palmer looked back with regret to the days of the medieval manor, where all men were said to have been united in a single community to cultivate the kindly fruits of the earth to the glory of God. The past had always appealed to his romantic sense. "The past for poets, the present for pigs," he said. Here, the appeal seemed justified by fact: the medieval past, it seemed to Palmer, really had been better than the Georgian present. And—so far as he could see—far better than the future; for Palmer shrank with suspicion from the world as it seemed likely to become: luxurious, mechanized, godless, contemptuous of the past.

As a matter of fact, at this stage of his career he bothered little about the world and its future. He was a dedicated man, absorbed in his art and in the faith which had inspired it. The function of "ideal art"—this was the phrase used by him and his friends to describe the kind of art they wished to practice—was to present the world of appearances in such a way as to reveal the divine element latent in them. This for him meant mainly in landscape. Sometimes he did attempt other subjects, mostly religious. He tried his hand at pictures of Adam and Eve, and of saints and angels: and he longed to paint a picture of Jesus Christ, at those moments when He manifested forth most gloriously His love and pity for sinful mortals. Now and again an image of Him would start before Palmer's eyes, only to vanish before he could set it down. He writes: ". . . I feel, ten minutes a day, the most ardent love for art, and spend the rest of my time in stupid apathy, negligence, ignorance, and restless despondency; without any of those delicious visions which are the only joys of my life—such as Christ at Emmaus; the repenting thief on the cross. . . ." ". . . Ask Christ to manifest to you these things; Christ looking upon Peter (called *Repentance*) and Peter's countenance. Christ's promise to the dying thief—the looks of both. Christ leading His blessed to fountains of living waters . . . ; Jesus weeping at Lazarus' tomb. The three first are the chief, and are almost unpaintable—quite, without Christ. Lay up, silently and patiently, materials for them in your sketch-book, and copy the prints to learn such nicety in pen

32

sketching, or rather, making careful studies, as may enable you to give the expressions. . . ."

For the rest, he treated his work as part of his devotional life. Every morning, before starting, he meditated on a passage of scripture and prayed for God's blessing on his task. Every night, he offered up thanksgiving for what he had been able to accomplish during the day. He implored God's help if things were not going well. This was liable to happen. Palmer still suffered from fits of melancholy when a fog of discouragement and apathy rose between him and his inspiration. It must be the work of the devil, he thought; Palmer deeply believed in the existence of the personal devil. At such times he decided that Satan was deliberately putting forth his powers to stop him from obeying his Lord's command to glorify Him through his art. At once he sought the Lord's help to fight the enemy. The Lord gave it. Soon—it might be within two hours—the clouds would disappear and Palmer fell to work again. In his notebook, he relieved his feelings by pouring out his troubles. ". . . I laid by the picture of the [*Holy*] *Family* in much distress, anxiety and fear; which had plunged me into despair but for God's mercy, through which and which alone it was that despondency not for one moment slackened my sinews; but rather, distress (being blessed) was to me a great arousement; quickly goading me to deep humbleness, eager, restless enquiry and diligent work. I then sought Christ's help the giver of all good talents whether acknowledged or not, and had I gone on to seek Him as I ought, I had found His name to me as a civet-box and sweeter than all perfume. . . ."

These fits of depression were a sign that he lacked confidence. This was to be expected: he was a highly strung young artist, who had not yet found himself and as a result was likely to feel depressed. Further, the 1820s did not provide a congenial atmosphere for any artist wishing to express a religious vision. Religious art seemed a thing of the past; and the past was different from now. Palmer longed for the encouragement that comes from a present example, yearned to find a contemporary painter with similar aims to his own.

IV

HE FOUND ONE. One day, he came across some drawings by William Blake. He was immediately excited. No modern naturalism here! These strange spectral figures tensely still, or extravagantly gesturing and apparently charged with some superhuman energy, were surely drawn from supernatural models. At last he had found a living painter of the spirit. Palmer longed to know him. He learned with excitement from Linnell that he was a friend of his. On a memorable day of October 1824, Linnell took Palmer and his sketchbook to visit him. Old, ill, and poor, Blake was now living with his wife in what had been a fine Queen Anne house at Fountain Court down by the Thames. Palmer and Linnell climbed the stairs and passed through a room, empty but for some pictures on its blistered paneling, to enter a shabby apartment which served the aging couple for studio, kitchen, and bedroom. They found Blake sitting up in bed; a plain little man, who, on their entrance, turned on them a pair of extraordinarily brilliant eyes. Here let Palmer take over the story. "We found him," he relates, "lame in bed, of a scalded foot (or leg). There, not inactive, though sixty-seven years old, but hard-working on a bed covered with books sat he up like one of the Antique patriarchs, or a dying Michael Angelo. Thus and there was he making in the leaves of a great book (folio) the sublimest designs from his (not superior) Dante. He said he began them with fear and trembling. I said 'O! I have enough of fear and trembling.' 'Then,' said he, 'you'll do.' . . . And there . . . did I show him some of my first essays in design; and the sweet encouragement he gave me (for Christ blessed little children) did not tend basely to presumption and idleness, but made me work harder and better that afternoon and night. And, after visiting him, the scene recurs to me afterwards in a kind of vision. . . ."

No wonder! Blake's personality, like his pictures, had something in it beyond nature. If to be a genius is to reveal life in a light no one has ever seen it in before, Blake was a genius in the strongest, strangest sense of the term. Lesser geniuses show us a new view of some limited and

34

secondary area of human experience: Blake shows a new view of the basic elements of human existence. Life and death, love and hate, good and evil—he perceived these things as directly and freshly as if he had been Adam looking around Eden on the day of his creation. Further— and this is what would have struck young Palmer—his was always a spiritual, even a supernatural, vision. Blake asserted that at the age of four he had seen the face of God looking in at the window of his home. Spirits haunted him throughout his early years. At Peckham, homely London suburb, the boy Blake beheld the trees starred with angels; on a summer holiday in the country he watched other angels flying about among the haymakers. Such unusual experiences did not cease with boyhood. In later life he said he had heard his dead brother's voice advising him about his work and he claimed that the famous dead— Moses and Julius Caesar among them—came and sat to him for their portraits in his studio. These visions are not to be described as delusions in the ordinary sense of the word; for, as Blake was careful to explain, he saw them with "the eye of imagination and not the eye of sense." But he held that the eye of sense was less penetrating and less trust- worthy than the eye of imagination.

In his so-called *Prophetic Books,* he sought to organize his lightning flashes of insight into a coherent symbolic system of belief. The result is obscure; and—though many have tried—no one has yet succeeded in fully elucidating it. To do so however is not necessary in order to appreciate his essential achievement. In his poems and pictures, Blake has opened men's eyes to behold his vision, even if he has failed to interpret it for them. He is one of the few men who have ever lived to reveal human experience in the perspective of a new spiritual dimension.

Impressive in art, he was equally impressive in life. To the youthful Palmer the plain little man in the shabby suit shone out, haloed with the light of a message from another world. In awe and astonishment, Palmer bowed before him. Blake responded gratefully. Prophets are prover- bially unappreciated in their own country, and he was no exception. Indeed he had the defects of his capacities. His sense of earthly reality

was weak in proportion as his sense of spiritual reality was strong. At home with angels, he was at sea with his fellow men. Blake could be depended upon to mistake people's characters; and, without particularly intending it, he was always outraging accepted convention. A neighbor who came to visit him was taken aback to find him and Mrs. Blake sitting in the garden, both stark naked. They were, Blake explained, reading *Paradise Lost* together and he had thought it would be more real to them if they read it unclothed like Adam and Eve. The neighbor was embarrassed. Blake was not.

Finally, he was an extravagant individualist, reacting instinctively against any person whether schoolmaster, or priest, or President of the Royal Academy, who appeared to claim authority over him. The result of all this was that he was continually at odds with the world he lived in. Many of his contemporaries thought him mad, others suspected him of being a dangerous revolutionary; and, though the friendliest of men, he generally managed to quarrel with those with whom it was important he should be on good terms: patrons, publishers, promoters of exhibitions. This, coupled with the fact that his art was so unusual, meant that he found it increasingly hard to make a living. In his later years, he might have starved without the help of Linnell and a few other friends. Such a history might well have made him downhearted; and there were moments when he was. Once he burst out:

> *O why was I born with a different face?*
> *Why was I not born like the rest of my race?*
> *When I look, each one starts! when I speak, I offend;*
> *Then I'm silent and passive and lose every friend.*

But these moods of discouragement never lasted long. Here was the advantage of living in the world of spirit: it stopped Blake from worrying too much about what happened in the world of matter.

All the same, after so much neglect, it must have been pleasant to him to meet an admirer like Palmer. In consequence, this interview was the first of many: Palmer became an attentive disciple. We get glimpses of the two in Blake's studio, their heads bent over engravings and antique

gems, or walking in the lanes around London, where, said Palmer, Blake taught him to perceive "the soul of beauty through the forms of matter"; or examining the pictures in the Royal Academy. Palmer turned to look at the quaint figure of his companion in his black suit and broad-brimmed hat, standing quietly amid the noisy fashionable crowd and thought, "How little you know *who* is among you!"

The more he saw of him, the more he admired. Blake's talk, though he spoke very quietly, had the magnetic power of his creative genius. Every subject he spoke of was glorified by the strange light of his imagination. Sometimes it was rather too strange. Palmer was bewildered when Blake described his encounters with spirits looking like "majestic shadows, grey, but luminous." But Blake never struck him as mad. His vagaries were too deliberate. Palmer noticed that more often than not Blake talked extravagantly in order to tease: his stories were at their most outrageous when he was conversing with some prosaic skeptic likely to be shocked by him. Anyway, how could a madman be so wise? "If Mr. Blake had a crack, it was a crack that let the light through," said Palmer.

Palmer admired Blake's character as much as his genius; his single-mindedness, his indifference to money or fame, his incapacity to say what he did not think true, his sensitive power of feeling. Palmer noticed how Blake's intent unroving eye now glowed with enthusiasm, now glittered with fine scorn, now melted with pity. Once Blake began re-peating the parable of the Prodigal Son. As he came to the words: "When he was yet a great way off, his father saw him," his voice faltered: he was in tears. Palmer, himself much given to tears, loved him for this. Indeed Blake was lovable; guileless, tender-hearted, spontaneous, re-sponsive. His very unselfconsciousness was endearing as well as comic. Nor was he made less winning by the bleak poverty-stricken surround-ings he lived in. On the contrary; "The high gloomy buildings," said Palmer, "assume a kind of grandeur from the man dwelling near them."

Impressed by Blake the man, Palmer was also influenced by his views, especially about art. These were religious. I have said that Blake looked on the imagination as man's supreme faculty, by which he was enabled

37

to perceive things in their divine essence. He also held that art was the means by which he communicated this perception to his fellows. To him, an artist was a priest and a work of art was an act of sacramental worship: "Prayer," he wrote, "is the Study of Art. Praise is the Practice of Art. . . . The Eternal Body of Man is the Imagination, that is, God himself." And again: ". . . I rest not from my great task; / To open the Eternal Worlds, to open the immortal Eyes / Of Man inwards into the Worlds of Thought, into Eternity, / Ever expanding in the Bosom of God, the Human Imagination." . . . "The Mocker of Art is the Mocker of Jesus."

Blake always held his opinions in their most extreme form; and his view amounted to saying that art was the only religious activity worth pursuing. Palmer could not go as far as this, he was too orthodox. But he did agree with Blake in thinking that art was primarily a religious activity and that its value and significance could only be understood in religious terms. Instinctively, he had believed this for years. Now Blake's teaching fortified and made articulate his instinctive conviction.

In addition to this, Blake set him an example as to how to give it practical expression. This may be thought surprising, since Palmer was a landscape painter and Blake a painter of visions. Indeed, he did not think much of landscape painting; he said that the visible world—or "the vegetable universe" as he preferred scornfully to call it—was not a worthy subject for art. But beggars cannot be choosers, even if the beggar be Blake. In 1821, when he was very hard-up, he had been glad to accept a commission to do some wood-cuts, illustrating a version by Ambrose Philips of the first *Eclogue* of Virgil. This meant that he had to depict the "vegetable universe" as shown in scenes of corn-growing, wine-pressing, and so on. Blake did not depict them very realistically: the little wood-cuts are stylized, summarized representations. Yet they revealed what Palmer already knew from their country walks together, that, though he professed to suspect it, Blake responded keenly to natural beauty. They convey the spirit of these scenes, heightened and made lyrical by their author's peculiar intensity of sentiment.

Palmer was overwhelmed by them. ". . . They are visions," he wrote,

38

"of little dells, and nooks, and corners of Paradise; models of the exquisite pitch of intense poetry. I thought of their light and shade, and looking upon them I found no word to describe it. Intense depth, solemnity, and vivid brilliancy only coldly and partially describe them. There is in all such a mystic and dreamy glimmer as penetrates and kindles the inmost soul, and gives complete and unreserved delight, unlike the gaudy daylight of this world. They are like all that wonderful artist's works the drawing aside of the fleshly curtain, and the glimpse, which all the most holy, studious saints and sages have enjoyed, of that rest which remaineth to the people of God. The figures of Mr. Blake have that intense, soul-evidencing attitude and action, and that elastic, nervous spring which belongs to uncaged immortal spirits." Palmer's friendship with Blake formed the final crowning stage in his artistic education. Already he had chosen his subject matter; already he had begun to devise an appropriate style in which to express it. Blake inspired him with the final confidence to go fearlessly forward and achieve his aim. The period now begins in which Palmer produced his most characteristic masterpieces.

Blake inspired Palmer's friends too. Introduced by Linnell and Palmer, other youths with similar aspirations came to Fountain Court, where they also fell under Blake's spell. Two we know already, Finch and Richmond. Prominent among the others were four artists, Frederick Tatham, Edward Calvert, Henry Walker, Welby Sherman; also Tatham's brother Arthur, a budding clergyman, and a young cousin of Palmer called John Giles, who worked in a stockbroker's office.

They met at Blake's house and elsewhere, and gradually began to cohere into a group, united by common interests, animated by a common spirit. The interests were literary and artistic: the spirit was religious. All were men to whom the inner life of the imagination was the most important life; and, since they had been brought up as orthodox Christians, they interpreted this life in orthodox Christian terms. They loved Purcell's music and Milton's poetry and Michelangelo's pictures as the bringers of a message from God. Their religious fervor was increased by the feeling that they lived at a time when their faith was in danger.

Round them a growing host of infidels denied the existence of the transcendental and sought to explain all human desires in material terms. There was no such thing as a soul, said these men, man was just a superior kind of animal, whose pleasure in beauty had purely physical causes. For Palmer and his friends such a view was a blasphemy, undermining man's faith in all that they held most sacred. They felt called upon to close their ranks and fight the infidels to the death. They needed a leader however. Who better than Blake! For Blake had already seen the attack coming and had evolved a method of defense. It was akin to that employed by D. H. Lawrence a hundred years later, and effective for a similar reason: namely, that it was aggressive and militant. Defenders of the spiritual have often tried to meet rationalists on their own ground; and have suffered unnecessary setbacks in consequence. Not so Blake; he rejected the whole rationalist-materialist basis of belief and tested truth not by sterile reason or soulless science but solely by the holy faculty of imagination. Magnificently he cried: "Babel mocks, saying there is no God or Son of God, that Thou, O human imagination, O Divine Body, are all a delusion. But I know thee, O Lord, when Thou lightest upon my weary eyes, even in this Dungeon." It was the body, not the soul, whose independent reality he questioned. "That called the body," he said, "is a portion of soul discerned by the five senses." Such words stirred Palmer and his friends like the sound of a bugle calling them to arms. For them, Blake was a Heaven-sent champion and leader.

They treated him as such and christened his house "the House of the Interpreter" after the house in *Pilgrim's Progress* where Christian was instructed in divine wisdom. When they went to visit it, each of them bent in turn to kiss the bell pull before entering. Blake welcomed these enthusiastic youths, advised them about their drawings and writings, discoursed to them about the meaning of art and faith. The rest of their time they spent mainly in each other's company; writing, reading, painting, and on long sketching expeditions into the country. They also passed regular evenings in each other's houses where they inspected each other's pictures, made music, and read aloud poems. When the

40

party had ended, they would accompany each other home through the empty London streets, chanting aloud any lines that had especially excited them, and enjoying themselves so much that it seemed intolerable to go to bed. To and fro they paced till the pale dawn light had begun to glimmer on roof and pavement.

Palmer's friends, like himself, felt a romantic sentiment for the past. One of them, his cousin John Giles, the future stockbroker, had an especial passion for the Middle Ages. He even went so far as to pronounce his words in what he thought was a medieval way and spoke of minced pies as "mincéd pies." He was always comparing contemporary products unfavorably with those of the ancients. "The ancients," he said, "would have made them much better." His friends shared this sentiment and christened themselves "the Ancients." It was an incongruous name for them; for in most respects they were so conspicuously and touchingly young. The records of their life at this time breathe a fresh infectious atmosphere of youthful hope and boyish fun and childlike affection and naïve young idealism; and, in two instances, of youthful genius. The two instances were Palmer himself and Edward Calvert. Calvert was much the most remarkable of Palmer's friends. He entered Palmer's life in 1826, a stalwart, stern-faced young man in white trousers and with the look of a naval officer. And in fact he had been brought up on the coast of Devonshire, where as an adventurous boy, he had learnt to love sailing. But there was another strain in him which also showed itself early. Playing in the garden at six years old one summer evening, with grass and flowers glowing in the light of the setting sun, he passed through a moment of intense spiritual experience; the sense, so he described it later, "as of a loving spirit taking up his abode within me and seating himself beside my own soul." This, like Palmer's sight of the shadows on the moonlit wall, marked the turning-point in Calvert's life. In the same way, it convinced him that earthly beauty was the manifestation of a spiritual reality.

The active adventurous strain in his nature, however, was also strong. As soon as he was old enough he joined the Navy. But though he enjoyed seeing the world and also such fighting as came his way, he did not settle

down as a sailor. Instead he took to art and, in his cabin by the light of a lantern, spent his spare time drawing. His artistic inclinations were encouraged by a voyage to Greece, which made him in love with classic architecture and classic art; and his dissatisfaction with his profession was intensified by the death of his greatest friend, a young brother officer, who was killed in action beside him. Indeed the shock of this last event finally put Calvert off the Navy. He returned to England, threw up his commission and became a painter. Soon he had married and settled in London. His talent flowered swiftly. By the time Palmer knew him, he had done some work which disclosed a beautiful and individual vision; unlike Palmer's, it was not Christian. Greece had set Calvert dreaming of a pagan earthly paradise, where faun and nymph danced beneath the olive groves, or lingered pensive beside the wine-dark sea.

Now, with the rest of his friends, he met Blake and fell under his spell. This was a Christian spell. The consequence was a little to modify Calvert's vision. It still presented an earthly paradise, but changed from classic Arcadia to Eden before the Fall; with its central figure no pagan nymph but Eve—Eve before she ate the apple, naked and unashamed and lovely. Calvert's vision of the Golden Age differed from Palmer's and Blake's, in that it centered around sex; sex glorified and idealized, tender, innocent, passionate. All the same Palmer was enthusiastic over Calvert's art and found his personality sympathetic. Particularly he liked Calvert's habit, disconcerting to the conventional, of sitting under a tree and loudly reciting Virgil. Calvert returned Palmer's affection— though he had to confess that he did sometimes find his jokes tiresome. Palmer discovered, for instance, that Calvert had a particular dislike of the song *The British Grenadiers*; perhaps its jaunty patriotism reminded him disagreeably of his naval days—and on one occasion Palmer teased him by singing it over and over again. It was some days before Calvert recovered his temper. He was the only one of the Ancients, people noticed, who could not take a joke against himself.

So passed 1825 and 1826. In the next year came a change. The Palmer household left London and settled about thirty miles away, at the village of Shoreham in Kent. The reasons were twofold. First, Samuel

Palmer was suffering from bronchial trouble and it was thought that the country air would do him good; secondly, his father had turned out such a failure at bookselling that his brothers persuaded him to give it up and retire with his son to the country. He was quite ready to, especially as he had learnt that Shoreham was the center of a Baptist connection and he would get a chance there of preaching and ministering. The change was made easier by the fact that Samuel had recently inherited a small legacy so that the family, if they were economical, could live there without earning. They established themselves in a small thatched cottage where they subsisted on eight shillings a week each, feeding mainly on eggs, milk, and fruit. Their only approach to luxury was a cup of green tea in the evening and an occasional pinch of snuff. Such simple living was no sacrifice to Samuel Palmer. The years he spent at Shoreham were to be the most blissful of his whole life. As a place, it was his idea of paradise; a little village of seventeenth- and eighteenth-century houses, through which wound the waters of the river Darent, and surrounded by corn fields, hop gardens, and water meadows, planted with alder and pollarded willows; all set in a valley, on each side of which rose hills thickly wooded with oak, chestnut, and beech, relieved here and there by the black foliage of an ancient yew tree. Sheltered and fertile, the Shoreham valley was a place of abundance, breathing a Keatsian lushness, a Wordsworthian peace. "It looked," said Calvert, "as if the Devil had not found it out."

It still does: even now in 1969, Shoreham is tranquil and sequestered. In Palmer's day, away from the main road and before the coming of the railway, it seemed completely cut off from the world. It retained its antique features unchanged, villagers in smock frocks, a ruined mansion, thought to be haunted, a wise woman with charms to heal warts and broken hearts, even a village idiot, leaning on the old stone-cut bridge and listening with vacant stare to the sound of rushing waters from the neighboring mill. Each phase in the cycle of the rural year at Shoreham was marked by immemorial and picturesque customs: the fragrant hop-picking, done to the sound of traditional songs; harvest home in sun-burnt August, winter days when, with the snow lying on the ground

outside, the men threshed corn in the huge old barn and returned tired to drink ale and, in the warmth of the great chimney corner, tell tales of ghosts and goblins. Palmer was delighted to find that the people of Shoreham believed in these supernatural beings.

After a year, he and his father moved to part of a bigger Georgian residence, Waterhouse, where they had a roomy, paneled parlor and the run of a large garden spreading down to the waterside. Meanwhile the other Ancients kept them company at Shoreham. Frederick Tatham actually made his temporary home there; the others came for long visits. They traveled on foot, or got lifts from wagons lumbering to and fro with produce for the London markets. Sometimes, towards three in the morning, a young man would knock on the door of Waterhouse, sure of a welcome. For, if there was not room enough, either Samuel or old Mr. Palmer would offer his bed to the visitor, and content himself to spend the rest of the night on the floor. Poor Mr. Palmer! The Shoreham people were surely right to christen him the Man of God. Once—it was a great occasion—Calvert brought Blake himself to Shoreham; traveling in a ponderous covered wagon, jingling with bells and fluttering with ribbons. The Ancients received him with the reverence due to a semi-supernatural being. Indeed, during the visit, he gave evidence of his unearthly powers. Samuel Palmer, traveling by coach for once, had set off one evening for London. Some hours later, sitting in the parlor, Blake clapped his hand to his forehead: "Sam is walking up the road," he said; and later, "He is coming through the wicket gate." The wicket gate opened and Sam entered. The coach had broken down and he had been forced to return. The Ancients thought this was final evidence that Blake was in direct touch with God.

For the rest, Palmer and his fellows passed the days in idyllic activity. Waking very early, they plunged into the waters of the Darent—fresh in summer, icy in winter—then came home first to say their prayers, then to spend their day painting, at home or out in the fields and woods. In summer they liked staying out, even after dark. They watched the soft summer twilight deepen to night, with the moon like a great lamp hanging low over hill and orchard—Diana, amorous of Endymion. Sometimes the young men would go on long night walks in the wooded hills

above the valley, threading their way through the dim trees till they emerged to watch the dawn break over the spreading landscape below. It made no difference to them if the weather was stormy. Shoreham was a place for summer storms. The Ancients loved them; first the flash of lightning, then the mutter and growling roll of the thunder, and then the warm flooding rain.

These were solemn experiences. But their nocturnal expeditions were far from being always solemn. Their spirits burst out more exuberantly in the country than in London. Half the night they would spend larking, singing and acting scenes of farce—Palmer, who was an excellent mimic, shone in farce—also horrific melodramas, inspired by the tales of Mrs. Radcliffe, the most famous contemporary writer of terror tales. She was a favorite of the Ancients, who would walk miles to borrow one of her books. They used to enact her stories in a deserted chalk quarry, where they also performed scenes from *Macbeth*, accompanying them by music which they sought to make as mysterious and alarming as possible; so successfully that they sometimes frightened themselves. They also frightened any villager who happened to pass by. The rustics of Shoreham were bewildered by their visitors. They had never seen anything like them—turning night into day, reciting outlandish rigmaroles. Moreover, they looked so extraordinary! Palmer, in particular, had taken to growing a beard and wearing his hair to his shoulders; also a long cloak that swept his heels. Thus attired, and with his high forehead gleaming in the moonlight, he was taken for a ghost, or at any rate for a magician. Perhaps they were all magicians, thought the rustics, or astrologers—"extollagers" was the version of the word used by the rustics—telling fortunes by the stars. This would explain their moonlight excursions. The "extollagers" turned out to be so harmless and friendly that the villagers soon stopped being frightened of them. But they did not get to know them well. It is to be noted that Palmer was never intimate with the people of Shoreham. He was too much up in the clouds for the homely countrymen to feel at ease with him. In consequence he tended to idealize their form of life; he never came close enough to see its drabber, grimmer side.

45

In any case he did not have much time to make new friends; for, stimulated by his new circumstances, he had grown more wholly dedicated even than before to the inner life of piety and art. He spent much time in his private devotions, which he performed in a little chapel he had made for himself in a shed in the Waterhouse garden. He also did much serious reading. It was now that he thoroughly studied theology, sermons, history, the works of the sixteenth- and seventeenth-century mystics and divines, and any book by or about Sir Thomas More, saint and martyr. More made a special appeal to him; for he had stood in his time, as Palmer wished to do now, for the past against the present. Moreover, he found himself exquisitely in sympathy with More's personality, as described in his biography, simple yet subtle and humorous, and with his mode of living devised in a comely order to serve the glory of God. Palmer looked on More as his patron saint and hung an engraving of him on his wall as a sort of ikon.

Reading and devotion enriched his imaginative life. So much more did the fields and woods around him. He was overwhelmed by the beauty of the Shoreham scene. Not only with his friends, but by himself, he spent whole days and nights in the open air. Men working in the fields in the stillness of the summer daybreak used to hear Palmer's clear tenor singing far away up in the woods where he had been walking all night. As always, moonlight and twilight had a special message for him. God seemed very close at such times. ". . . Creation," he wrote, "sometimes pours into the spiritual eye the radiance of Heaven: the green mountains that glimmer in a summer gloaming from the dusky yet bloomy east; the moon opening her golden eye, or walking in brightness among innumerable islands of light, not only thrill the optic nerve, but shed a mild, a grateful, an unearthly lustre into the inmost spirits, and seem the interchanging twilight of that peaceful country, where there is no sorrow and no night.

"After all, I doubt not but there must be the study of this creation, as well as art and vision; tho' I cannot think it other than the veil of Heaven, through which her divine features are dimly smiling; the

46

setting of the table before the feast; the symphony before the tune; the prologue of the drama; a dream, and antepast, and proscenium of eternity.''

The fruitfulness, the rich fecundity of the Shoreham scene also spoke eloquently to Palmer's heart. He delighted in the full-foliaged trees; the chestnut with its creamy candelabra, the smooth-boled beeches; and the ripe corn, the scented hops, the apple trees, clotted with blossom in the spring and in autumn bending under the weight of fruit; and fine summer days with the blue sky marbled with snowy cumulus cloud, later to be translated into gleaming pool or stream. Palmer loved to linger by pool and stream. A landscape, to be perfect, must have water in it, said he.

It was not tragic conflict or romantic yearning that roused his spirit to its highest intensity, but harmony, fulfillment, fruition. In these he recognized God's love visible and tangible on earth. As much as twilight did they stir his religious sense; and most of all when the two were combined, when he looked at a ripe cornfield glowing in the summer dusk, with the harvest moon rising above the horizon. Years later, he wrote: ''. . . rising moon with raving-mad splendour of orange twilight-glow on landscape. I saw that at Shoreham.'' He christened Shoreham ''The Valley of Vision.'' For there, as never before, he saw the two inspirations of his imaginative life—his sense of God and his response to the English landscape—fused to show him the Divine Reality incarnate. He loved to quote from the sixty-fifth psalm:

> *Thou visitest the earth, and blessest it; thou makest it*
> *very plenteous.*
> *The river of God is full of water: thou preparest their*
> *corn, for so thou providest for the earth.*
> *Thou waterest her furrows; thou sendest rain into the*
> *little valleys thereof; thou makest it soft with the drops*
> *of rain, and blessest the increase of it.*
> *Thou crownest the year with thy goodness; and thy clouds*
> *drop fatness.*

*They shall drop upon the dwellings of the wilderness; and
the little hills shall rejoice on every side.
The folds shall be full of sheep; the valleys also shall stand
so thick with corn, that they shall laugh and sing.*

Here, Holy Scripture speaks with the very voice of Samuel Palmer at
Shoreham.

V

SHOREHAM released the full energy of Palmer's genius. The seven
years he spent there were those of his most active achievement.
He spent much time out of doors drawing direct from nature; the
bridge at Shoreham or one of the great oaks in Lullingstone Park. He
sought to make his drawing as accurate as he could, but also to suggest
the spirit of his subject as a poet does. "Milton, by one epithet, draws an
oak of the largest girth I ever saw, 'Pine and *monumental* oak': I have
just been trying to draw a large one in Lullingstone; but the poet's tree
is huger than any in the park: there, the moss, the rifts, and barky
furrows, and the mouldering grey (tho' that adds majesty to the lord of
forests) mostly catch the eye, before the grasp and grapple of the roots,
the muscular belly and shoulders, the twisted sinews."

The spirit rather than the letter was always Palmer's aim. Indeed his
sketches from nature were only a preparation for the landscapes he
painted at home: and these were inventions, ideal scenes designed as
vehicles for religious sentiment, nature depicted as an expression of the
mind of its Divine creator. This meant that they portrayed the kind of
landscape that most stirred Palmer's spiritual sense; twilight and moon-
light scenes on the one hand, and, on the other, scenes of fruition, of
harvests and summer orchard. His pictures suggest his notion of the
ideal life lived close to nature; he shows us the plowman yoking his oxen,
the reapers at work beneath the harvest moon, the shepherd folding his
flock. There are also biblical scenes of rural life: Ruth returned from
gleaning, the Holy Family resting in a field on its journey to Egypt.

48

Palmer draws scenes of repose more often than scenes of activity. Rest after toil in country surroundings suggested supremely well that mood of tranquil, blissful fulfillment which is Palmer's primary inspiration.

For all his delight in landscape, he thought that it had no significance unless it related to man. Often his pictures include a human figure; and even when they do not, he likes to put in some sign of human life—a cottage, a barn, a church spire. Sometimes he shows us twilight pierced by the ray of a lamp shining from a cottage window, sign of the warm and loving home life within. Natural things themselves are depicted in such a way as to suggest human associations. Hills are rounded like women's breasts; tracery of bare branches recalls tracery in a church window. He writes "Now I go out to draw some hops that their fruitful sentiment may be infused into my figures." By these means Palmer suggested the kinship of all created things, and thus conveyed his sense of the unity of creation.

These pictures are less realistic than the studies in detail and style, as well as in general intention. Though the material in them is drawn from nineteenth-century England, Palmer sought to create a vision of some ideal and blessed region like the land of Beulah in *Pilgrim's Progress*, which lay within sight of the Celestial City. Convincingly to express this vision, he forswears realism, plants exotic palm trees in English coppices, lights up his sky with stars as big as moons, draws his figures in a stylized convention derived from archaic art. "I think the great landscape painter," he once said, "needs only as much truth as is necessary to make the ideal probable." And again, "Nature is not at all the standard of art, but art is the standard of nature. The visions of the soul, being perfect, are the only true standard by which nature must be tried. The corporeal executive is no good thing to the painter, but a bane. In proportion as we enjoy and improve in imaginative art we shall love the material works of God more and more. Sometimes landscape is seen as a vision, and then seems as fine as art; but this is seldom, and bits of nature are generally much improved by being received into the soul. . . ."

He believed in intensification because it expressed the characteristic

quality of spiritual vision. "Excess," he cries, "is the essential vivifying spirit, vital spark, embalming spice . . . of the finest art." Only by excess could the work be made to leave the earth and soar upwards into celestial air.

The sentences I have quoted come from his notebook and from his correspondence. During this flood-tide period, Palmer poured out his thoughts in voluminous letters to his friends. They were an odd mixture. Much space is taken up with practical and unromantic matters: Palmer writes often about cures for indigestion. Interspersed with these passages are jocular though decorous references to the charms of the female sex; as when he playfully describes his idea of the perfect wife, "a nice tight armful of a spirited young lady who will soothe him when vexed and patch up his old clothes." Then something turns his mind to art or religion—the two were inseparable to Palmer—and suddenly the whole tone of the letter changes and his words take fire to blaze up in a passage of impassioned thought, lit by vividly imaginative phrase: "Genius is the unreserved devotion of the whole soul to the divine, poetic arts, and through them to God; deeming all else, even to our daily bread, only valuable as it helps us to unveil the heavenly face of Beauty." Or "Nature, with mild reposing breadths of lawn and hill, shadowy glades and meadows, is sprinkled and showered with a thousand pretty eyes, and buds, and spires, and blossoms gemm'd with dew, and is clad in living green. Nor must be forgotten the motley clouding, the fine meshes, the aerial tissues, that dapple the skies of spring; nor the rolling volumes and piled mountains of light; nor the purple sunset blazon'd with gold and the translucent amber. Universal nature wears a lovely gentleness of mild attraction; but the leafy lightness, the thousand repetitions of little forms, which are part of its own genuine perfection (and who would wish them but what they are?) seem hard to be reconciled with the unwinning severity, the awfulness, the ponderous globosity of Art."

To be creative is not to be tranquil: and, even at Shoreham, Palmer was sometimes disturbed and unhappy. He passed through days when inspiration deserted him and he was plunged into a black morass of

50

despondency. It was Satan's deliberate doing, he told himself, and he took steps to defeat him. In his journal he noted the ups and downs of the battle: ". . . Satan tries violently to make me leave reading the Bible and praying. . . . O artful enemy, to keep me, who devote myself entirely to poetic things, from the best of books and the finest, perhaps, of all poetry. I will endeavour, God helping, to begin the day by dwelling on some short piece of scripture, and praying for the Holy Ghost thro' the day to inspire my art. Now, in the twilight, let Him come that at evening-time it may be light.

"*Wednesday*. Read scripture. In morning, ill and incapable, in afternoon really dreadful gloom; toward evening the dawn of some beautiful imaginations, and then some of those strong thoughts given that push the mind [to] a great progress at once, and strengthen it, and bank it in on the right road to TRUTH. I had believed and prayed as much or more than my wretched usual, and was near saying 'what matter my faith and prayer?', for all day I could do nothing; but at evening-time it was light; and at night, such blessed help and inspiration!!"

In the end the blessed help was always forthcoming. Soon, Palmer was happily engaged on some new image of Paradise. For the moment, he despised the Devil and his works. He apologized to Richmond: ". . . Forgive my spirits; they sometimes haunt the caves of melancholy; ofttimes are bound in the dungeon, ofttimes in the darkness; when the chain is snapt they rush upward and revel in the temerity of their flight. What I have whisper'd in your ears I should not blaze to vulgar apprehensions: if my aspirations are very high, my depressions are very deep . . . so I may *sometimes* bound upwards; pierce the clouds; and look over the doors of bliss."

These Blake-like moods and Blake-like artistic principles brought with them a Blake-like unpopularity. Palmer's new Shoreham style did not appeal to the public as his earlier manner had. During these years, fewer and fewer of his pictures were accepted for exhibition; and he hardly sold any of them. He did not mind partly because he had come to prefer art that was strange—all the most original art was quaint, he said—and partly because he thought that, in resisting the temptation

to paint popular pictures, he was obeying the direct command of God. But what in fact upheld him was the radiant confidence of his youthful genius.

This radiance was as fugitive as it was glorious. By 1830, it had begun to fade: by 1833, it was gone. Poverty was the basic trouble. For a few years Palmer had been able wholly to disregard the world's opinion because he was financially independent: but this was only so long as his small legacy lasted. If he had been earning, he could have stayed at Shoreham. But he took the view that he could only earn by sinning against the teaching of God's prophet, William Blake, and the promptings of his own genius. "By God's help," he proclaimed, "I will not sell His precious gift of art for money; no, nor for fame neither. . . ." Instead, he decided to maintain himself at Shoreham by drastic economy. He cut down his weekly expenses to 5/2d. per head. After nightfall, he refused to light more than one candle. This limited the pleasure of the evening severely; in particular, it made it impossible for the Ancients to hold reading-aloud parties at night. In summer, Palmer hurried them out to amuse themselves in the open air; in winter, he sent them to bed.

To the troubles of poverty were added those of loneliness. By 1829, his father and brother were no longer much at Shoreham. Can it be that they found the evenings lit by a single candle unbearably depressing? Samuel Palmer stayed behind, with only his old nurse Mary Ward as companion. The circle of his friends, too, was breaking up. Their guide and guardian spirit was already gone. On April 12th, 1827, his voice uplifted in joyful hymns, his face lit up at the sight of angelic visions, Blake breathed his last. Most of the Ancients went to his funeral: but Palmer felt too upset to face it. Throughout his life he could never bear funerals! A year or two later, Blake's disciples started to disperse. Their circle had been a students' circle. When they ceased to be students, the activities of maturity intervened to divide them in fact, if not in spirit. Professional activities in the first place; by this time Giles was a hard-worked stockbroker, Arthur Tatham an ordained clergyman, his brother and Richmond busy professional painters. Religion also drew the Ancients in different directions. Most of them were possessed

by an unsleeping desire to save their souls; and, since all were individualists, they tended to search for salvation in different places—generally odd places. Arthur Tatham, it is true, was an orthodox clergyman; but his brother followed Carlyle's friend, Edward Irving, who proclaimed that the Day of Judgment might occur at any minute, and commanded his followers to rearrange their lives in the light of this alarming prospect. The mystically minded Finch strayed even further from orthodox paths and became a Swedenborgian, a member of that curious spiritualist sect, founded in the eighteenth century, which had such an influence over Blake himself. Calvert gave up Christianity altogether. He had never been more than half a Christian: the other half worshipped the Great God Pan. Now Blake was dead, Pan exacted more and more of Calvert's homage. Disturbed by what he called Calvert's "naughty disobedient heresies," Palmer argued with him for hours. In vain: within a few years, Calvert had put up an altar to Pan in his garden and, it was suspected, performed ceremonial devotions before it.

These religious differences did not make the Ancients less fond of one another. But it weakened their sense of common purpose and their power to give each other support. Palmer began to feel more spiritually lonely. The third force that broke up the Ancients' circle was love: Finch married, Calvert married, Richmond engaged himself to Tatham's sister, Julia. These last were too poor to marry. This horrified Palmer's romantic heart. Although so hard up, he scraped together £40, to lend to Richmond, who put it in his pocket and eloped with Miss Tatham to Gretna Green. Afterwards, since they had no home, they stayed for a time with Palmer. He felt for them all the more because they had felt for him in a similar situation. Palmer, who was susceptible to feminine charms, had, two years earlier, fallen in love—with whom is not recorded. Alas, his love was not returned! Richmond and Julia had shown themselves to be especially understanding at his disappointment. But it remained, forming another cloud to darken the horizon. The sorrows of poverty and loneliness were thus increased by those of

unrequited love: while the fact that so many of his friends were happily settled meant that they needed his company less.

To these personal reasons for unhappiness were added public reasons. Palmer—and many others at this time—began to fear that the nation was on the brink of a dreadful catastrophe, in which the old England which they loved would be destroyed. It was true that the nation was undergoing a major transformation. First of all, the Industrial Revolution was turning it from an agricultural to an industrial society: and, in the process, throwing up a working class violently discontented with the conditions in which they were forced to live. Meanwhile the ideas inspired by the French Revolution were starting a movement to undermine the chief institutions, political and religious, of the old semi-feudal England. During the Napoleonic wars, this movement was kept under. But now, twenty years later, discontent was stirring again, and, in spite of repression, grew stronger. To many people it looked as if it would soon break irresistibly forth and sweep to victory on a wave of blood-stained anarchy. "Look what happened in France only thirty years earlier!" people said. The great Duke of Wellington himself prophesied that, within ten years, King and Church would be gone. The Ancients, most of them, agreed with him. When Arthur Tatham was ordained, he told Palmer that he fully expected to be martyred for his faith within ten years. Palmer agreed that it was very probable. Himself, his mind soaked in Bible prophecies, he saw the future in a sinister Apocalyptic light, with the land shrouded in horror and great darkness, men's hearts failing them for fear, nation rising against nation, and the reign of Anti-Christ about to begin.

His fears were brought to a head by the agricultural disturbances that preceded the passing of the Reform Bill of 1832. The Reform Bill was the crucial event in the new phase of political change: for it finally deprived the landed interest of its monopoly of political power and opened the gates to the gradual extension of the franchise to all. Though not itself a democratic measure, it was an irretrievable step towards democracy. The poverty-stricken laborers realized this; and, when the issue was in the balance, began to show their support for the Bill in

54

riots and rick burnings and machine breaking—and this in Palmer's neighborhood. He would look out of his Shoreham window to see the night sky luridly lit up by the flames of the burning ricks. All this horrified him so much that he actually rushed into political action himself. In the General Election of 1832, he published an agitated pamphlet on behalf of the Tory candidate. It was couched in the most sensational terms: "You will NOT suffer those temples where you received the Christian name to fall an easy prey to sacrilegious plunderers! You will NOT let that dust which covers the ashes of your parents, be made the filthy track of Jacobinical hyenas! . . . Landholders, who have estates confiscated or land in ashes: Farmers who have free trade, and annihilation impending over you: Manufacturers who must be beggared in the bankruptcy of your country: Fundholders, who desire not the *wet sponge*: Britons, who have liberty to lose: now is the time for your last struggle! The ensuing Election is not a question of party politics: much less, a paltry squabble of family interest: but Exhistence, or Annihilation to good old England!"

This curious document was taken to be the work of a mad clergyman. Indeed artists in general are as inept about politics as politicians are about art. Palmer was no exception. His fears were comically exaggerated: for the forces of order in England were far stronger than the forces of anarchy. Moreover, if he had known the peasantry better, he would have realized that their violence, though misguided, was intelligible. Rural life was not so idyllic as he fancied. Palmer might speak wistfully of the disappearing charms of country life. For many of the poor, they had already disappeared. They were ignorant, overworked and underfed: it was not surprising that they should break machines and burn ricks. Palmer dwelt too much in the world of spirit to discern the uglier realities of life around Shoreham in 1832.

But he was only wrong about the immediate situation. Taking a longer view, and looking at it from his angle of vision, he was right to be despondent about England's future. The double revolution was indeed working against the things he valued most. The Industrial Revolution was in the end to threaten England's rural beauty, and the

rationalist movement to undermine the creed that told him this beauty was something divine. Both encouraged people to substitute materialist and human for spiritual and religious values. Palmer was to realize all this more clearly later. For the moment, all was merged in a general sense of impending doom, which added to the anxiety caused by the more immediate troubles of poverty and loneliness.

It made his views sterner. Suffering he saw as the consequence of sin. The English, including himself, had been too lax, especially in tolerating heretical views. "Once I was full of this lightness and folly," he said to Richmond, "yea even to the present time my old Adam can see no reason why the sleek and sober Quaker or the meek and moral Unitarian should be beholden to the Church, claiming the power of the kingdom of Heaven. But blessed be God I am changed even since you saw me. I am a free-thinker in art, in literature, in music, in poetry;—but, as I read of but one way to Heaven and that a narrow one, it is not for me to chuse which way I will be saved. . . ." No cranny should be left in the wall of orthodoxy through which error could creep in. Perhaps people did not believe enough in Hell. This, thought Palmer, was a great pity. "None," he said paradoxically, ". . . will fully enjoy the comfort and peace who do not know also the terrors of the Lord." He wondered if he knew it enough himself. For there was nothing self-righteous in Palmer's sternness. On the contrary, he feared he had been as lax in conduct as in opinion. Surely he was a thorough sinner: frivolous, pleasure-loving, and conceited. His self-confidence began to ebb away. This had unfortunate results to his art. Palmer began to wonder if he had been right to break away so boldly from tradition in his style. Moreover, loss of spirit meant loss of inspiration. Palmer's shaping spirit of imagination weakened. For his art was in part born of his bliss. It expressed his sense of glory; as his sense of glory faded, his creative impulse faded with it. He still responded to the beauty of the world more than most men. But it was not with the supernatural intensity of four years back. The trees no longer seemed trees of Eden; the moon was not radiant with the light of Heaven itself.

Meanwhile, for the time being, Palmer stayed on at Shoreham, grow-

56

ingly depressed, and looking about for any means by which he could make some money. "If I could but get a twenty-guinea commission, even if it were . . . to draw the anatomy of a pair of stays," he sighed in humorous melancholy. In 1834 he went back to London. He sought to comfort himself with the thought that, in so doing, he was acting as a Christian: for after all Christianity was the religion of self-sacrifice. All the same, he felt as if he were leaving Paradise. He was right. In later years, his time at Shoreham loomed in his memory through a golden mist. "There," he said, ". . . the beautiful was loved for itself, and if it were right . . . to live for our own gratification, the retrospect might be happy." Pathetic words, in the light of later events! For Palmer never had another chance of living for his own gratification. His departure from Shoreham was the turning point in his history. If there he had lived in Paradise, for the rest of his long life he was out struggling on a harsh and sunless earth that at times was wholly plunged in wintry darkness.

The first years were not so bad. He was still young, still hopeful. Besides, his life still offered considerable pleasures. Back in London, living at Lisson Grove, he was able to see more of his friends again; both individually, and together on one evening a month, when the Ancients resumed the practice of gathering for a formal meeting. These evenings started more or less gravely. The painters walked round and inspected each other's pictures propped up against the candle-lit walls; then came supper, and afterwards everyone relaxed; singing, acting, and reciting, with the company in fits of laughter at Palmer's comical imitations. Palmer's life was also diversified in the summer by an occasional sketching expedition. In search of new subjects, he explored new districts. Since he was poor, he did this on foot; sleeping under the stars, or, if it was wet, at a humble ale house. He cut an odd figure. Though still bearded, he had cut his hair; his face, no longer soft and youthful, was half concealed by huge goggling spectacles and his short figure was hidden by a long overcoat, with many pockets bulging with sketching apparatus. He was also bowed down by a large pack on his back, containing the rest of his luggage.

His first visit was to Devon. The landscape there was green and fecund and intimate and he loved it. In 1834 and 1835 he tried Wales, which he liked less; too grand and mountainous for him, he said, and with far too much rain. On the way back, he stopped at Tintern. From here, he wrote a letter to Richmond, which oddly and vividly illustrates his situation at this period. It opens with an eloquent rhapsody in praise of the Gothic beauty of Tintern Abbey, silhouetted against the sunset. At this point, he is interrupted; by the time he takes up his pen again, it is in a very different mood, for he has in the interval discovered that he has spent all his money. "If you've a mangy cat to drown, christen it 'Palmer,' " he laments, and he goes on to ask Richmond to send him £3 by return of post.

He made many acquaintances on these journeys. They generally began by taking him for a peddler, but soon found themselves delighted by his conversation. Crabb Robinson, friend of Blake and Wordsworth, met Palmer in Wales in 1836. He was impressed by his deep eyes and capacious brow; bought one of his sketches and invited him to visit him in London. But he was disconcerted, and even shocked, by Palmer's reactionary opinions. Fancy upholding the penal laws against the nonconformists! Fancy believing in witches! For leaving Paradise for the harsh world had not modified Palmer's views. On the contrary, it had made them stricter. The more he saw of human beings, the more sinful he thought them. England was in an evil state: this emerged even in small episodes. "As Mr. Calvert," he told Richmond, "and I walked in a romantic dell we saw a very young Welsh girl of more than ordinary beauty and loveliness of expression. The features were softened with that delicate shade of pensiveness &c., &c. She timidly approached, and offered (I think for sale), a large, winged beetle, not yet impaled on a pin, but girt with pack-thread. It was taken away from her and let fly, to her utter astonishment. O! for a safe passage to that world where undivorced beauty shall ever be the index and form of goodness! O! for a heart with none of the girl and beetle in it!" Clearly human nature was so congenitally cruel and corrupt, Palmer began to think, that only the sternest discipline could keep it straight. He recommended Rich-

58

mond to remember now and again to beat his children. This came unconvincingly from a man who could hardly bring himself to brush away a fly. For the rest, pessimism about human life did not prevent Palmer from enjoying himself very much at times, whether at the monthly meetings, or in his tramps round the countryside; lying out at night under the starry sky, or spending a quiet evening at an inn, where, he said, "all is solitude and utter stillness, except the fall of a mountain stream and the ticking of a clock." Nor had he yet lost his sense of the holiness of created things. There were moments when the faith inspired by it still glowed white-hot in his heart. "How does all animate and inanimate creation," he cries to Richmond, "all the range of high arts and exquisite sciences proclaim the immortality of the soul, by exciting, as they were intended to excite, large longings after wisdom and blessedness, which three-score, or three hundred years would be too short to realize. We are like the chrysalis, asleep, and dreaming of its wings!"

In this last sentence Palmer proclaimed his central and fertilizing conviction. The trouble was that he could not any more express it in his art. His pictures ceased to be pictures of his vision. Consider the water color study of a Tintern garden done in 1835. It is marked by all Palmer's power of observation and sense of natural beauty. How subtly and truthfully does he present the varied greens of the foliage relieved against the pale amber of the cottage wall and crumbling stonework! Indeed his technical accomplishment was by now such as to enable him to reproduce reality more exactly than in the drawings of the Shoreham period. Yet the result lacks the special imaginative quality of Shoreham days. Then such a sketch would have been an image of Paradise: now it is just an image of a garden at Tintern. The difference between it and *Cornfield by Moonlight* is significant of a profound change in the spirit of the man who painted them.

This was not an intellectual change. Palmer's views about art were unaltered. He still held that the highest art was "ideal" art, that is to say reality transfigured by the light of the artist's ideal vision: he still looked on his sketches from life as only valuable in so far as they were a preparation for some ideal picture to be painted later on. Indeed, the

sketches he did in Devon or Wales were meant to be preparatory studies of this kind. But the intended ideal picture never eventuated: and though his contemporaries might not mind—realistic studies were in fact more to their taste than were painted visions—yet Palmer felt frustrated and uncertain and disheartened.

V I

IN 1837, his life changed once more. Two events took place which were permanently to alter its course. In January his nurse, Mary Ward, died. It was to him as if he had lost his mother. Not only had Mary Ward looked after the practical side of his life—and he was so very unpractical that he had to have someone to do this—but he had continued to look to her for spiritual comfort. Indeed, and though, as he was regretfully forced to admit, she was a benighted Baptist, she had come to embody for him the idea of a life dedicated to God. He described her last hours with a particular tenderness; told how, lying on her deathbed, she had given him her copy of Milton's poems and then, "at about a quarter past four, I asked Mary Ward to bid God bless me and to kiss me (as I kissed her). She said 'May the Lord bless you for ever and ever' and kissed me quickly several times on the cheek, though so exhausted. . . . My dear nurse and most faithful servant and friend, Mary Ward, died at five minutes to five o'clock 18th Jany 1837, the same day of the same month on which my mother died."

The second event was partly the consequence of the first. Without feminine sympathy and care Palmer was lost, and in the autumn of the same year he got married. It is to be feared that this also turned out a misfortune. It was less the fault of his bride than of her family; she was Hannah, the daughter of his old mentor, John Linnell. This forceful, cranky, uneasy man had never lost interest in Palmer; but, for a time, his influence had waned. Linnell had not sympathized with the Shoreham experiment. He thought it financially imprudent, and disliked the Ancients as a group. Himself a Radical Nonconformist who had never

learnt Latin and Greek, he disapproved of them as too High Church, too Tory; and too educated. Their culture gave him a disagreeable sense of inferiority. "I am not learned enough to be admitted to these monthly meetings," he said with heavy sarcasm. Nor, in spite of his own taste for Blake and Gothic art, did he approve of the stylized, mock-primitive manner of Palmer's Shoreham work. What might be right for Blake was not right for a young man with his living to earn. Linnell had come to take a very practical view of an artist's career. As early as 1824 he told Palmer that he should draw less from imagination and more from nature. At first Palmer, who shrank nervously from anything like a scolding, sought to placate Linnell by saying he was already doing so. "I may safely boast," he protested humorously, "that I have not entertained a single imaginative thought these six weeks." As time passed, however, and Palmer began to be possessed by the full power of his genius, he found it impossible to maintain this apologetic attitude. In 1828, Linnell heard that he was hard up and wrote advising him to try and make money by doing some landscape sketches in a more realistic and popular style. With high-minded contempt, Palmer refused to consider making his living by such means.

Now, however, he was too poor to afford to be high-minded. Back in London, he asked Linnell's advice and visited him. This is how he came to know Hannah well. She is not a vivid figure to us, all the more because she was not an exceptional one, but just a normal, pious, affectionate girl, without much imagination, and one who, if she had not been born into an artistic circle, would have seemed simply likable and commonplace. However, she had the high spirits and naïve charm of her youth; and also enough taste to fall in love with Palmer—the more readily because she wanted to get away from home. For it was not much pleasure being Linnell's child. His household was run as a patriarchal autocracy. He kept all his children there, short of money and without friends, and he made them work for him. This came especially hard on the girls; for Mrs. Linnell was a neurotic invalid, who kept to her room and left all the domestic arrangements to her daughters. Hannah found it difficult to get a moment to herself to write or speak to

Palmer. However, they managed somehow to get engaged. Linnell agreed to the marriage—though he did not hide the fact that he strongly disapproved of his future son-in-law's views on religion and politics. He soon made it clear that Palmer must submit to his guidance, even if this involved acting against his own convictions. For instance, he insisted that his daughter must not be married in church. Palmer agreed, but with shame. For him, a civil marriage was hardly a marriage at all. He wrote in his commonplace book: "1837. . . . S. P. was married at the Court-house, Marylebone; he, a churchman!" And now a brighter prospect opened for Palmer, and one which luckily Linnell did not disapprove of. Richmond, now a rising painter, proposed going to Italy with his wife to study art, and asked the young Palmers to go with him. There was no question of Palmer refusing: for years he had longed to visit Italy, home of "ideal art." The only trouble was that he was too poor. However, Richmond offered to lend him some money and this, Palmer thought, added to his own small savings, would be enough to give him a start. Later Linnell was to help Samuel and Hannah further by commissioning Hannah, who was a trained copyist, to copy some of the Vatican frescoes.

The Palmers left England in 1837 and were away two years, mainly in Rome, but also visiting Naples and Florence. At first the journey was a great success. Hannah—free for the first time from household drudgery—was bubbling over with high spirits; and Palmer was dazzled by the works of art and fascinated by the strangeness and picturesqueness of the Italian scene. The smoke rising from Vesuvius seemed to him to be the ghosts of those buried in Pompeii: he gazed with awe at Michelangelo's statues, gleaming out of the shadows of the square in Florence, and impressing his mind, he said, with their "sullen stateliness and strength."

But after the first few months, new factors intervened to make the Palmers not so happy. For one thing, Linnell's commission kept them so hard at work that Hannah in particular grew dispirited out of sheer fatigue. Palmer, who took time off to draw Rome, enjoyed himself more. But his pleasure was marred by the guilty sense that he should have been

helping his wife. A stronger reason for depression was poverty. They had only just enough to live on; in one room and with Hannah cooking a chicken—eternally chicken, Palmer complained—on a wretched little stove. If they did go out to a cheap eating house, things were no better. "Italian cooking is hateful to me," Palmer lamented. He gave curious reasons for his dislike. "There is nothing portly in it," he explained, "nothing majestic or profound." The winter weather too was very trying. Palmer was so cold that he wore four flannel waistcoats, two coats, and a waterproof cloak.

Because he was poor, he did not get patrons. There were plenty of these in Rome at the time. It was a leisurely civilized afternoonish phase in the history of the eternal city, when many foreigners—and especially the rich English—came out to spend the winters there; occupying themselves in card-playing, riding in the Campagna, and gentle patronage of the arts. They were patriotically disposed to patronize English artists. Severn, who had arrived sixteen years before with the dying Keats, had stayed on to pursue his professional career very profitably. Richmond was now doing the same thing. But, to succeed, a painter must lead a social life. This required good clothes and social ease. Palmer had neither. Never a dandy, he was now so shabby that people stared at him in the street. If invited into good society, he did what he could to smarten himself up. But, he admitted, beside a real man of fashion, he looked like a coal-barge beside the royal yacht. Besides, his conversation was too naïve and fanciful and unconventional to be in place in a Roman salon. He hated desultory party talk, he said. He preferred "the solemn and inexhaustible eloquence of nuns and monasteries." As for Hannah, she deplored the fact that her bonnet was too worn and threadbare for her to enter a drawing-room without shame. The result was no commissions and not much society. The Richmonds were soon fully launched in it; so that, though always affectionate and anxious to be helpful, they had not much time to spare for the Palmers; that is, if Richmond was to earn enough to support his wife and the child she was expecting.

Palmer did what he could to make the best of things. He bought a

goose, which he cooked himself, as a change from so much chicken; he made brave little bad jokes about the way hunger and heat had reduced his figure—"I am as thin as an easel, or a weasel," he said—he even sought to get amusement out of the fact that he grew so nervous at times as to be nearly hysterical. "I like a touch of hysteria," he remarked surprisingly; "I like now and then to be allowed to yell and roar a little!" He certainly did. When he learned that Hannah had, after some difficulty, got permission to copy the Titian-Bellini *Feast of the Gods* in the Camuccini Collection—a picture which he much admired—he was so excited that he screamed loudly, fell flat on the floor kicking his legs in the air and then, rising, seized a tambourine to the accompaniment of which he performed a wild Bacchic dance.

All this he related in a letter to Linnell. Palmer's letters, though not so high-flown as in earlier days, were still a strange mixture of jokes and complaints and opinions about politics and religion, interspersed with outbursts of demonstrative affection. This was not the sort of letter that his father-in-law approved of. He thought the jokes irresponsible—how could a self-respecting man say he liked hysteria?—he disapproved of the opinions; and he was embarrassed by the demonstrations of affection. During Palmer's sojourn abroad, his relations with his father-in-law deteriorated. Linnell suspected that Palmer was drawing Hannah away from his influence, though pretending to be so fond of him; and, uncontrollably jealous, began picking quarrels with him about politics and religion. Palmer defended himself, but still protested his affection. The infuriated Linnell then accused Palmer of concealing under a show of flattery a heart encased in ice. He ordered him to come home at once.

This Palmer was unwilling to do. He had not yet learnt all he wanted from Italy: for Italy was effecting a fundamental change in his art. Not in its ultimate aim; this was still to paint ideal landscape. Indeed, he had come to Italy to learn more about how to do this from the great masters of ideal painting. This was what was causing his art to change. At first, he had been bewildered by the fact that the Italian landscape was so unlike the English. He found himself longing for scenery that held more associations for him: "I yearn," he said, "to go nutting in the

magic northern twilight and to hear the clock ticking on a grey tower."
However, he gradually fell under the Italian spell. Groves and
mountains and vineyards, evoking, as they did, memories of Virgil,
began to impose themselves on his imagination. Further, he began to
see them through the eyes of the great artists who had portrayed them;
Titian, Poussin, and above all Claude. Claude struck him as the greatest
genius in his line who had ever lived, the supreme master of ideal
landscape. "Ordinary landscapes," Palmer once wrote, "remind us of
what we see in the country; Claude's of what we read in the greatest
poets and of *their* perception of the country." Such a view had an
immediate and profound effect on Palmer's own painting. If Claude
was the king of ideal art, he should follow him and try to acquire his
manner. This meant a period of doubt and difficulty while he was
shaking off old habits. But he managed it. "I have been lately absorbed
in meditation on the ancients' art and landscape," he wrote. "I think
that my future efforts will be comparatively free from inequalities and
eccentricities."

In so far as this was true, it was a pity. The classic style of landscape,
which he was seeking to imitate, was unsuited to express Palmer's vision.
He had come too late to Italian landscape for it to speak to his heart or
penetrate to those depths of his nature where the creative seed lay
hid. Palmer, like Blake, could see eternity in a wild flower; but it had to
be a wild flower of a kind he had known from childhood. Nor was the
classic manner of depicting nature suited to his genius. The classic is
a generalized style. Palmer's genius, on the other hand, showed in his
eye for the particular; in the wood less than in the tree, in the tree less
than in the leaf. Further, the classic manner is solid and monumental;
whereas the art that best conveys Palmer's sort of spiritual vision does so
by diminishing our sense of the solidity and weight of objects, either by
representing them in a flat linear convention like Blake's, or in insub-
stantial fluid forms like those of El Greco, or by dissolving them in light
and shade as Rembrandt does. It is by such means that these artists
create an effect of the mysterious and supernatural. Not so Poussin and
Claude: there is nothing magical or mysterious in the scenes they

65

present. Indeed they idealize the natural rather than suggest the super-natural. Palmer's earlier Shoreham manner was fitted to express both his sense of the particular in nature and to shed over it an atmosphere of spiritual mystery. The classic manner he adopted in Italy does neither. He seems to have been obscurely aware of his failure; for his lack of confidence increased. Had he passed his prime, he asked himself, and again "Where is the golden autumn of life?" he cried. "We are green, then grey, then nothing in this world!"

Meanwhile, the Italian days were drawing to their close. Linnell's letters were growingly insistent. He now called Palmer a deceitful fox; and once more commanded him to come home—"though," he added, "I have not the least desire to see you." Palmer did not much desire to see him. Or London either: "if I cared what became of me," he wrote, "I should be sick at the thought of coming back to smoke and filthy chimney pots." But he was running out of money and there was no help for it. In the autumn of 1839, Palmer landed in England. With tears in his eyes, he declaimed—adapted to his present situation—some lines of Milton from Satan's speech on arriving in Hell: "Farewell, happy fields, where joy for ever dwells! Hail, Railroads, Hail!"

VII

THE words were truer than he knew. The next twenty years of his life, if not positively hellish, were the darkest in his history. In the first place, throughout the period, Palmer was haunted by money worries. For now he was responsible for others besides himself. In 1842 a son was born to him, whom he named Thomas More, after his chosen hero; in 1844 came a daughter, Mary Elizabeth; later, another son, Herbert. How was he to provide for them? The question preyed on his nerves. Indeed, Palmer was unfitted for such a responsibility. Too uncompromising to seek popularity by altering his style, he was yet not tough enough calmly to face poverty for his family. Worry distracted his mind and weakened his creative energy. The struggle of life was to

him the reverse of a stimulant. Further, he was very unpractical. He tried not to be; he sat down to keep an account book, in which he laboriously traced out every penny of expenditure. Hopefully, on the title page he wrote a quotation from the Bible: "Who giveth food to all flesh, for His mercy endureth for ever." Not much food, it turned out! Nor could Palmer be sure that it was coming at all. His painting was commercially a failure. The galleries often rejected his pictures. When they were accepted, they seldom found a buyer. During a period of five years Palmer made no more than £70 from his paintings. This was not enough on which to keep a family; and all the more because Hannah was a bad manager. With the help of a slatternly Dickensian servant girl, she tried to cope; but ineffectually. Once again, the unpractical Palmer sought to be practical. In his notebook he jotted down some pathetic little suggestions as to how he himself might economize: "Avoid snuff, two candles, sugar in tea, waste of butter and soap."

He failed to obey the first command: Palmer could not resist snuff. For the rest, he did his best to keep things going by teaching. Drawing was then thought a necessary accomplishment for young ladies: and, during the next twenty years, Palmer's house was filled by a succession of Victorian young ladies—Dora Spenlows and Amelia Sedleys—in crinolines and pelisses, who had been sent by their mothers to learn how to paint sprigs of roses or picturesque ruins, with which to ornament the satin-striped paper on their drawing-room walls. Palmer was liked by his pupils, and liked them in return. All the same, it was a pity he had to teach. The work wasted his time and in fact helped to keep him poor; for he was paid very badly and was prevented by teaching from living the kind of life which could best develop his art. This was a country life. But only in the town could he get pupils. Year after year, therefore, he lingered in London, tantalized in spring by the thought of what he was missing, in summer oppressed by dust and heat: "If only I could get away for a moment," he cried, "to look once more at the hops and the apple trees, to see the moon rising golden to shed its benignant light upon the corn stooks!"

His dislike of the town was increased by the conditions of his life there.

These were not so bad between 1847 and 1851, when he lived in a thatched cottage with a garden. But he was afterwards forced to move into a semi-detached villa in Kensington, which represented all that depressed him most; a shabby-genteel residence, prim and poky, with no studio to paint in, only a little back room, so small, he noted, that it was almost filled up by the crinolines of his pupils. Outside was a patch of garden with nothing but a geranium bed in it, and which was made horrible by the continual jangling of a piano next door. The only pleasure he got there was from letting the weeds grow. Lovely and disheveled, they rambled in green luxury over lawn and porch, an image of wild country abundance, invading the sterile and ignoble modern city. But the neighbor with the piano disapproved: such untidiness, he said, let down the reputation of the neighborhood. He insisted that the weeds be cut down. "Farewell, soft clusters"—Palmer wrote, "the only pretty things about the premises; ye are to be mowed this evening, and to leave a scraped scrap of 'RESPECTABILITY!' " Life in London seemed to him equally out of touch with earthy and with spiritual realities. Trivial and artificial, it was in every respect contrary to life in pastoral Shoreham.

Even worse than his house was his father-in-law. For the time being at any rate, success and advancing years had not mellowed Linnell. He was crankier and more intolerant than ever. If he thought he was over-charged, he was liable to roar like a bull: he severely rebuked anyone who ventured, however politely, to disagree with him, and he divided his spare time between re-interpreting the Bible in order to make it suit his prejudices and writing verses, in which solemn commonplaces and heavy jocularity were displeasingly blended. Like many other humorless persons, Linnell was fond of a joke. Further, his desire to dominate over others had increased. Partly to preserve his influence and partly to save money, he had kept his children at home, segregated from the world, and brought up to spend their lives in helping him. In London, or later at Redhill, the Linnell family carried on its life as in a self-supporting citadel; doing their own brewing, baking, and poultry-keeping under Linnell's supervision, and where no opinion contrary to

68

his was permitted to be heard. As might be expected, the children got on each other's nerves and quarreled; but they united against any outsider. Palmer, though officially a member of the family, was in their view an outsider, and a silly outsider at that; fanciful and frivolous, prone to puerile exaggerations in his talk, and wholly out of touch with sober reality. "S. P. . . . lived," said one of the sons severely, "in [an] atmosphere of sentimental imagination . . . not always in touch with truth." His character was such as to make it impossible to assimilate him to the Linnell spirit, which was puritanical, unimaginative, and opposed to any show of feeling. For Linnell himself, Palmer was the enemy within the gates.

He showed his hostility in various ways. From the first, he tried to direct Palmer's life; plying him with unasked-for advice about his art, his friends, his management of his children, and his financial situation. When Palmer did not answer his questions, Linnell tried to extract the information from others. Once this earned him a rebuff; Giles, as a stockbroker, advised Palmer about money. Linnell therefore questioned him about Palmer's affairs. "My dear Sir," answered Giles, "you have no right to ask me any questions about Mr. Palmer's affairs, and if I had done as I ought I should not have answered you, but I was induced to answer you from your saying 'Secrecy will be the worse for Mr. Palmer.' " Linnell was too impervious to be checked in his researches by these words, especially as Giles was a Roman Catholic and, as such, in his opinion, clearly on the road to Hell. Linnell was not sure that Palmer was in much better case. He was nearly a papist, so he told his daughter; and he poured scorn on Palmer's liking for choral services. His words were repeated to Palmer, who defended himself with some spirit. Generally, however, he tried for the sake of peace to evade controversy and to show good will. This had no effect on Linnell. Indeed, no amount of tact could remove the basic cause of conflict between them. Linnell wanted Palmer to submit to him in everything: and this Palmer simply could not do.

How did Hannah feel about her husband's relation to her father? So far as we can tell, she tried to be fair to both sides. Though she loved

and revered her father, she would not, whatever he said, take sides with him against her husband. In fact, however, she could not support Palmer with great conviction. It had become clear as the years passed that she had not much in common with him; she did not understand his high-flown ideas about art, nor enter into his sacramental, ritualistic religion. She felt far more at home at the cozy, chapel style of service to which she had been brought up. This made Palmer feel isolated. More and more he was thrown on his own resources.

VIII

THESE, luckily, did not fail him. During this long, dark, dreary period of his middle age, he was sustained by two things. In the first place, his work: neither lack of worldly success nor frustrating conditions had weakened his sense of dedication. He felt less inspired than in youth. But he still lived for his art. He labored at it whenever he had a free moment; he thought about it when he was not laboring. His notebooks are filled with memoranda about subject matter and technique, with hints that he had picked up from others, and with reflections on his own mistakes and resolutions not to make them in future. He worked sometimes in oil, more often in water color. When he could, he went back to wander again in Wales and the West looking for subjects. These journeys followed the same pattern as in the past. The middle-aged Palmer cut the same odd figure as the youthful; more grizzled and lined, but still with his huge overcoat and the pack on his back, wandering over wood and heath and passing nights in the open air, "to watch the mystic phenomena of the silent hours"; or spending long evenings in an ale-house, listening happily to the slow talk of the countrymen; or reading some favorite old book, far from any threat of interruption by a censorious father-in-law.

Palmer's water colors, though they did not make money, won him a little success of esteem. In 1844, he was made a member of the Society of Painters in Watercolours. He was touchingly pleased by this sign of

recognition. Linnell was not so pleased; he spoke of it with disparaging sarcasm.

Some years after he got back to England, Palmer began trying his hand at a new medium: etching. Once again, he made a success of esteem. His first effort was accepted for exhibition by the Etching Club; in 1854, he was created a Member of the Society. He was never to exhibit very often, for he seldom had anything in what he considered to be a fit state for exhibition. His few completed etchings were the rare result of many and lengthy experiments. But the result was worth the trouble. Palmer's genius in later life fulfilled itself most completely in etching. The medium gave more scope to his peculiar gifts than did water color. It gave an opportunity for those effects of mingled mystery and radiance in which he delighted; and he found a special stimulus in the fact that it was such a laborious medium. The tension produced by the effort to express himself by means so slow and difficult generated a peculiar concentration of sentiment. As Sickert said of them, "Palmer's etchings are rich, concentrated, indefatigable and intense. He had certain things to say, and he said them completely." Moreover what he had to say in them was more important than what he said in water color. For in his etchings Palmer once more attempts "ideal" art. Like his Shoreham masterpieces, etchings such as *The Sleeping Shepherd, Sunset,* and *The Morning of Life* are not studies from life, but imaginary compositions; lyrical inventions in visual form and inspired by what Palmer read as much as by what he saw. "Oh the joy!" he wrote, "Colours and brushes pitched out of the window; plates the *Liber Studiorum* size got out of the dear little etching cupboard . . . needles sharpened . . . and a Great Gorge at old poetry to get up the dreaming!"

This account shows how the middle-aged Palmer had changed from Palmer the youth. In youth the creative spirit had swept in to possess him, unbidden and irresistible. Later it had to be evoked and conjured up deliberately by the right kind of reading. And even then it never came with the same force as before. The etchings are without the intensity of the Shoreham pictures. Yet the subjects are much the same.

He still depicts woods and sheep-folds and dusk and moonshine and woodland streams. Nor had his artistic ideals altered. In 1850 he could still sit up all night, lost in passionate reverent examination of some drawings by Blake. For, though Blake was dead, his soul still spoke to Palmer; teaching him that art was a holy sacrament, the supreme means by which the Divine manifested itself in bodily form to man. Conversely, he thought physical beauty had no significance except in so far as it was associated with beauty of soul. "Landscape," he wrote, "is of little value, but as it hints or expresses the haunts and doings of man. However gorgeous, it can be but Paradise without an Adam. Take away its churches, where for centuries the pure word of God has been read to the poor in their mother tongue, and in many of them most faithfully *preached* to the poor, and you have a frightful kind of Paradise left—a Paradise without a God. For the works of creation will never lift the soul to God until we have been taught that our Lord Jesus Christ is the 'Way,' and that 'no man cometh to the Father' but by Him. . . ."

These last sentences betray a fear that, seduced by pleasure in mere beauty, man may forget the claims of religion. Palmer supported these claims more strongly than ever. Every day he read family prayers to his household and passed some time in family devotion; regularly he partook of the Sacrament. For religion, he found, was his chief strength and hope in a sorrowful world. It was also the only safeguard against the world's wickedness. Palmer continued to find the world alarmingly wicked. Incurably innocent, he was also incurably credulous, especially of anything lurid and sensational. He knew for a fact, he told Richmond, that a large number of women in Essex had been poisoning their husbands with arsenic in puddings in order to get the burial money; and also that a boy of eight had just stabbed his sister of five to death and was found calmly cleaning the knife afterwards. Clearly, thought Palmer, he was living in an age in serious need of moral education.

He spent much time teaching his own children. The second thing that brought some sunshine into his sad middle years was his love for his children. He had always lived largely in his affections. Now, with

his parents dead, his friends absorbed in their own lives, and his wife lacking in fundamental sympathy with him, he turned the full flood of his power to love on to More and Mary and Herbert. In their company he forgot for an hour to be sad. But if they brought Palmer some happiness, they also made him more vulnerable. Just in so far as he loved his children, did he suffer with them and worry about them. Each of them presented Fortune with a hostage which he feared she might use against him.

Only too soon she did. Palmer was especially fond of his little daughter Mary. Gentle and affectionate, she warmed his chilled and loving heart: he delighted to teach her, to play with her, to caress her. In November, 1847, she was taken ill. Within a few weeks she was dead. Palmer yielded to grief with characteristic abandon. He went about with choked voice and face bleared with crying. All Mary's clothes and play-things were carefully preserved: himself, he made a cast of her hand and wrote an account of her last hours—lingering in agonized memory over its every moment. "Her mother was sitting at the end of the bed when Mrs. Linnell said 'I think she is gone.' Anny put her face close to Mary's, but could hear no sound of breathing. Her eyes were open and fixed, but her face turned deadly pale. . . . SHE WAS DEAD. Mrs. Linnell closed her eyes. The last I saw of her dear grey eyes was in the after-noon, when I watched them. The lids closing a little over them made it seem like a mournful and clouded sunset."

The effect of his misfortune was—for his third child was not yet born—to lead Palmer to concentrate all his affection on his surviving child. From 1847, his elder son More was his chief source of happiness. He came to mean more even than Mary had done. For Palmer identified himself with his son as he could not with a daughter. Like many fathers who feel themselves failures, he sought to make up for his disappoint-ment by transferring his hopes and ambitions to his son. If More could succeed, then Palmer would feel recompensed for his own failure. He therefore devoted himself to bringing out the boy's talents. More was a child who fitted the role assigned to him—spirited, gifted, responsive. Palmer gave him his first drawing lesson when he was only three. Soon

More went on to learn reading, writing, history, English, Latin. He learnt quickly and Palmer, excited by success, redoubled his efforts. Calvert, coming over one fine summer morning to take Palmer out, was shocked to find little More set to spend his day bowed over his lesson books. Not that Palmer was harsh with his son; though in theory he believed in severity, in practice he made use of other methods. "If you learn your lesson," he writes to More, "I will bring you some cake. Some might say that this is making use of base selfishness. I assure you that the love of cake is not base. . . . I thought of promising you kisses; but I believe you would like cake better."

All the same, the child found life a strain; for, with the cake, went a steady, if unintentional, emotional pressure. The consequence was that poor More began to feel guilty lest he might not live up to his father's expectations, while Palmer worried far too much lest anything should divert More from his dedicated task.

All this showed itself in a curious little tragi-comic episode in 1853, when More was eleven years old. His great friend was Willy Richmond, son of Palmer's old friend. Both boys were excitable and imaginative, and all the more so from the diet of high-flown poetry and poetic romance on which their parents had seen fit to bring them up. Dressed in homemade suits of armor, they delighted to play at knights errant, riding round the world to right wrongs and to call men to devote themselves to God's service. One day, More, the dreamier and more daring of the two, was seized with the idea of putting his ideals into practice. Why should not Willy and he adventure forth into the world and support themselves by drawing and singing while spending the rest of their time summoning men to God? It is possible that More was also attracted by the notion that in this way he might get free from the intensive education imposed on him by his relentlessly loving father. He persuaded young Willy Richmond; and they set off, their only luggage a Bible, the score of Handel's *Messiah*, and two pence in money. They did not get very far. Within two days, when they were still only five miles from London, a policeman found them, seized each by the coat collar and marched them ignominiously through the streets to their homes.

74

The episode is too trivial to be worth mentioning, but for the extraordinary way to which Palmer reacted to it. He behaved as if More had committed some terrible sin. Not only did he rebuke him with unprecedented severity, but—since he apparently took the view that Willy Richmond had been the leader in the affair—commanded More never to speak to him again. He impressed this upon him so formidably that when, two years later, the two boys passed each other in the street, More turned his head away. Why should Palmer have taken so absurdly extreme a line? The romantic idealism which had suggested the plan would, one would have thought, have appealed to him. The answer is fear. Until More was found, Palmer was overcome with the unbearable thought that he had lost him forever, that there had been reft from him his chief source of happiness, his single hope for the future. At all costs, More must be made to feel that such a thing must never happen again.

The consequence might well have been a rift between father and son. In fact, however, the records of the next years show them delighting more and more in each other's company. Together, they explored the antiquities of London and attended services in Westminster Abbey, where both listened enraptured to the strains of the organ and gazed in awed meditation at monuments of the mighty dead; poets, warriors, and the pious monarchs of the Middle Ages lying rigid and at rest under the fluted folds of their long robes. In summer, Palmer took More sketching in the country, where Palmer was delighted to find that his son responded with enthusiasm to the same kind of beauties that appealed to himself. On his side, Palmer sought to take an interest in whatever appealed to More. When More began to evince a special interest in music, Palmer threw himself into the study of its technique, so that he might be able to discuss it with him.

His pleasure in his son's company was enhanced by the fact that they agreed about the Linnell family. Linnell did not care for his grandson, whom he thought mischievous and impertinent. For when More came to stay, he refused to submit to the discipline that Linnell imposed on his household. If he did not actually play any pranks there—and sometimes he dared even to do this—he looked inquisitive and mocking and

silently critical of what he saw around him. Linnell found this highly displeasing and, after a time, refused to have More in the house. Palmer protested that this was insulting. In fact, he could not but be pleased to have in his home an ally against his family-in-law.

He needed one more than ever: for during the 1850s, Linnell had redoubled his efforts to make bad blood between his daughter and her husband. He took to writing to her continually, mostly about Palmer's misdoings; the way he spoilt More and his mistaken religious views. Hannah should leave the Church of England, he said. She declined to do this; but one evening she stole into a Baptist chapel where a service was taking place. She could not disguise from herself that she found the service much more comforting than the average evensong in an Anglican church. Conscience compelled her to tell Palmer this. He looked hurt: sadly Hannah decided that she must stick to Anglican evensong. A show of loyalty was preserved on both sides, but the effect of the episode was to widen the gulf between Palmer and Hannah.

These were years of growing difficulty for Palmer: time was passing; he was on the way to be sixty; he sold few pictures. Now he began to find it harder to get pupils. Yet the bills continued to come in, the debts were mounting. At times, he lost hope completely. "I seem doomed never to see again that first flush of summer splendour which entranced me at Shoreham," he wrote. ". . . I work quite as much as I ought as to the time spent, and vary my work; but I feel as if I were repeating myself, and have very little impulse or enjoyment in it. I don't know whether it proceeds from body, or mind, or both, but my feeling all day is that of Macbeth. . . . 'The wine of life is drawn,' the lees alone left."

No wonder that, more than ever, he staked all his hopes on More's future! The prospects for this looked good. More had done very well at school. Now, in 1861, he was nineteen years old and working hard at his classics with a view of going up to Oxford. Then, in the spring, he began to be conscious, for the first time in his life, of a curious sense of

languor. Palmer, who put this down to the bad air of London, was not deeply worried, and arranged that Hannah should take her children in the summer to High Ashes, a farm set high on the Surrey hills. Himself, he had to stay in London to work, but he came down for regular visits. More felt better at first, but in May he took a turn for the worse. The doctor diagnosed the disease. With a chill of horror Palmer learnt that it was consumption. More's condition deteriorated rapidly. Soon he was too weak to walk. Instead, he lay hour by hour, pale as a ghost, in the shade of a grove of scented pines that stirred and sighed in the breeze that never quite ceased blowing round the house. By July, his mind had begun to wander. The agonized Palmer hardly left his side for a minute. On July 11th, he kissed him goodnight and went to bed. He was wakened next morning to be told that More had died in the night. Palmer gave a cry and rushed blindly from the house. He never went back to it.

The next year was the saddest of Palmer's sad life. With More's death was extinguished the one light that had brightened his recent years of drudgery and despondency. There was nothing left to hope for now. Worse, Palmer felt himself responsible. His grief at the loss of his son was embittered by remorse. He thought that by pressing More so hard he had undermined his health. One paroxysm of grief succeeded another. "Yesterday was the *only* day," he writes months later, "a part of which I have not passed in bitter weeping." At times, his sorrow embodied itself in strange flights of fancy. He wrote to Richmond, "I dreamed one night that dear More was alive again and that after throwing my arms round his neck and finding beyond all doubt that I held my living son in my embrace—we went thoroughly into the subject, and found that the death and funeral at Abinger had been fictitious. For a second after waking the joy remained—then came the knell which wakes me every morning—More is dead! More is dead!" And again, a few months later: "Today the first snow has fallen upon our dear boy's grave! . . . Yes! he will lie tonight under his new winter shroud. . . . There is no sensation in the grave, so it is a foolish fancy; but I have always felt it

so very sad that, while *we* are warm by our winter fire-side, those precious limbs, mouldering though they be, of our lost dear ones should be far away from us, unhoused and in the damp, cold earth, under the wind, and rain, and frost."

He held on to his religion desperately; he told himself he must be resigned to God's will. But the words carried no weight or meaning to him. Nor was he helped by the sympathy of others. Calvert and Richmond gave him a great deal and so, even more, did Hannah; and he depended on her to help him with any practical action that had to be taken. It was Hannah who had arranged More's funeral and attended it. Palmer could not bring himself to go. He was grateful to her and to his friends; but, for the time being, he was not to be comforted. For the first and only time in his long life, he even lost his sense of the value of art, and of the natural beauty that inspired it. "My loss," he said, "has made me so incapable of *personal gratification* from external objects, that what is called a beautiful view gives me no more real pleasure than contemplation of the kitchen sink." With the clear eye of despair, he looked back at the past and the hopes he had cherished then. They had ended in absolute defeat: "At Shoreham I thought that an honest industrious life," he wrote, "would lead through many perils to some tranquility in age. Look at mine! Here is a consummation of all our walks and poetic dreams."

Meanwhile, he must get back to work if he was to support his wife and remaining child. Also, he must find somewhere to live; for the Palmers had decided to give up London. Here they were helped by Linnell. At the time of More's death he had appeared characteristically unsympathetic. "Let the dead bury their dead," he said robustly, and added that it was foolish of his daughter to waste her time arranging her son's funeral instead of leaving it to the professionals paid to perform such tasks. However he felt far more kindly than he spoke: the tragedy had made a deep impression on him—deep enough to modify his harsher feelings about the Palmer family. As always with him, feeling translated itself into action. Since Palmer preferred to be alone with his grief, Linnell took Hannah and little Herbert into his house for the winter

and began to plan for their future. Clearly they should not live in London. Linnell bought them a house near his own. Further he saw to it that they were sufficiently endowed for Palmer no longer to need to earn his living. In 1862, therefore, the bereaved family settled down at Furze Hill House, Redhill. Palmer was still too unhappy to care very much where he lived. It was just as well, for his new residence—except that it commanded a fine view—was everything he disliked most; a genteel, tudor-style Victorian villa, all gabled pinnacles and faked half-timbering, set in a district rapidly growing suburban and within sound and sight of the railway—to Palmer a symbol of all that was most sinister in the modern world. It was not even a convenient house: once more, he found himself without a proper studio and had to make do with a minute sitting-room. The rest of the rooms were poky and pretentious. Palmer gave them nicknames. The little living-room, he called the Saloon; the chief bedroom, which he found damp—Bronchitis Bower.

He produced these nicknames later; at the moment, he was too sad for such quips and found such solace as he could from reading his old favorites, Milton and Virgil, and playing with a little black cat. Curled in front of the fire, it diffused an atmosphere of carefree comfort, which, for an instant, dulled the sharpness of his sense of bereavement. A year passed, and very gradually this began to abate. He was helped by the fact that a new figure began to find a place in his heart; his third child, Herbert. While More lived, he seems to have taken little notice of him: and he was never to love him as he had loved More. But he was so paternal by nature that now it was not long before he took more interest in Herbert than many fathers ever take in their children. Too nervous to let him out of his sight, he decided to educate him at home. Soon he was giving him drawing lessons, teaching him to pray, to read, to write, to do sums. But More's fate had left Palmer terrified of overdoing education. No longer did he approve of severity, even in theory. "Beguile a child into his A, B, C, instead of beating him into it," he said. All the same Palmer was too nervous ever to become an easy-going father. Little Herbert, though an adventurous child, was forbidden to play with the local boys, for fear of infection, and made to carry a

sunshade in summer, for fear of getting sunstroke. Yet, like More, he found his father a delightful companion; so entertaining, so sympathetic, and as anxious to enter into his interests as he had been in More's. This time it was not music, but beetles. Palmer did not like beetles; but soon he had learnt all about them. Meanwhile interest in Herbert helped Palmer's shattered nervous system to put itself together again.

His religion, too, began to recover its strength. The Christian faith, though it might not soften the blow of his loss, did suggest a reason for it. For Christianity, if properly understood, is a tragic religion. It teaches that it is through suffering that the soul achieves perfection; and that only by resigning himself to the loss of earthly goods is man able to find God. Palmer began to accept this doctrine. In 1865 he wrote to another bereaved person: "If we will but be still and *listen*, I think we shall hear these sad trials talking to us; saying as it were, 'You have known life and enjoyed it, you have tried it and suffered from it; your tent has been pitched in pleasant places among those of dear relations and tried friends, and now they are disappearing from around you. The stakes are loosened one by one, and the canvas is torn away, with no vestige left behind, and you want something which will *not* be taken away. You want something large enough to fill your heart, and imperishable enough to make it immortal like itself. That something is God.' "

IX

EIGHTEEN SIXTY-SEVEN found Palmer outwardly restored to normal; seeing his friends, taking an interest in the news, talking and laughing apparently as freely as ever. But inside he had never completely recovered. Every morning he woke feeling dull and unhopeful: not a day passed but he thought of his dead children, and often with tears. As for his youthful aspirations, to remember them was to recognize that he was a failure. One day, he looked through an old notebook. He commented: ". . . I knew the positive and eccentric young man who wrote the notes in these pages. He believed in art (however foolishly);

he believed in men (as he read of them in books). He spent years in hard study and reading and wished to do good with his knowledge. He thought also it might with unwavering industry help towards an honest maintenance. He has now lived to find out his mistake. He is living somewhere in the environs of London, old, and neglected, isolated—laughing at the delusion under which he trimmed the midnight lamp and cherished the romance of the good and beautiful; except so far as that, for their *own sake*, he values them above choice gold. He has learned however not to 'throw pearls to hogs'; and appears, I believe, in company, only a poor good-natured fellow, fond of a harmless jest. . . ." These words vividly convey his prevailing mood at this time. It was more discouraged than it need have been. To say that he was looked on as no more than a good-natured fellow fond of a jest was nonsense. His old friends, Giles, Richmond, Calvert, loved and looked up to him as much as ever.

Nor was it true that he had trimmed the midnight lamp under a delusion, if this meant that his lifelong dedication to art had ended in nothing. His sensitive, bruised spirit bore within it an unquenchable vitality: and though near seventy, he was to enter on a phase of his life more creative than any since Shoreham days. It is to be noted that in the last embittered passage he says that he still valued the good and the beautiful above choice gold. This showed that, once the first anguish of grief had passed, the principle of life, which had sustained him ever since childhood, had risen mysteriously and silently to nourish his spirit once more. Love of nature, love of God—it was only a question of time before these two had once again fused to utter themselves in a work of art.

Already, in fact, this had begun to happen. Since More's death, Palmer had acquired a new patron in the shape of a stern-faced, black-browed lawyer called Valpy. In 1865, he asked Palmer if he was doing any work which expressed his "inner sympathies." Palmer admitted that he was meditating some engravings illustrating the early poems of Milton. Reading Milton had been one of the few things he had found comforting after More's death: instinctively, he had turned for help to

that poet who had first imaged forth for him in words his sense of the divine in nature. On hearing this, Valpy suggested Palmer should do a series of etchings illustrating *L'Allegro* and *Il Penseroso*. Palmer agreed to the suggestion. "I shall try," he said, "to unite poetic remoteness with such homely reality as the smell of turned-up earth and the details of the farm afford." He succeeded. The Milton etchings are, after the Shoreham pictures, Palmer's finest achievements. In them he did achieve his true aims and unite earthy reality and poetic remoteness, as he had not done since the days of his youth. For in them he had at last managed to solve the problem that had beset him ever since his Italian visit: namely how to reconcile native inspiration with the classic mode of "ideal landscape" painting as practiced by Claude and his school. In Italy Palmer was submerged; Claude's influence had drowned Palmer's native inspiration. Back in England this inspiration had emerged again. But for the time being Palmer dropped ideal landscape painting in favor of direct studies from nature. When he took up etching, however, he resumed his attempt at ideal landscape, but using a classic and not a Gothic convention for the purpose. The best of the Milton illustrations—*The Bellman* and *The Lonely Tower*—show the perfecting and culmination of this phase of his art. They employ the classic convention of landscape composition, the classic mode of idealization: but these are adapted and acclimatized to suit the English scene and the Palmer spirit. Once more the typical Palmer scene opens before us: twilight with the moon rising over farm and village, the flocks in fold and their guardian, his labor over, returning home, or reclined in repose under the evening sky. The effect is not as compelling as that of the Shoreham masterpieces. For, even in its modified form, the classic convention could not convey the unearthliness of Palmer's vision as could the bold and Blakean mode he had employed in his youth. More important, the vision itself had faded. The Milton etchings represent rather the memory of a vision: in them we see it, as it were, at second remove—as a reflection, an echo. But that echo, that reflection have their own fainter and elegiac beauty.

At the same time as the Milton illustrations, Palmer was engaged on

another project. So far back as 1865, he had conceived the idea of writing an English paraphrase of Virgil's *Eclogues*. It was to be very free; more to be described as "meditations on an air by Virgil" than as translations in the accepted sense. His notion was to try to give something of what he called its pastoral essence to those who knew no Latin. Encouraged and helped by More, he had started on the task, which was still unfinished at More's death. Virgil, like Milton, had proved of comfort to him in his bereavement: after a time he had turned to the paraphrase again. He finished it by 1872, and offered it to a friend of his, a publisher called Hamerton. Hamerton agreed to take it, but only if Palmer would illustrate it as well. After hesitating—for had not Blake already illustrated an *Eclogue* perfectly—Palmer agreed. Soon he was as deeply occupied on etchings for Virgil as etchings for Milton.

These two tasks were to occupy him until his death. For his spirit of dedication did not make for speed. On the contrary, it made him more careful, and therefore slower. Before starting on the final plate, he made many preliminary studies in pencil and chalk and watercolor. Only when he was fully satisfied with his conception did he start to etch. This also he did slowly. His son, Herbert, used to watch him standing before his easel, meditating for many minutes between each stroke. He stayed up working late into the night; and always, before each session at his easel, he prayed long for Heaven's blessing on his work. Possibly Heaven did not equally approve of both projects. For the results were not equally successful. The Italian landscape, right for Virgil, could never inspire Palmer so immediately and so intimately as could the English landscape that was right for Milton.

Round these two projects the rest of his day fell into a regular and unchanging pattern. From 1872 on, Palmer's life settled into a fixed phase; and his personality assumed a fixed and final form. The strange youth of genius was now a quaint, picturesque old person, with a touch of a Dickens character about him. He still insisted few things were more pernicious than the dread of being peculiar, and he was true to this principle in practice. The short, bearded, spectacled figure was dressed usually with outrageous shabbiness; or—if he wanted to look his best—

like a cleric of some former age; in a white neck-cloth, a high double-breasted waistcoat and a voluminous coat, whose pockets bulged with pencils and books and a large yellow snuff box. His manners were as unselfconscious as ever. He still burst into tears if moved; or, if in high spirits, broke out into an exuberant flight of fun; startling a chance visitor by coming to greet him with his head hidden in a blanket and addressing him in tones that fantastically imitated those of an affected neighbor.

Palmer's solitary habits were eccentric too. He carefully pasted into his notebook a vulgar popular ballad, called *The British Volunteers*, in order to have something at hand to refer to when he wanted an example of something hateful. He talked a great deal to himself. His gardener was surprised to hear Palmer walking about conversing with an imaginary person, whom he addressed as Mr. Jackson or Mr. Jinks or Mr. Jick. His little painting room, cozy, shabby, and packed with heterogeneous objects, reflected his idiosyncrasies. The furniture included a battered armchair, an oil lamp, mysteriously nicknamed Nancy, and a table of rough unstained wood, chosen by Palmer deliberately as a protest against the gimcrack elaboration with which the house was designed. Walls and floor were crowded with pictures, sketchbooks, plaster casts, etching tools; and also with sentimental relics of the past such as his old nurse's ear trumpet, a countryman's old-fashioned smock, a chest of drawers containing mementos of his two dead children. In the middle of the room stood the easel, used mainly for work, but sometimes as a sort of memorandum tablet. A visitor was once surprised to see scrawled on it in huge capital letters the single word "parsley." The explanation for this was that Palmer had recently read that parsley was an essential ingredient in good cooking, but never to be used too much. This suggested to him that it should stand as a symbol for some aesthetic quality he thought an essential ingredient for the picture he was working on, but which he must remember to use in moderation.

His room seemed all the odder for the fact that it was so different from the rest of the house, which Mrs. Palmer had striven to decorate and furnish according to the dictates of correct middle-class Victorian

taste, presumably much red plush and mahogany and lace curtains. As such, it stood for an ideal of life to which Palmer was deeply opposed: "The drawingroom, genteel-like, servant-keeping system!" he wrote in horror, "to think that, loving peace and a simple life, one should be entangled in these things like a fly in a tar barrel." Within the confines of Palmer's room and of the garden outside it, the daily routine of his life unfolded itself. It was meant, as far as possible, to cut him off from the world around him. Someone said that, entering it, he felt that he had gone back to Shoreham in 1833. Consciously or not, Palmer, once he had begun to recover from despair, was striving to reconstruct the life he had led in the Valley of Vision. It could not be very like it, since it was spent not amid the woods and water meadows of rural old England, but in a district well on the way to being urbanized. Yet it did achieve an atmosphere in which Palmer could pass his days in satisfying work, in thoughts of Heaven and in contemplation of the beauties of nature.

His routine was regular. He got up late—Palmer had come to hate early rising—breakfasted, and held family prayers, which included some Bible reading and some extempore praying. Palmer read with an old-fashioned pronunciation and a poignant expressiveness. After prayers came half an hour in the garden. This was small and badly kept. But he loved it. Leaning on a staff, concocted characteristically out of an ancient and worm-eaten umbrella stick held together with string, he would gaze rapt at the white convolvulus wreathing itself delicately over the turf; or with delight breathe in the sweetness of the honey-suckle that clambered up the garden wall. "We have sensual pleasure in smelling a honeysuckle," he said "but of so refined a class that it almost suggests poetry." Though unexpectedly clumsy at heavy manual labor, he did some amateur gardening himself, cut vistas and planted wild flowers that he had dug up in the woods. His gardener sometimes destroyed these as weeds: it was one of the few things that made Palmer lose his temper.

From the garden, Palmer went back to the studio and worked for the rest of the day, except when he broke off for meals. After his work was

over, he walked out into the country. He liked Herbert to come with him, otherwise he felt lonely—"I, who used to love the wildest solitudes," he sighed ruefully. In the summer especially, these evening walks were the high spot of his day; strolling through the fields of young corn or sweet-scented trefoil, lit up by the level rays of the setting sun. Nature, it seemed, had recovered her mysterious power to illuminate Palmer's soul. It was as if the physical world grew transparent to reveal shining through it the radiance of the Divine presence. Without words, Palmer conveyed some of this experience to his son: when his father was not with him, said Herbert, sunset and twilight lost their peculiar significance. He thought that walking with him he had felt as his father had, when walking with Blake. Back from the walk, Palmer drank a cup of green tea and read aloud to his family, generally from the writings of the lighter among his old favorites; not Milton and Virgil, but Chaucer and Shakespeare. "Blessed Green-tea-time winding up to Hamlet and ecstasy," he exclaimed. About ten o'clock, the family dispersed to bed; Palmer himself sat up working or reading or writing letters to friends and old pupils. These are a little different from his earlier letters; less high-flown, more natural and colloquial and revealing more of his intimate and humorous sides. At two or three in the morning, he put away pen or pencil and climbed the stairs to bed.

He was most alive when most alone; for his family were unable to share in his inner life. He was fond of Herbert and depended on him for practical help. But he was never spiritually close to him as he had been to More. An aggressive young male, who secretly longed to have been brought up on more sporting and Spartan lines, Herbert was too different from his father to make intimacy possible. Hannah also was too different, even though husband and wife had grown closer to each other since More's death. No more than in earlier years was she able to enter into the world of his imagination. He never discussed his work with her; and she was never seen to enter his studio. When he shut his door on the world, he shut it also on his wife.

Now and again, the muted order of his days was broken by a visit to London to see an exhibition. Rare and momentous event! Preparations

would begin days before; Palmer's best clothes were brought out, to which he added a huge top hat of antique design. Thus attired, he embarked on his journey. He cut so strange a figure that he attracted a lot of attention in the streets of London; especially as he often stopped to declaim in a ringing voice on any sight that struck him. It might be a fragment of medieval architecture that pleased him, it might be a shop window, showing fashionable bonnets which offended his taste. "Look at those Jezebel Tops!" he would call out. A crowd collected round the strange old man. It was a friendly crowd though: there was something winning about Palmer's personality and manner. For all his feudal opinions, he was wholly without class consciousness. He talked to all men with the same warm diffident courtesy; indeed, with age, he had come to feel easier with the simple poor than with the genteel and prosperous.

The daily routine was occasionally varied by visitors. Not local neighbors: the polite society of Redhill did call from time to time; and Hannah, perhaps relieved to be free for a time from the oddities of her husband and father, was pleased to welcome them. Not so Palmer: when callers came, he stayed in his studio. But he loved seeing his old friends, especially any Ancient who survived. Giles, Richmond, and Calvert kept in touch with him. Otherwise, fate had led them different ways. Richmond was now a successful professional portrait painter, Giles a stockbroker; while Calvert had retreated more and more into a pagan world of his own creation, where, indifferent to wife and family, he sat alone, concocting cranky theories about the relation of color to music, or painting vague, cloudy pictures of some imaginary Arcadia. All three men, however, were still united in their love and reverence for Palmer. Unsuccessful he might be in a worldly sense; but they recognized that, more than any of them, he had remained faithful to the ideas taught them by Blake thirty years earlier. Round his aging head still quivered the unearthly light of Blake's divine fire. When the friends met, the spirit of the old times revived. They talked about religion, art, and life, relaxing often as in the past, into fantasy and fun.

Palmer also took pleasure in the company of young people. Two sons of a neighbor, called Williams, became great friends of his. Naïve,

ardent, idealistic, they used to call every week during their holidays, bringing poems and essays to show him and enthusiastically propounding ideal schemes for making the world better. These often involved modern notions repellent to Palmer. He vehemently disputed with them, stating his own point of view in the most extreme and unacceptable form possible. Aristotle, he asserted, was far more likely to be right about science than Darwin; and he dismissed modern archaeologists as "cavernous bone-grubbers." On the other hand, he said that he firmly believed in witches and sea-serpents.

He had held the same views as a young man. What had changed was the mood in which he held them. Experience and fatigue had softened this. Palmer was still against anything new; his letters are full of diatribes against railway trains and contemporary architecture and the Franco-Prussian War, and other disagreeable features of modern life. But these opinions were delivered not fiercely, as in youth, but with a burlesque self-mocking violence, or a rueful pessimistic humor. Moreover, though still strongly anti-Liberal, he had learnt to realize the way the working class lived as he had not realized it in 1832; and in practice, usually, he found himself sympathetic with their complaints. "Nothing more refreshes the spirit than a battle for the rights of the poor," he said: and he denounced the government's Enclosure Acts which had taken away from them their little strips of gardens. He said, "Sin, however, lies heavily on those who have suffered their poor to live in pig-sties and have filched from them their gardens." He felt it all the more because this had been done in the name of science and progress. The word progress only had a good meaning for Palmer if it meant progress in the paths of piety and virtue. England during his lifetime had not, in this sense, and by his standards, progressed at all. Religiously she had even gone back. In his youth, open infidelity had been confined to people with officially "advanced" views like Shelley. Now, most respected thinkers were not Christian; Carlyle was not, nor Ruskin, nor George Eliot, nor Matthew Arnold. Worse still, many men preached open atheism. Such a state of things horrified Palmer. He feared that humanity was in danger of lapsing into a mental state in which a sense of the

spiritual unseen world would be extinguished. Any superstition, he felt, was better than this: for superstition did imply belief in some kind of spiritual force. This was why he was so keen to believe in ghosts and witches.

This also was why he felt so hostile to science. He suspected that it encouraged infidelity; and infidelity was the diabolical enemy to be guarded against all the time and at all costs. Fear of infidelity made Palmer ever more orthodox; so much so as even to weaken his whole-hearted approval of Blake. He admired Blake's art as much as ever, he still thought him often divinely inspired. But he had to admit that there were other times when Blake spoke like a downright heretic. Palmer was especially distressed by the views proclaimed in *The Everlasting Gospel*. The only explanation he could find for them was that Blake, when writing the poem, had been the victim of a deliberate plot by the Devil who had cunningly misled him to state his opinions in such a way as to lead the ignorant into error. In view of such a shocking possibility, said Palmer, surely it would be wiser that *The Everlasting Gospel* should be left out of any popular edition of Blake's works.

Indeed Palmer had grown nervous of anything that might by any chance lead the innocent astray. There is an early engraving of Calvert's, *The Chamber Idyll*, in which a bridal pair are portrayed naked in their bedchamber. It is a beautiful work, whose outstanding characteristic is a passionate innocence: and in the past Palmer had admired it because he thought it conveyed so wonderfully the sacramental quality of married love. In the past he would have shown it to anyone. Now he kept it under lock and key, only to be disclosed to those he could be sure would not take it as encouragement to loose living. For the rest he avoided reading works by rationalist writers. He feared he might find himself infected by what he called "the epidemic of infidelity."

As a matter of fact he need not have worried. Palmer's faith was unshakable; rooted in the foundations of his nature, inextricably entangled with his sense of natural beauty, which is another way of saying his basic sense of the value of living. To respond to life was, for him, to respond to God as the author of life. This meant that religious experi-

ence was the mainspring of his creative vitality, and therefore any explanation that minimized the significance of religious experience, or interpreted it as a result of some material or mechanical process, was to Palmer more incredible than the most preposterous miracle to be found in the legends of the medieval saints. To be satisfied with materialist explanations showed merely that a man was spiritually deaf. Palmer quoted from scripture: "Natural man receiveth not the things of the Spirit of God, for they are foolishness unto him: neither can he know them, because they are spiritually discerned." His faith was further strengthened by the habit of religious practice. He recognized this and drew his conclusions. Palmer was a religious existentialist before his time, who had discovered that the best way to maintain his faith was to act on it.

Certainly it was his faith that vitalized his art. For, as he saw it, it was his faith that made his vision imaginative and therefore aesthetic. A lifetime's experience had only confirmed him in his conviction that a man is an artist in so far as he can put his sensual vision to the service of his ideal vision. It was the failure of his contemporary artists to do this that made Palmer judge them inferior to their predecessors. In his seventieth year Palmer wrote: "Lord Bacon says it is the office of poetry to suit the shows of things to the desires of the mind. We seem to aim at suiting the desires of the mind to the shows of things. Does not the former imply a much more profound and inclusive study of the 'shows of things'—'nature,' as we call it, itself? What was it but his ideal of Helen which obliged the Greek to study all the most beautiful women he could find?

"When I was setting out for Italy I expected to see Claude's magical combinations. Miles apart I found the disjointed members, some of them most lovely, which he had suited to the desires of his mind. There were the beauties; but the Beautiful—the ideal Helen, was his own: and the sense of this ideal is so lost and forgotten by a materialistic age, that Claude himself is considered rather as an accomplished master of aerial perspective, or what not, than as the genius, equally tender and sublime, who re-opened upon canvas the vistas of Eden."

X

MUTE and uneventful, the years passed in Palmer's little studio. Outside, the world changed, in his view mainly for the worse. The suburbs crowded nearer: more villas rose to spoil the views from his window and to disfigure the landscape outside his garden gates. Palmer found ways of defeating these threats to his peace of mind. He had the window whitewashed that faced in the direction of a particularly objectionable structure; and he took care, when taking the air, not to walk beyond the garden.

These were not acts of desperation. He had other windows to look out of; and he was too old for more than a short stroll anyway. Now that he was well over seventy, his strength was beginning to fail. No more London visits or country holidays: nor was he any longer able to work for more than four hours on end. Declining strength, however, did not mean declining spirits. Receding insensibly from the world around him, Palmer lived peacefully and serenely in memory of his days in the Valley of Vision. "More and more," said his son, "he nestled in the past." He never read a modern book; he was always looking at his youthful sketches; and, if taken on a drive, liked it to be on the neighboring downs, where the spreading beeches and clumps of ancient yew recalled the scenery round Shoreham. More than ever, the visitor entering the studio felt that he had left the nineteenth century for an earlier age.

Meanwhile, Palmer remained absorbed in his work. Unable to persist for more than a short stretch, during that stretch he maintained a complete concentration. And even when not working, he occupied himself. The doctor advised him to take a complete rest now and again on the sofa. He had never done such a thing before; but he tried. After two minutes, he leapt up with a howl of exasperation. He never tried resting again.

His work was all on the Virgil and Milton illustrations. As always, he began with preliminary studies from nature to be used later for imaginative composition. Sometimes he would sit at the window, trying to get

91

down an impression of some fleeting sunset effect: or wandering slowly round the garden, leaning on a staff, he would pause to gaze intently at a wild flower, as if pondering how he might make use of it in one of the illustrations. Now and again he would hire a cab and go for a slow drive to such unspoilt country as the district could provide. Hannah usually went with him. In these very last years, the two came closer together than they had been since honeymoon days. She began to realize, she said, his wonderful goodness and sweetness; while, on his side, he found comfort in her simple unquestioning religious faith. In the evenings she used to read to him, and especially the works of Bunyan: the *Holy War* and *Pilgrim's Progress*. Though he knew the book almost by heart, Palmer listened with emotion to Hannah's soft tones telling of Christian sitting with the wise shepherds and gazing out to where, in the distance, rose the towers and spires of the Celestial City, to which he was bound.

Palmer longed to follow him—if he could be sure he would be admitted to it. But, as his faith grew stronger, so also did the sense of his own unworthiness. "If I were *quite* certain of rejoining my beloved ones, I should chide the slow hours which separated me," he said wistfully. He desired death the more because only after it, he knew, could he attain the full clear vision of the Divine Beauty that he had glimpsed in youth. Remembrance of it had, save in the black months after More's death, kept his hope alive during the long sad struggle of his subsequent existence. Freed from the veil of mortality, he believed he would see it shining out; and, revealed in its radiance, the figures of those great men like Thomas More and William Blake who had shown him the way he should follow. He had not long to wait. 1881 opened with a cold spell. Palmer, now very feeble, kept in bed, but still went on working. Herbert watched him as he sat, propped up against his pillows, intent to add some delicate touch to his etching, and with the winter light, intensified by the deep snow outside, reflected in his eyes. Spring brought gentler weather and for Palmer the appearance of returning health. In May, however, his strength suddenly began to fail. Herbert summoned Richmond, oldest and closest of his surviving friends, to his bedside. The

two took turns watching night and day beside him. In the shabby room, crowded with relics of the past, Palmer's life ebbed away. Anxiety and sadness had left him, though inevitably he suffered. Now and again, he whispered an apology for any trouble he was causing. But suffering did not ruffle his inner serenity. It was as if fortune, after a lifetime of un-kindness, had relented, to bless his last hours with a foretaste of that peace of spirit for which he had craved so often and in vain. On the morning of May 24th, Herbert came into the room to find Richmond on his knees, reciting some prayers in tones broken with grief. Palmer was dead. Two days later he was laid in his grave in Reigate churchyard. It was a warm showery May morning, his son noted, and high in the sky above the green turf and the elm trees, a lark was singing.

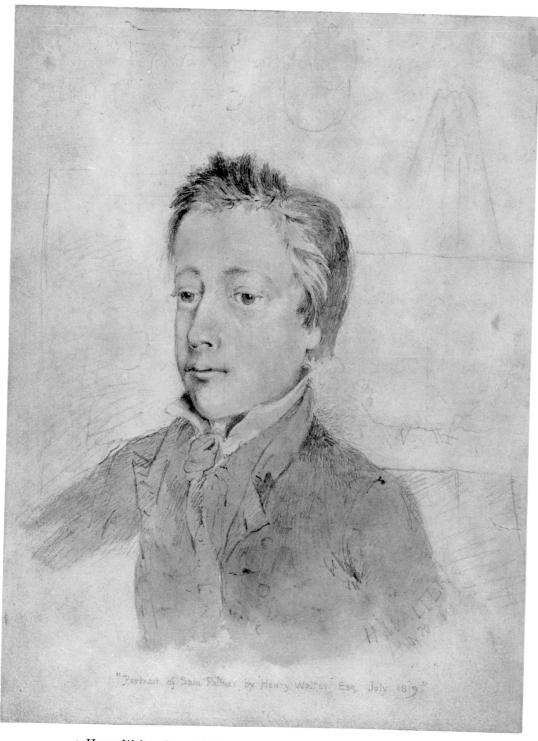

"Portrait of Sam Palmer by Henry Walter Esq July 1819"

2 Henry Walter. *Samuel Palmer at age 14.* July 20, 1819. Pencil, 11¾ x 9″

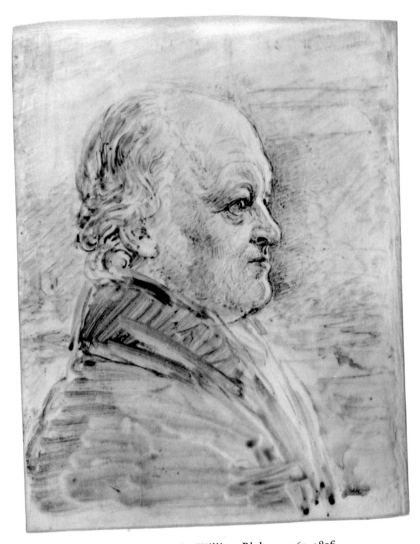

3 John Linnell, Sr. *William Blake, age 69.* 1826.
Painting on ivory, 5¹⁄₁₆ x 4⅛″

4 William Blake. Four woodcut illustrations
for Ambrose Philips'
"Imitation of Virgil's First *Eclogue.*"
Published 1821

5 Henry Walter. *Samuel Palmer*. 1849. Water color and pen, 21¼ x 14⅜″

6 Samuel Palmer in late middle life, photographed 1863 holding a copy of Virgil's *Eclogues* given him by Edward Calvert

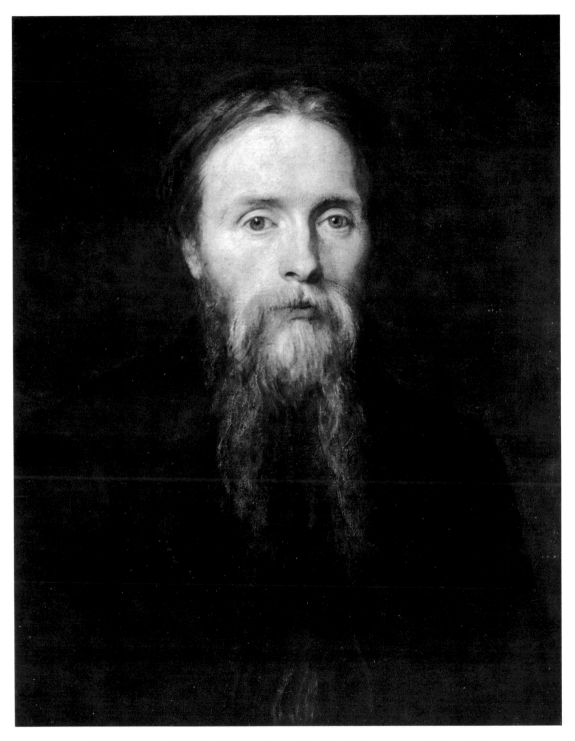

7 G. F. Watts. *Sir Edward Burne-Jones, Bt.* 1870. Oil on canvas, 25½ x 20½″

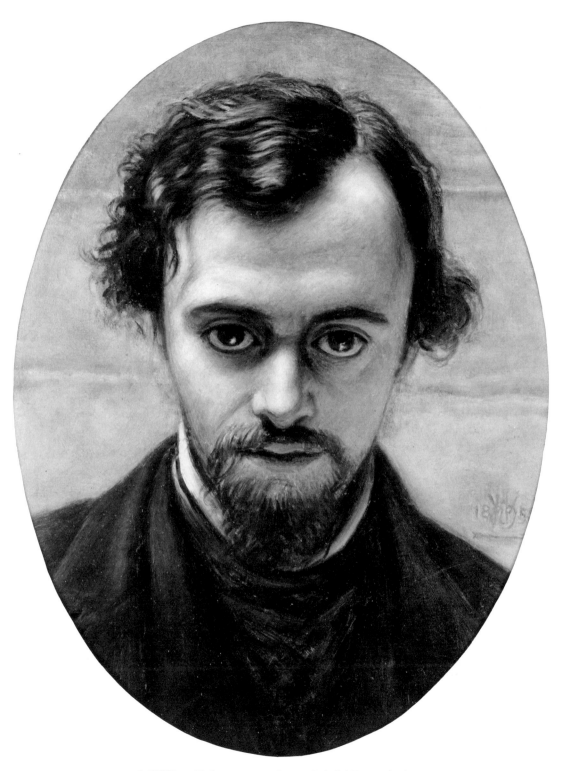

8 William Holman Hunt. *Dante Gabriel Rossetti*. 1853.
Oil on panel, 11⅞ x 9″

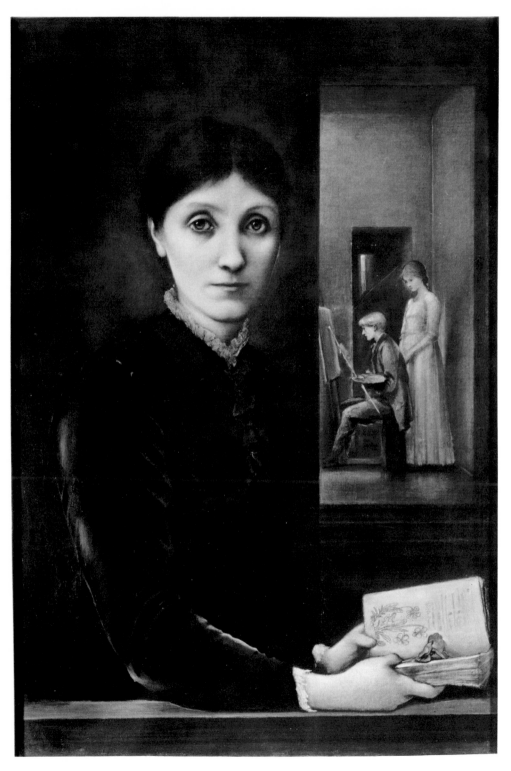

9 Edward Burne-Jones. *Georgiana Burne-Jones*. Undated. Oil, 31 x 21″

10 Edward Burne-Jones. *Portrait Group of the Painter's Family: Lady Burne-Jones with son
Philip and daughter Margaret.* Unfinished oil painting, begun in October 1879

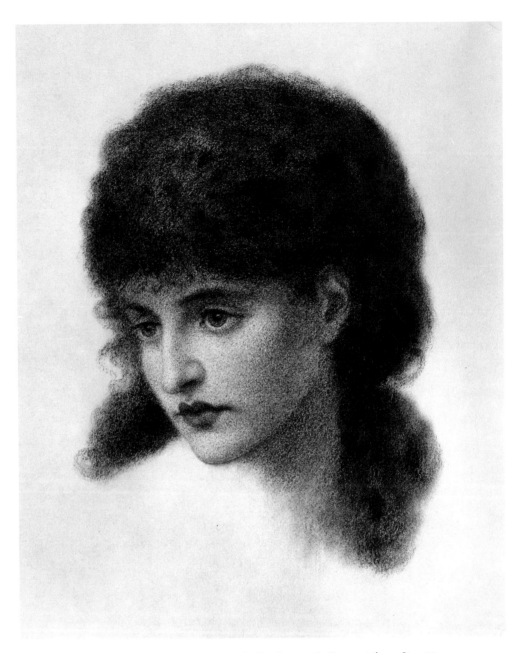

11 Dante Gabriel Rossetti. *Maria Zambaco, née Cassavetti.* c. 1870–72.
Pastel, 20�5⁄16 x 15�5⁄16″

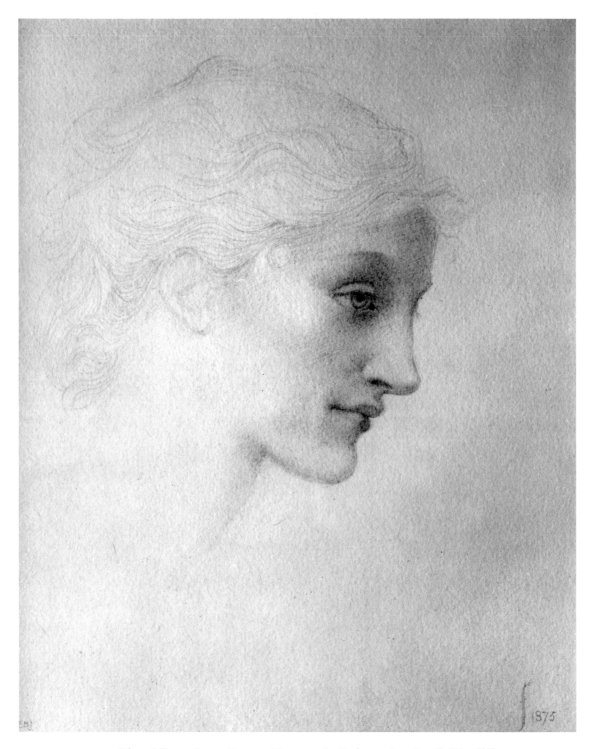

12 Edward Burne-Jones. *Frances Horner, née Graham.* 1875. Pencil, 8½ x 8½"

13 Philip Burne-Jones. *Sir Edward Burne-Jones, Bt.* (Portrait of the painter by his son.)
1898. Oil on canvas, 29½ x 21″

Edward Burne-Jones

Only this is true, that beauty is very beautiful, and softens, and comforts, and inspires, and rouses, and lifts up, and never fails.

EDWARD BURNE-JONES

14 Edward Burne-Jones. *The Mill.*1870–82. Oil on canvas, 35¾ x 77¾"

BURNE-JONES was against artists' having their lives written: "You can tell the life of those who have fought and won and been beaten," he said, "because it is clear and definite—but what is there to say about a poet or an artist? I never want a life of any man whose work I know, for that is his day of judgment and that is his doom; . . . My life is what I long for and love and regret and desire." He was wrong. No doubt an artist's history is the history of his work. But that work tells us a story, the story of the artist's spirit. Moreover an artist, as much as a man of action, fights and wins and is beaten; and what he longs for and loves and regrets and desires shows itself in the events of his life. So it was with Palmer; so it was with Burne-Jones.

Like Palmer's, his pictures reveal the man who painted them. A very different man! Contrast Palmer's *Cornfield by Moonlight* with a typical Burne-Jones picture like *The Mill* in the Victoria and Albert Museum. *The Mill* is both less earthly and less unearthly. On the one hand, one cannot tell from it if Burne-Jones ever looked closely at a tree or a building, or even a human being. On the other, the spiritual impact of the picture is much less fierce than that of Palmer's. It lacks both the strangeness and the immediacy of a vision. Rather, it seems to depict a pensive daydream deliberately evoked.

Is it beautiful? In their own day, Burne-Jones's pictures were thought so, and by distinguished judges. Ruskin and Henry James thought them very beautiful indeed. Later critics have been less enthusiastic. But whether or not Burne-Jones's pictures are themselves beautiful, they certainly appear to express the feelings of someone who loves beauty and yearns for it—and also the sadness of one in whom such a yearning is perhaps unsatisfied. In all this the pictures speak for the man. Burne-Jones did love beauty and was sad sometimes. But not all the time; just as often he was paradoxical and full of fun—impish, flippant, and rollicking. His art did not express its creator anything like as completely as Palmer's did. More complex and selfconscious, he was less ready to give himself away, to disclose his whole self in his work. All the same, he may be considered in the same historical context. For his life is an illustration of the same predicament: the predicament in which an

imaginative painter found himself if he had the bad luck to be born in the nineteenth century. He too had to face the problem of how to be a poetic artist in a prosaic age.

His life began less auspiciously than Palmer's. He was born in 1833 in Birmingham in the respectable middle classes, the only surviving child of a man with a gilding and framing business.* His mother died within a few months of his birth and he was brought up by his father and by a maiden lady whose name was Miss Sampson. The atmosphere of his childhood was melancholy and muted. A high-strung, fragile boy, with pale skin, pale eyes, and pale hair, he was of a type that especially needed to be educated amid warmth and gaiety. But his father, a timid downcast little man, connected Edward with his mother's death and at first turned away from him. Later he grew fond of him—till Edward was grown-up, they always slept in the same room—but he remained aloof and uncompanionable. Miss Sampson too, though kind, did not bring fun into Edward's life. She fussed about his health, and forced him to listen to so much Bible reading as to put him off it for life. She was also inquisitive. However, he soon learnt how to parry her questions. "What are you thinking of?" she would ask the little boy. "Camels," Edward replied repressively. He made it clear that he had retired into his inner thoughts where he was not to be interrupted.

Indeed very early he learnt to rely on his inner resources; he was an intensely imaginative child, who created a world of his own, round which his pleasure was centered. At first it was a typical child's fancy world, full of camels and other grotesque and comical creatures. Later it grew romantic and poetic. His father had few books other than the works of some favorite poets, which he liked to read aloud to his little boy; Shakespeare, Byron, Scott. From these, and from other sources, Edward early became acquainted with the classic myths, the tales of Troy and the Golden Fleece, and the journeys of Odysseus. These appealed intensely to him and were to become part of the per-

* He was christened Edward Coley Burne Jones. After he became an established painter he joined Burne to Jones with a hyphen in order to add dignity and distinction to his surname.

manent furniture of his mind. His second resource was drawing. He had a natural talent for it, and used it in the service of his imaginative life. The child Burne-Jones was not interested in drawing what he saw, but what stirred his fancy: comic camels to begin with, later on scenes of legend and fairy tale; the same kinds of scenes which were to be the subjects of his mature art. He said, when he was middle-aged, that he liked to paint the same subjects as he had when a child.

He added that he had always led a double life, one in the world he saw and the other in the world that he imagined. The circumstances of his childhood accounted for this. For he was a born aesthete, delighting in the beautiful; that is to say, in what appealed to his senses and through them to his imagination. Such a nature drew little satisfaction from the surroundings in which he found himself. It is hard to imagine a more uncongenial place for a born lover of beauty than Birmingham in 1840. It was an outstanding example of the new industrial civilization which the Ancients had looked on as the enemy. To the eye, it was mean and grimy, and to the spirit a citadel of the puritans and the philistines. He who wanted beauty there must find it in his own fancies, or be content to read of it in books.

The result of all this was that Edward was from an early age driven to create an imaginary world to dwell in, more in keeping with his instinctive desires. At the age of eleven he went to school by the day at King Edward's School, Birmingham. He might have been expected, like Palmer, to hate school. In fact, he did not mind it very much. He had much more in common with the ordinary boy than Palmer had. His fragile-looking body contained an exuberant and mischievous spirit. He enjoyed horseplay and practical jokes: he used to delight in leaning out of the window and sprinkling drops of water on the cap of a smart officer walking below so that he thought that it was raining. His schoolfellows thought this amusing, and liked Burne-Jones for doing it. He also entertained them by drawing caricatures of the masters. Finally, from his earliest years, Burne-Jones had charm; a charm blended of gaiety and humor and an attractive oddness. "Are you happy?" This

was his usual form of greeting during his schooldays. It was not a form used by other boys. But somehow they liked him for it.

Burne-Jones was further helped to endure the rigors of school life by the fact that he could always retire from it to his inner world. During his teens, this grew and was enriched by reading: for it was now that his literary taste took shape. Though he retained his love of Greek mythology, it was a romantic Gothic taste. Once a friend asked him, "Do you believe in witches?" "I should very much like to," he replied. He fed his imagination with Ossian, with northern folk tales, with the Border ballads: he loved to spend his free time lying with a friend amid the grass and crumbling gravestones of a neighboring cemetery, declaiming ballads with zest. As he grew older he made his first acquaintance with the romantic poets, especially Keats and Coleridge. This was a crucial event in his inner history. These near-contemporary spirits described an imaginary world of the type most attractive to him; composed of features suggested by medieval art and literature, but in fact a new kind of dream region, embodying the private and nineteenth-century longings of the poets themselves. Keats and Coleridge have written lines and stanzas which seem descriptions of the pictures Burne-Jones was to paint forty years later; of knights at arms "alone and palely loitering," of mysterious chambers in lonely castles

> *Carved with figures strange and sweet,*
> *All made out of the carver's brain. . . .*
> *The lamp with twofold silver chain*
> *Is fastened to an angel's feet.*

When he was sixteen, Burne-Jones's reading took a new and less characteristic turn. He became deeply interested in religion, studied theology and church history, pondered and discussed doctrinal problems, and showed himself inquisitive about the new High Church Movement that had recently started in Oxford. This religious phase of his was a passing phase, never to be repeated. What was the reason for it? Partly personal: for all his appearance of gaiety, Burne-Jones was

often sad. His lonely childhood and hypersensitive nature had bred in him a basic fear of life, which was increased by the anxieties of adolescence. In melancholy moods—and these often overtook him—he turned to religion for strength and comfort. Unlike Palmer, he seems to have not had any direct private religious experience. There was nothing of the mystic about him. But he needed comfort, and the Church spoke words of comfort. Burne-Jones was also attracted by religion because it appealed to his aesthetic sense; because the services were conducted in beautiful words and beautiful buildings. Moreover, the beauty was a romantic medieval kind of beauty. The Oxford Movement looked back to this medieval tradition: no wonder Burne-Jones liked the Oxford Movement. Particularly did the figure of its leader, Newman, appeal to his imagination. Burne-Jones was always to be a hero-worshiper and Newman was one of his first heroes. "Once," he related later, "when I was fifteen or sixteen he taught me so much I do mind—things that will never be out of me. In an age of sofas and cushions he taught me to be indifferent to comfort, and in an age of materialism he taught me to venture all on the unseen, and this so early that it was well in me when life began. . . ."

This quotation illustrates yet another motive for his religious phase: a wish to satisfy his moral sense. By nature he was not unduly moralistic. But the world from which he sprang was the world of the Protestant, middle-class, nineteenth-century English. Burne-Jones was far too sensitive to atmosphere not to be infected by their feelings. His love of beauty became inextricably connected with his reverence for virtue; his yearning for the beautiful identified itself with his yearning for the good. He had been brought up to think of orthodox religion as the source of all good, the appointed guardian of the moral law. Here then was another reason for turning to it. For the time being, the highest life seemed to him to be the religious life. At eighteen, he visited some monks at Charnwood Forest. Their form of life impressed him with an extraordinary sense of peace, dedicated as it was to communion with God and His angels and lived amid rural beauty, far from the ugliness and confusion of the world he saw around him at Birmingham. He

101

remembered his visit till the end of his days. For Burne-Jones was always to visualize the good life as something remote from the world. As a youth he even fancied the idea of going into a monastery himself. In his dependent circumstances, and with his severely Protestant background, this was an idle dream and he knew it. But he seriously took up the idea of being a clergyman.

It was with this idea in mind that—shy, hopeful, his mind a boyish confusion of high spirits and gloomy moods and romantic aspirations— he went up in 1852 to Exeter College, Oxford. He was slight and tall and still pale-colored, with a charming voice and excitable manner, and a face that lit up readily if anything pleased him. For the first week or two, it did not light up often. Oxford seemed unwelcoming; dons and fellow undergraduates alike appeared a stodgy and prosaic lot. One day, however, he got into conversation with another freshman, also at Exeter: a stocky, broad-shouldered, breezy youth, with a mop of dark curls and a pair of hooded eyes, as bright and inhuman as those of a bird. His name, it transpired, was William Morris and he was the son of a well-to-do bill-broker. Burne-Jones was delighted to find that he too was interested in religion and poetry, that he too hoped to take Holy Orders and that he too was disappointed with Oxford. Within a few weeks, the two were inseparable, with Morris calling Burne-Jones Ned, and Ned calling Morris Topsy, since his curly head reminded him of Topsy, the colored child in *Uncle Tom's Cabin*. Soon, Morris offered to share his fortune with the poorer Ned. Ned refused; but gratitude for the offer bound him still closer to Topsy.

The friendship was to last both their lives. It was founded on the best of foundations, namely kindred tastes and complementary dispositions. Their tastes were almost identical. Both liked the Middle Ages and fairy tales and horseplay and practical jokes; both hated the eighteenth century, railway trains, and modern industrial civilization. Temperamentally, however, they presented a contrast. For Ned was high-strung and gentle and inward-looking and a little feminine: while Topsy seemed an extrovert boisterous tempestuous dynamic male; I say seemed, for Morris was a more complex and vulnerable character than showed

102

on the surface. Lurking in the depths of his nature was an anxious hypersensitive strain—it glimpses out now and again in his poetry—that afflicted him at times with a sense of loneliness, a craving to be loved, an acute awareness of the sad fleetingness of all things human. This strain was at war with the rest of his aggressive and apparently extroverted personality and he did his best to suppress it. The result was to inhibit him, so that he was to become in time incapable of a really intimate relation with anyone. Gradually, instinctively he began to cut himself off from others: gradually he came to care less for people than for ideas. Indeed always, and in spite of his youthful impulses of affection, there was something inhuman about Morris: it was not for nothing that his eyes looked like a bird's. This inhuman strain of him was to show itself later in his relations with Burne-Jones.

For the time being, however, each was a blessing to the other. Ned gave Topsy sympathy; Topsy gave Ned confidence. The friendship was in the highest degree fertilizing. Morris's genius had matured earlier; while still at Oxford, he produced his first good poems and showed them to Burne-Jones, who admired them passionately. On his side, Morris admired Burne-Jones's drawings. More influential even than the work they showed each other was the inner life they shared. For Morris also lived largely in a similar world created by his own fantasy; he too, disgusted by Victorian England, had turned to fairy tale and medieval legend as a refreshment. The two pooled their spiritual resources: under a double inspiration, the world of their dreams expanded and enriched itself. It proclaims startlingly their wholehearted opposition to the world they saw around them. This it is that has stirred the imagination of posterity. In life as in music, apparent dissonance can create a rarer harmony; and for us, surveying it from the distance of a later age, this fantasy region of Burne-Jones and Morris gains a curious and piquant charm from the odd contrast between its exquisite archaism—peopled as it is by armored knights-errant and samite-clad damozels wandering through green forests or dallying in daisied pleasaunces, or gazing down from machicolated battlements—and the fog and gaslight and top hats and bulky umbrellas and thundering factory wheels of the

England of the 1850s, in which its inventors found themselves reluct-
antly forced to live.

Both Morris and Burne-Jones were personalities, and, as such, they
gathered a little group of admirers round them at Oxford. As Palmer's
circle had christened themselves the Ancients, so these christened them-
selves the Brotherhood. The Victorian moral impulse was strong in the
whole group. All believed in an austere and fervent Christianity, and at
first they even thought of forming themselves into an order under the
patronage of Sir Galahad, vowed to poverty and celibacy. This idea came
to nothing—luckily for Burne-Jones, who was to mature into a man with
little taste for poverty, and for celibacy none at all.

Spending so much time together, the Brotherhood, and more par-
ticularly Morris and Burne-Jones, began to evolve a set of opinions.
These were in accordance with their taste, and in rebellion against the
conventional views of their time. In most ages, this would mean looking
forward. In the nineteenth century, it meant looking back. The Brother-
hood romanticized the past as much as the Ancients had done: and for
the same reasons. Loving the beautiful, they failed to find it in the new
industrial England. But they did find it behind them in the Age of
Faith. All the more because they were at Oxford: for nineteenth-century
Oxford still whispered the last enchantments of the Middle Age. It was
still a little town of gray quadrangles and sculptured cloisters and pin-
nacled towers from which one stepped straight into an unspoilt country-
side of elms and water meadows. Ned and Topsy explored it with
passionate enthusiasm. ". . . I have just come in from my terminal
pilgrimage," writes Burne-Jones in 1854, "to Godstowe ruins and the
burial place of Fair Rosamond. The day has gone down magnificently;
all by the river's side I came back in a delirium of joy, the land was so
enchanted with bright colours, blue and purple in the sky, shot over
with a dust of golden shower, and in the water, a mirror'd counterpart,
ruffled by a light west wind—and in my mind pictures of the old days,
the abbey, and long processions of the faithful, banners of the cross,
copes and crosiers, gay knights and ladies by the river bank, hawking-

parties and all the pageantry of the golden age—it made me feel so wild and mad I had to throw stones in the water to break the dream. I never remember having such an unutterable ecstasy, it was quite painful with intensity, as if my forehead would burst. I get frightened of indulging now in dreams, so vivid that they seem recollections rather than imaginations, but they seldom last more than half-an-hour; and the sound of earthly bells in the distance, and presently the wreathing of steam upon the trees where the railway runs, called me back to the years I cannot convince myself of living in."

These are strong words, but not too strong. The combined effect of Morris and Oxford architecture, after a childhood spent in Birmingham, was to drive young Burne-Jones into a state of imaginative intoxication. This was intensified by his reading. Within a year, he had put away his religious and history books, and plunged deep into poetry. Morris and he read aloud to one another, Chaucer—they never tired of Chaucer—and the modern authors who shared their sympathies: Keats, Coleridge, and the works of two figures even more contemporary, Ruskin and Tennyson. It was a memorable morning for both when Morris ran up into Burne-Jones's rooms with a copy of Ruskin's Edinburgh lecture in his hand. Straightaway they started to read it aloud to each other; and they did not stop till they had finished it. From that day Ruskin was the contemporary whom they turned to for ideas. He had put into words the thoughts and feelings which had for years been moving obscurely within them. With what magnificent eloquence he sang the praises of the Gothic and declaimed against modern machinery! Nor did he do it merely in the name of good taste. A true Victorian, he asserted his views in the name of morality; building in iron, he said, was worse than ugly, it was wicked. Morris and Burne-Jones agreed warmly. They were Victorians too.

If Ruskin made articulate their ideas, Tennyson embodied their visions. Vividly and precisely, he described a region where figures of fairy tale and legend move across an English landscape, observed with delicate accuracy.

On either side the river lie
Long fields of barley and of rye,
That clothe the wold and meet the sky;
And thro' the field the road runs by
To many-tower'd Camelot;
And up and down the people go,
Gazing where the lilies blow
Round an island there below,
The island of Shalott. . . .

Sometimes a troop of damsels glad
An abbot on an ambling pad,
Sometimes a curly shepherd-lad
Or long-hair'd page in crimson clad,
Goes by to tower'd Camelot;
And sometimes thro' the mirror blue
The knights come riding two and two. . . .

Burne-Jones also responded intensely to Tennyson's characteristic vein of sentiment, in which the sense of beauty mingles with a realization of its transience to well over in wistful regret.

Tears, idle tears, I know not what they mean,
Tears from the depth of some divine despair
Rise in the heart, and gather to the eyes,
In looking on the happy autumn-fields,
And thinking of the days that are no more.

"There are some passages here and there," Burne-Jones said, "so strangely accordant to that unutterable feeling which comes on one like a seizure at certain times, and which Schlegel writes of under the term 'Sighing after the Infinite,' that it is sometimes an inexpressible relief to know and be able to utter them aloud, as if the poet had, in an inspiration, hit upon some Runic words to give voice and form to what were otherwise painfully ineffable. Of these, I think one song in the *Princess* is remarkable. 'Tears, idle tears, I know not what they mean,'

is of this kind. In some hot dreamy afternoons I have thought upon it for hours, until I have been exquisitely miserable. . . ."

"Exquisitely miserable"—we note that Burne-Jones, though an aesthete, is also ironical. Romanticism never succeeded in wholly subduing his sense of the comic. His exalted flights of fancy were interspersed with flashes of fun and succeeded often by outbursts of exuberant spirits. This was true of the rest of the Brotherhood, and especially of Morris. The characteristic feature of their Oxford life—as shown in the records—is a curious incongruous mixture of delicate romantic fancy and boisterous male jollification. It was not a unique mixture: the Ancients, as we have seen, blended poetry and mysticism with jokes and farcical charades. But the contrast in the Brotherhood's life showed up as sharper. On the one hand, their art was a much more fragile and yearning affair than that of the Ancients; on the other, their fun was of that distinctively hearty and masculine kind, generally associated with rowing crews and football teams. At the end of an evening occupied in reading poems like "Tears, idle tears" the young men would fall to wrestling and boxing; or, led by Burne-Jones, they would rush to the window to pour a basin of water on some unlucky fellow students who might be passing below: "Such fun, by jove!" he exclaimed. Their manner of talk was slangy. Everyone had a comic nickname: a pretty girl was called a "stunner"; a poem was a "grind." "Go on, Topsy, read out one of your grinds," Burne-Jones would call out; and in singsong uncharacteristic tones, Morris would chant some tale about damozels and jousts, couched in archaic and precious terms. After he had finished, the company would relax to fall upon him and a genial bear-fight ensue.

The brief University years were passing: the members of the Brotherhood had to begin to think of their futures. To Burne-Jones it was a different future from what he had envisaged when he came up. There was no longer any question of taking Orders. During these years, his faith had ebbed to near vanishing point. All that was left of it now was a taste for the charm of Christian legend and a vague belief in God. But he retained that aspiration to do good which had

partly inspired his faith. Encouraged by Morris—whose faith had declined even more decisively—Burne-Jones's aspiration now directed itself towards the arts. He wanted to add to the beauty of the world; and to do good by so doing. For him, delight and duty went the same way. The Brotherhood followed Ruskin here. Like Ruskin, they were typical of their time in that they were conscience-ridden idealists, who felt an obligation to leave the world a better place than they found it. Like Ruskin, they were not typical, in that they were against the strongly philistine and puritan tone which pervaded so much of the middle class from which they sprang and led it to suspect art as frivolous and sensual. Ruskin and the Brotherhood were out to refute this view and to persuade the age to cultivate the beautiful as a means of attaining to the good.

It was a noble project: the trouble about it was that their idea of beauty was wrong for its purpose. Appalled by the ugliness round them, Morris, Ruskin, and Burne-Jones turned, as we have seen, to the beauty bequeathed them by the Middle Ages. They then made it their aim to adapt its idiom to the needs of the nineteenth century. Victorian England was obstinately unmedieval, and they failed: they were to live to see their ideal defeated. For the time being, however, this sad prospect was hidden from Topsy and Ned, who looked at the future with faith and hope. Ned in particular was confident as he had never been before. He had come up to Oxford rather diffident. He was the type of man who needed understanding sympathy; and his home, though affectionate enough, had not given it to him. But Morris and Oxford were able to. He had also acquired a philosophy that justified his instinctive longings. He was by now convinced that it was not only pleasant but right to follow his dreams. One day he began talking to Morris and another friend of what Oxford had come to mean to him toward the end of his first year there. " 'I feel,' he said, speaking with a strange excitement, 'that my heart has burst into a blossom of love for my friends and all the men round me.' "

In 1852, two events took place which were to affect his future decisively. One day, he or Morris—it is not certain which—came upon a

copy of Malory's *Morte d'Arthur*. Both read it avidly, and for both the experience was momentous. Indeed, it is impossible to overrate what it meant to Burne-Jones: more even than Virgil or Milton meant to Palmer. The *Morte d'Arthur* combined the noblest aspirations of his soul and the loveliest dreams of his fancy in what was, for him, the perfect form. In this he was a man of his time. His admiration, though unusually extravagant, was shared by his literary and artistic contemporaries. Neglected by writers for four hundred years, the legends of King Arthur flooded back into literary popularity in the nineteenth century, to inspire, among others, Tennyson, Arnold, Morris, and Swinburne. It was their symbolic potentialities that brought them back. The romantic writers were turning away from the contemporary and social subjects that had inspired their eighteenth-century forebears, to concern themselves rather with the inner life of man—with the dreams and aspirations and fears and visions of the solitary soul. Now since these could not be expressed directly, the artist must do it by symbol: and how better than by the basic symbols of the human situation to be found in folklore and in ancient myth! In the romantic movement, these legends and myths—neglected for any serious purpose during the previous age—became a mode through which to express the artist's deepest and most serious preoccupations.

But what legends and myths were most suitable for the purpose? Those of Greece and Rome had been traditional material for poetry for centuries; and the romantic poets, too, were to make symbolic use of them. For many Victorians however they were less appropriate than the medieval, and particularly the Arthurian legends. For one thing, these were—or had grown to be—Christian legends, and the Victorian poets, though seldom orthodox, were deeply interested in religion, and had inherited the Christian religious tradition and the morality founded on it. They were much concerned with sin and atonement and the search for salvation. Further, the romantic Victorians believed profoundly in romantic love; and for this too the love stories in the Arthurian legend offered symbols, better than any to be found in the classic myths. Thus Tennyson used Malory's stories as a mode through

which to express his own views on some of the moral problems that perplexed the age which he lived in; and in Swinburne's hands the Tristram and Iseult story becomes a vehicle by which he communicated his fin de siècle view of lawless passion as something at once infinitely glorious and inevitably leading to disaster.

The Arthurian stories had another advantage over the classical myths for the romantics. They were more mysterious. In classical myths all is explicable. If the women of Thebes are seized with madness, we know that it is because their king Pentheus has insulted the god Dionysus. The northern legends, like those of King Arthur, are not thus explained—at least not to the common reader in the nineteenth century. Sir Bedivere flings a sword into the lake and an arm, clothed in white, rises from the water, to grasp and draw it under. We are informed that it is the arm of the Lady of the Lake—but who she is, whether witch or fairy or angel, and what are her powers, remain a mystery. Now the romantics were dealing with much that was inexplicable to them: for who understands altogether the workings of his inner mind? Thus, for them these mysterious northern stories provided symbols closer than the Greek to the inner reality they wished to convey. No classic tale could express as that of the Ancient Mariner did Coleridge's sense of the hidden enigmatic drama of basic good and evil. Keats' view of sexual love as a magic spell, at once irresistible and fatal, finds a fit embodiment in the ballad of *La Belle Dame sans Merci*, as it could never have done in a Greek legend.

Both the mysterious strain and the Christian strain in *Morte d'Arthur* especially appealed to Burne-Jones. For him, a thoroughgoing romantic, mystery was an essential element of beauty: and he was a typical example of the Victorian who, while losing faith in Christian dogmas, remained Christian in his moral sympathies. Burne-Jones saw life in Christian terms: as a search for spiritual salvation, to be achieved with the help of the specifically Christian virtues of charity, humility, mercy. As such, it was aptly and nobly expressed in the figure of a knight-errant vowed to right wrongs and to help the weak at the behest of his King, in the name of God and in honor of his lady. Above all, the story of the Holy

110

Cup, the San Graal, had significance for him, the notion of the sacramental vessel, used by Christ himself in the Last Supper, appearing in glimmering vision to mortal men and compelling them to forswear all else and to go in quest of it. For Burne-Jones the Grail symbolized the ideal good—for an artist like himself identical with the ideal beauty—which it was his compelling obligation to pursue; the ideal beauty, seen fleetingly and seldom, a radiant and ghostly visitant from another world than this. Even as a youth, his hero had been Sir Galahad: and to the very end of his life, the San Graal story continued to stir his heart with a unique emotion. He wrote a year or so before he died: "Lord, how that San Graal story is ever in my mind and thoughts. . . . Was ever anything in the world beautiful as that is beautiful?" Malory's superb version of it, read for the first time at this formative moment, played a major part in shaping the pattern of his imaginative life.

The second decisive event of 1855 came in August. Morris and he paid a visit to France, looking at all the medieval churches and cathedrals they could find. The impression made on Burne-Jones was as powerful as that made by *Morte d'Arthur*, especially the spectacle of a High Mass at the cathedral of Beauvais: "Do you know Beauvais," he wrote years later, "which is the most beautiful church in the world? . . . I remember it all—and the processions—and the trombones—and the ancient singing—more beautiful than anything I had ever heard and I think I have never heard the like since. And the great organ that made the air tremble—and the greater organ that pealed out suddenly, and I thought the Day of Judgement had come—and the roof, and the long lights that are the most graceful things man has ever made. What a day it was, and how alive I was, and young—and a blue dragon-fly stood still in the air so long that I could have painted him. Oh me, what fun it was to be young. Yes, if I took account of my life and the days in it that most went to make me, the Sunday at Beauvais would be the first day of creation. . . ."

Such experiences had their effect. At Havre, the night before they sailed back to England, Ned and Topsy went for a walk on the quay: under the night sky, and with the vast murmur of the waves in their

ears, they recalled their past together and, in the light of the experience they had gained, declared to each other their unalterable decision to devote their future life to the arts. "That was the most memorable night of my life," said Burne-Jones.

He never looked back on this resolution. Indeed, it steadied and calmed him. For Burne-Jones's Oxford years, though so full of rapture, were not untroubled. He was still prone to fits of melancholy, the more because he had grown liable to suffer from other causes as well. The troubles of love for one thing; Burne-Jones had grown up easily susceptible to the charms of feminine beauty and, it seems, had suffered from at least one unrequited passion while at the University. Recovered from this, he had, when back home at Birmingham, got to know the family of a nonconformist minister called Macdonald. It consisted of five daughters, pretty and winning and witty. The third, Georgiana, a minute sprite of twelve, with very bright eyes, roused an interest in him which even the presence of Topsy and Gothic cathedrals could not efface. Frequently he found himself thinking of her, with pleasing but also disturbing emotions.

Burne-Jones suffered more disagreeably from his loss of religious faith. In the first place it isolated him from his home. In the world in which he had been bred, to doubt orthodox Christian beliefs was to be an outcast. Even if Burne-Jones did not proclaim his doubts to his relations—and it is unlikely that he did—he knew what they would have thought if he had; and he was much too sensitive and anxious not to mind this. Besides, his loss of faith affected his own spiritual mood and cast a shadow over his last months at Oxford, all the blacker by contrast with the happiness of his first years there. He felt adrift on a dark sea where no light shone to give meaning to the mysterious universe. Like Palmer before him, he feared modern skepticism, modern materialism, as a threat to his basic faith, his sense that beauty was the manifestation of an absolute and eternal value. Unlike Palmer, however, he could not call on the help of the Church to combat this threat. The result was that his melancholy moods were intensified by intellectual anxiety and bewilderment. During such a mood he painted an allegorical self-

portrait. In it, he depicted himself as a man sitting dejected before a desk, on which lies an unfinished drawing of an angel; behind him, heavy rain falls into a dark sea. Written beneath are the words: "When shall I arise and the night be gone?" He longed in such moods for some simpler mode of life in which he could see his duty clear. He even played with the idea of joining the army and going off to the Crimean Campaign. A hundred years ago soldiering could still seem romantic. This improbable and warlike fancy soon passed, but the depression which gave rise to it recurred occasionally during Burne-Jones's Oxford days. It was eased by his decision to become a painter. Now, in spite of the troubles brought by love and doubt, he knew what he meant to do and concentrated his mind on how best to do it.

For—and this is rare in the story of distinguished painters—Burne-Jones at twenty-one was only just beginning to concentrate on the art of painting. As a child, though so fond of drawing, he had not got much pleasure from pictures. Such of them as he saw were not the type to attract him; engravings after eighteenth-century portraits, or scenes of domestic life in the Dutch manner. Oxford made a change; for there Morris and others introduced him for the first time to the kind of picture that did appeal to him: the works of the early Italian painters and the new English school of the Pre-Raphaelites—more particularly those Pre-Raphaelites whose pictures illustrated myth and legend and romantic poems. Here was an art which was the visual equivalent of the literature he liked! Here were examples he wanted to follow! For he had discovered that he wanted such an example. He was in a similar position to Palmer before he met Blake. He had discovered the way he wanted to go: but he was not sure how to take the first steps on his journey. He needed a guide. Like Palmer, he found one.

It was sometime in 1855 that someone showed him a volume of poems by William Allingham, in which a lyric called *The Maids of Elfenmere* was illustrated by Dante Gabriel Rossetti. Burne-Jones looked at this illustration and was struck, as by a supernatural revelation: for it was the pictorial equivalent of his most cherished type of daydream. "It is I think the most beautiful drawing for an illustration that I have ever

seen," he said, "the weirdness of the maids of Elfinmere, the musical timed movement of their arms together as they sing, . . . are such as only a great artist could conceive." Would that he could meet this great artist! Later that year, he heard that Rossetti gave lessons in drawing to working men's classes in London and hurried thither. Arriving early, he watched Rossetti enter. His appearance was no disappointment. The swarthy figure, with lofty brow and somber bistered eyes, projected a strong impression of mingled mystery and vitality, which drew Burne-Jones as with a magnet. He was too shy to speak to him that evening, but got a chance a few days later at a friend's rooms. Here Rossetti talked brilliantly and decisively. Another guest spoke with contempt of Browning's poems: Rossetti silenced him with a few devastating words. Burne-Jones was awed and exhilarated. He liked to find his hero could be formidable. All the more because to him he was friendly: the two had a talk, at the end of which Rossetti invited Burne-Jones to visit him next day at his studio, overlooking the river Thames near Blackfriars Bridge. There he found Rossetti, amid dust and disorder, but surrounded by drawings which seemed to Burne-Jones of unearthly beauty. He stayed for hours, and left, having once again made a friendship that was to last almost for life. It was to prove an even more influential friendship for him than that with Morris. Morris was an encouraging comrade. But Rossetti was a master; older in years and experience and, to Burne-Jones, an artist of unique and supreme genius. He looked up to him as Palmer had looked up to Blake.

But not in the same way: Blake's personality had the authority of a prophet, Rossetti's that of a magician. It cast a spell which, on those susceptible to it, was not to be resisted. The effect of a spell is hard to convey to the un-spellbound. So it is with Rossetti's spell. We know a great deal about him from letters and memoirs and diaries. But these do not explain the impression he made on others: even his own letters, though vigorous enough, are without any peculiar charm or distinction. It is as though with time the individual flavor of his personality has evaporated. We have to guess it from the kind of praise he received and from the facts of his tragic and picturesque life. It seems to have been

the complex spell of a mixed nature. Rossetti's Italian blood showed in his Mediterranean sensuality, his Renaissance capacity for passion; and there is something exotic in the rich, subtle fantasies of his imagination. But his English mother had blended his foreign blood with an English, even a Cockney strain; so that Rossetti was also born a boisterous Londoner with a robust sardonic Cockney sense of humor, and only at home in an atmosphere of London public houses, London music halls, and London fogs. He hated going abroad; he never paid a visit to Italy; he even disliked staying in the English countryside for more than a few days. More fatally for his peace of mind, his English and Protestant education had imbued him with a sense of sin, which was always in conflict with his pagan temperament. He rebelled against the laws of a puritan morality; but afterwards felt superstitiously guilty for his rebellion. In other ways too, his personality was paradoxical. Aggressively masculine in his pleasures and sexual tastes, he was feminine in his gift for intimacy, his caprices, his desire to charm and seduce. "Gabriel was half a woman," said Burne-Jones once. Finally, he was both princely and bohemian: bohemian in the feckless, disorderly way he preferred to live, princely in his arrogance, his generosity, the magnificent authority with which he seemed, without effort, to dominate the society in which he lived.

He dominated young Burne-Jones already. Within a short time of their meeting, he had persuaded him to leave Oxford without a degree and set up as a painter in London, without any money with which to support himself. This meant some hard months for poor Burne-Jones, with seldom enough to eat and sometimes nowhere to sleep. Once he was forced to spend a night stretched out on the steps of a church porch. He was too proud to ask anyone, even Morris, for help; but Rossetti discovered his plight and immediately lent him money and took charge of him. For the next year, the two were always together. Burne-Jones would arrive each morning at Rossetti's studio to find him eating his big meal of the day—a huge breakfast of eggs and bacon and bread and jam. Together, they worked at their painting till evening: then Rossetti liked to sally forth to take Burne-Jones to sample the delights of Victorian

night life. First, they had a sandwich at a public house—leaning at the bar, Rossetti would read aloud from *Morte d'Arthur*, which he loved almost as much as Burne-Jones did—then they went to a theater. If, as often happened, the theater bored Rossetti, he swept the reluctant Burne-Jones out to spend the rest of the evening at the "Judge and Jury," a sort of combined ale-house and music hall. So passed the evenings when Rossetti was in funds. When he was not, he pawned his coat to pay for some supper for them both and they stayed at the studio talking till the dawn rose pallid over the river and Burne-Jones crept home to his lodgings for three hours' sleep before he came back to the studio to begin work again.

They talked much of art and poetry; but also, it is to be imagined, of less elevated subjects. Rossetti was not chaste, nor his talk prudish. Burne-Jones was not put off by this. On the contrary, he seems to have joined gaily in the Rabelaisian fun and, as a young man at any rate, could do comic drawings that would have been a distressing surprise to the more refined admirers of his later pictures. Rossetti helped to widen Burne-Jones's outlook in other ways too. He took him with him wherever he went, introducing him as the youthful genius of the age. Through him, Burne-Jones made the acquaintance of the other Pre-Raphaelite painters, Millais, Madox Brown, Holman Hunt; Burne-Jones was amused by the way Rossetti passed his paintbrush through Hunt's golden beard while he talked to him. They also met—and this was a cause of especial excitement—the patron and prophet of the movement, Ruskin. Rossetti showed him some of his protégé's designs. Ruskin was enthusiastic. "Look out! He should run you hard," he said. "Jones, you are gigantic." Burne-Jones was embarrassed at what was to him a preposterous piece of over-praise; but he was also pleased. He looked up to Ruskin as yet another hero, never to be loved as were Morris or Rossetti, but regarded with affectionate reverence. It was true that Ruskin did give him much dictatorial advice. But, as he interspersed it with praise, and also bought his drawings, Burne-Jones found his advice forgivable.

One day, Rossetti took him into higher circles. The two drove out

in a hansom cab to dine in suburban Kensington at Little Holland House. There, a rich artistic lady, Mrs. Prinsep, kept open house to all that was most distinguished in Victorian artistic and intellectual society. On this particular afternoon Ruskin and Tennyson and Thackeray and G. F. Watts could all be seen strolling on the spreading lawns and inhaling the sweetness that breathed from the rosebeds. Shy, and clinging close to his swarthy companion, Burne-Jones appeared among them. He made an excellent impression there and was asked to come again. He did so, often. Soon he was a close friend, who called Mrs. Prinsep Aunt Sarah. When she heard he was ill, she carried him off to be nursed at Little Holland House. Burne-Jones felt happy in this new and elegant milieu, though he worried lest it should cut him off from Gabriel. For Gabriel was not at home in such surroundings; so much money and refinement and culture made him feel stifled. However, Burne-Jones need not have worried. The two men were too close for Mrs. Prinsep to come between them. "Dear old fellow, . . ." Rossetti wrote to him, "there is no man in the world I love so well by half or who loves me so well." Fearful of appearing sentimental, he went on, "However, this letter begins to read rather flabby." But he had meant what he said. As for Burne-Jones, for the time being, he was completely under Rossetti's spell. He was surprised, he said, as he walked down the street with him that the crowd did not stop to look. For him, it added to the attraction of Rossetti's personality that it was such a mixture. At one moment, it had the glamor of some prince-painter of the Renaissance; on the other, Burne-Jones was delighted to find something comic about him. He liked thinking his friends comic. He was amused that Rossetti could never find his hat: "Sunk into the earth, by God!" he would exclaim; or to note that when he found his room too full of books, he simply threw them out of the window into the river. As for the darker aspects of Rossetti's character, his wilful unfairness about those he disliked, the streak of cruelty which could show in his teasing, the easy cunning with which he got money out of patrons and fobbed off creditors, Burne-Jones found them rather exhilarating than otherwise: a

sign of Gabriel's splendid superiority to the conventional standards which had ruled his own prim childhood at Birmingham.

And, of course, he was grateful to him—endlessly grateful for the unique service he had done to his spirit. "He taught me," he said, "to have no fear or shame of my own ideas . . . to seek no popularity, to be altogether myself, . . . not to be afraid of myself, but to do the thing I liked most." Rossetti inspired him to have full confidence in his own talent and, more important, encouraged him to paint without hesitation the kind of pictures he liked best; drawn not from nature, but from fancy. He taught him by approval and also by example. For Rossetti himself sought in his pictures to create an imaginary world; he was, he announced, trying to do in paint what Keats and Tennyson did in such poems as *The Eve of St. Agnes* and *The Lady of Shalott.* Burne-Jones had for years wanted to do the same. Before his meeting with Rossetti he had hesitated to set about it; but never afterwards.

And he learnt his lesson effortlessly, gaily, during the most enjoyable year of his life—though enjoyable is too weak a word to describe the rapture that irradiated Burne-Jones's spirit in 1855. Even his month of hunger glowed golden in his memory. For never, he said, had he seen the dawn rise over the Thames so gloriously as when, starved and homeless, he stood watching it on the Embankment. Nearly forty years later he described this year with Rossetti in a letter to a young friend; and as he speaks, his voice seems to change and grow charged with an extraordinary emotion: "There was a year," he wrote, "in which I think it never rained nor clouded, but was blue summer from Christmas to Christmas, and London streets glittered, and it was always morning, and the air sweet and full of bells; and then I saw that I had never lived till then, or been born till then—how did I even speak to him—I don't know. What had I to say fit for his hearing? For I was with him every day, from morning till it was morning again and at three and twenty one needs no sleep. His talk and his look and his kindness, what words can say them? . . . I loved him and would have been chopped into pieces for him—and I thought him the biggest; and I think so still."

Burne-Jones and Rossetti remained close friends for many years after

118

this. But after 1857 Rossetti was too deeply involved with his future wife, Elizabeth Siddal, to see anyone else very often. However, he still had an important service to render his young protégé. Already he had helped him to discover the kind of picture he wanted to paint. Now he was to help him to find the right mode in which to paint it. For Burne-Jones had not yet fully achieved his characteristic manner. Rossetti advised him to visit Italy. Accordingly he spent four weeks in 1858 in Pisa, Florence, Milan, and Venice. Once more, his life can be compared to Palmer's. Both visited Italy to learn from its great masters, the supreme exponents of poetic painting. But the results were different. Palmer's visit to Italy was a misfortune; it diverted his talent from its natural course. Burne-Jones's visit, on the contrary, was a piece of luck, it helped him to cut a channel through which his natural genius could flow easily. He needed a non-realistic mode. For he wanted to paint a dream world; and dream worlds are not to be depicted in a realistic convention. Up to date, he made do with an imitation of the convention created for himself by Rossetti. But this did not exactly suit Burne-Jones's vision. Rossetti's compressed packed angular designs, in which the figures seem crushed down, as by the weight of some obsessive claustrophobic passion, suggest an emotion too somber and stifling for Burne-Jones's lighter and more lyrical spirit. In Italy, for the first time, he received the full impact of the work of the fifteenth-century Italians; of Mantegna, of Bellini, above all of Botticelli. The effect on him was electric. There was no question indeed of his assimilating the stronger deeper strain in Botticelli's art. To do so was beyond the digestive powers of Burne-Jones's minor talent. What he did learn from Botticelli was a congenial pictorial language. For Botticelli's mode of stylization was not too weighty to express Burne-Jones's vision; this could be conveyed in the visual terms created by the painter of *Spring* and *The Birth of Venus*. Further, Burne-Jones's strongest gift was for decorative design, and this found sympathetic inspiration in Botticelli's flowing intricate patterns and in the vibrant calligraphic line with which he executed them. Burne-Jones returned to England in October, 1858, a mature artist who had found himself in style as well as subject matter.

119

He saw himself as following a tradition; not pedantically—for he must adapt it to his own age and individual purpose—but with the confidence of one who feels that there is a whole trend of great painting behind his own efforts.

Meanwhile, Burne-Jones had introduced Morris to Rossetti. Morris was not spellbound—nobody ever cast a spell on Morris—but he was sufficiently impressed to take Rossetti's advice about his future: with the result that he also came to London and, with Burne-Jones, set up in a studio in Red Lion Square. They painted the walls with medieval scenes, and, in company with old friends and new, continued the life of the Brotherhood. All day the two worked hard. In the evening, they relaxed, playing with shouts of laughter a game called "Mexican Duels," apparently a kind of pillow fight conducted in the dark; or, by the light of the fire, Burne-Jones would rouse pleasing shudders by relating, in bloodcurdling tones, tales about poisoning monks and gibbering white ghosts. In the morning, they sometimes had a call from Ruskin. They listened decorously as he ecstatically praised or severely criticized their work. Rossetti was another visitor. Then the atmosphere became pleasantly indecorous, full of jokes and freespoken male conversation. One day, the little maid of the lodging announced that a bishop had called, wanting to see some designs for church furnishings. "Send the bloody bishop up!" roared Rossetti; his words reverberated through the open door, into the ears of the embarrassed prelate below.

The general atmosphere of Red Lion Square was deliberately bohemian. Morris refused, as a gesture, to possess any evening clothes; Burne-Jones grew his hair and beard long and invested in a velvet jacket. But theirs was an English and Victorian version of Bohemia. There was nothing exotic or sophisticated about it. Though it enjoyed flouting the conventions of the bourgeoisie, basically it still accepted bourgeois moral standards. There was something naïve and normal about it that contrasted strangely with the fragile and precious art that it produced.

Normality led, in fact, to its speedy end. For soon the young men fell seriously in love; and, for them, serious love meant marriage. Morris was the first to go. At Oxford—where, led by him and Rossetti,

120

a group of young artists had gone to paint some scenes from Malory on the walls of the University Union—he had come across a Queen of "stunners," in the shape of Miss Jane Burden, the daughter of an Oxford livery stable keeper, a simple enough English girl, but looking like La Belle Yseult herself, with a column-like neck, magnolia-white skin and a pair of brooding eyes, "full of nocturnal mysteries." Morris married her in the summer of 1859. Some months later, Rossetti—though his temperament required a love-life too rich and varied to be comfortably confined within the bonds of marriage—found himself so entangled with Elizabeth Siddal that he decided to marry her.

With his two heroes wedded, Burne-Jones did not long remain a lonely bachelor. He had, in spite of the other excitements of the last years, kept up his connection with the Macdonald family, first at Birmingham, later in London and Manchester; and had always enjoyed doing so. It was natural: the Macdonalds were the attractive fine flower of cultured and intelligent nonconformity, whose home life exhaled a delicate perfume, blending piety and poetry, idealism and a sense of fun. Georgiana Macdonald's charms, too, had increased with the years, though she herself had grown very little, but remained an erect and vivacious sprite, her gray eyes alight with enthusiasm for music and for Tennyson. She had her own sharp turn of wit; as when—this was in later years—she described some philistine ladies she saw at a concert; "They had no faces, only a portion of their bodies that they had decided to keep uncovered, hoping that their friends might notice and become accustomed to them." This is severe as well as amusing. Indeed beneath her winning exterior, there was something formidable about Georgiana Macdonald; a touch of the puritan, strictly principled, censorious of weakness, quick to snub the over-familiar. Even her admirers recognized this. "She is awe-inspiring," said one, "so grave, wise, pure, and penetrating."

Hardly the type of woman most men would choose to spend a lifetime with! In time Burne-Jones was to discover this. Not yet though: in 1860, Georgiana Macdonald's more formidable aspects had not revealed themselves. She was still a young girl, with a young girl's gaiety and

uncertainty and softness. She yielded immediately to Burne-Jones's charm; and he responded to her girlish, eager sweetness. Like most young men too, he took pleasure in instructing her. He told her what books she should read, what pictures she should admire. Soon, he found himself a little in love. The relationship warmed up, till in June 1856, when she was not yet sixteen, he proposed to her and was accepted. After offering up a prayer together, the lovers informed Mrs. Macdonald, who agreed to the engagement, but said that they must wait. Burne-Jones seems to have taken this so philosophically that one wonders how deeply attached he was. There is no doubt Georgiana was in love; also that she had a strong character. These facts, combined with the example set by Topsy and Gabriel, had their effect. In the summer of 1860 Burne-Jones and Georgiana Macdonald decided to be married. Just before the wedding he had an attack of cold feet. He wrote to Gabriel: "I am very frightened about getting married. I should not wonder if I bolt off the day before and am never heard of again." Perhaps he was not serious: anyway, the attack of cold feet passed. September saw them in London, back from their honeymoon, starting life with fifty-five pounds, a bed, a table, and a few rush chairs—poor, hopeful, and happy.

Marriage did not weaken the bond between Burne-Jones and his friends. Georgiana and they took readily to one another, and she became an enthusiastic convert to their beliefs. The Burne-Joneses saw much of Rossetti and Morris, especially at Morris's new home, The Red House, Upton, Kent, newly built and furnished in accordance with his taste. It was Pre-Raphaelite taste, which meant it was uncomfortable: uncushioned chairs, uncarpeted floors and not enough heat. But it was romantically pretty, furnished with inlaid chests and carved settles, with tapestry and mural paintings and wrought-iron work, and with a bowling green and walled apple orchard outside. Life there was like the life of the Brotherhood elsewhere; only differing in that the community that lived it now included both sexes. While the men painted and carved, the ladies embroidered or wove tapestry. When the painting stopped, the bear-fighting began: once an apple

battle was fought so vigorously as to give Morris a black eye. In their quieter moments, the company played bowls, or listened to Georgiana Burne-Jones singing French and English folk songs. In the tapestried, candle-lit chamber, Ned and Topsy and Gabriel and beautiful Janey Morris leant back to listen pensively to the clear voice, raised in minor-key sweetness to sing airs first heard centuries before in a Cotswold village, or on the hills of Provence.

These visits to the Red House had a practical consequence. Morris had been forced to have his furnishings specially designed and made: everything to be found in the shops he thought ugly. This suggested to him a project. He proposed to establish a firm whose aim was to produce things necessary for a house—furniture, tiles, textiles, candlesticks— properly made and after simple and beautiful designs. Here was a way by which artists might both improve taste and earn a living: thus might England be made beautiful once more. Forcible and enthusiastic, Morris had by 1861 begun to put his idea into execution. He raked in all his artist friends to help. Burne-Jones was very willing to be raked in. He needed the money, and he had a particular liking for the sort of work. He was always to like easel painting less than applied art: mural painting, decorating furniture, illustrating books, designing for tapestry or stained-glass windows. Moreover, Morris's scheme appealed to him morally. In spite of Gabriel's releasing and exotic influence, Burne-Jones was still English enough and Protestant enough to like thinking he was doing good by his art.

I I

EIGHTEEN SIXTY was to prove a crucial turning point in Burne-Jones's story. It also entails a change in the way that I tell it. Up till then, Burne-Jones's life falls naturally into a narrative form. The previous years were formative years, during which he had made his friends, wooed his wife, and discovered himself as an artist. Now all this is done. He has settled down as a married man to practice his

art; and, though he lived nearly forty years more, his life did not alter its pattern. For this reason, it is hard to make a story of it. Further, such story as there is divides into two: the story of Burne-Jones's art, and his personal story. These two were unrelated. For his art was the expression of his inner life which pursued its own way, unconnected with his outer life and unaffected by its events. It is therefore impossible to fuse the two lives into a single tale.

Let me begin then with the story of his personal life. On the face of it, this is a story of success. An honorable success: for Burne-Jones remained throughout his life dedicated to his art, and with a dedication that was wholly disinterested. He never pushed, never made any concession to popular taste. He exhibited very seldom, and then only a few pictures at a time. This meant that for some years he continued to be poor. But his confidence was sustained by the appreciation of his friends. Gradually his reputation began to grow. For, unlike Palmer's, Burne-Jones's work was to the taste of his age, though at first it was the taste of an advanced and sophisticated minority. He had early acquired a patron: William Graham, a Scottish merchant and a Liberal M.P., who bought his first Burne-Jones picture in 1856. Soon he was a regular purchaser, who could be depended upon to take some of his work off its creator's hands. Graham thought one of his purchases so beautiful that, when he first saw it, he leaned impulsively forward and kissed it. Members of Parliament, it seems, were more aesthetic and less inhibited in the days of Queen Victoria than in the days of Queen Elizabeth the Second.

One patron leads to another. Burne-Jones's fame grew. In 1875 we learn that Arthur Balfour, leading Conservative statesman and member of the Souls, most cultivated of aristocratic circles, had ordered Burne-Jones to paint a series of pictures for his dining-room. Success gave Burne-Jones self-confidence. In 1877, for the first time, he showed several important pictures at the Grosvenor Gallery. They made a stir. The older school of critics were hostile and accused the pictures of being morally objectionable; morbid, effeminate stuff, with boys and girls looking the same, and both sickly. These accusations did Burne-Jones no

harm, however. It seldom harms an artist for his work to be described as immoral. On the contrary it encourages public interest. Besides, more sophisticated critics were favorable, and a young American called Henry James who was visiting London wrote a notice of the exhibition praising Burne-Jones's pictures in the highest terms. For him, he said, they placed their author at the head of the English painters of the day, and very high among all painters living in this degenerate age. There was a lot of the nineteenth-century aesthete about Henry James's taste in pictures: and Burne-Jones's art was just the kind to appeal to the rising aesthetic movement. Within a year or two up-to-date connoisseurs agreed with Henry James, and Burne-Jones was accepted as one of the few very important living English artists. Not only in England, either: in 1879, he sent some pictures to Paris, where they were much admired. Finally, in 1881, an official seal was affixed to Burne-Jones's reputation: the University of Oxford awarded him an Honorary Degree. At fifty-three years old, and though only painting what he wanted in the way he wanted, he had reached the top of the artistic tree.

Success made his circumstances easier. He grew richer and took advantage of it. During these years, with his wife and children, Phil and Margaret, he moved twice: to Kensington Square in 1865 and in 1867 to The Grange, Fulham. In 1880, he bought a little holiday house in the village of Rottingdean, near Brighton. But The Grange, Fulham, remained his main dwelling. Enriched and improved over the years by Georgiana, it became a charming expression of Pre-Raphaelite sentiment. No more than Morris's house was it very comfortable. But it was pretty and secret and romantic—like the house of the Sleeping Beauty, it was said; an antique mansion standing back from the road behind wrought-iron railings, with a dim green Morris-papered hall, a pale drawing-room decorated with a cast of a relief after Michelangelo, and a window looking across the garden to where Burne-Jones was later to build a studio so that he could work at his painting cut off from the noise of the world. Not that his was ever a secluded life. During the first years, he saw much of his old friends: and, with fame, came invitations to the homes of the great in the world of art and letters—to meet Tennyson,

Browning, George Eliot—and later to the world of fashion and high politics. Wherever he went, Burne-Jones's attractiveness made itself felt—"I have never known a man of equal charm," said Balfour. The invitations multiplied. Georgiana began to disapprove a little: but Burne-Jones could not help being pleased. Meanwhile at The Grange the Burne-Joneses kept a modest open house to friends old and new. People played and sang in the pale drawing-room of a winter evening; or, in the summer twilight, wandered out to enjoy the flower-scented warmth of the garden. There were dinners at little restaurants in the Soho neighborhood and sometimes a night at the theater. Every Sunday, Morris, now living in London again, came to breakfast and spent the morning in the studio.

The descriptions of these days present an idyllic picture in a Victorian and Mendelssohnian mode. Was the man who lived it happy? Not so much as one would expect; those who saw most of him detected beneath the pleasant surface an undercurrent of sadness. It was partly congenital: Burne-Jones never outgrew his tendency to fits of melancholy. During his early struggles, when his work was unappreciated except by his few friends, these fits could be acute. At moments he thought his work was no good. He could not sleep for anxiety about the future, and looked back with painful regret to the hopeful past: ". . . at present," he wrote in a letter in 1866, "I have evil nights and am most often awake at three, with some four hours of blank time to lie on my back and think over all my days—many and evil they seem—and when I think of the confidence and conceit and blindness and ignorance of ten years ago I don't know whether most to lament that I was ever like that, or that I ever woke out of such a baseless dream. . . . I am really at present at the very lowest ebb of hope."

These depressions did not pass unnoticed. Ruskin and Morris and other good friends grew concerned and tried to help in their own way. One evening in 1865, the Madox Browns gave a party in their house at Kentish Town. All the circle were there: Morris, Swinburne, the Rossetti family; also Whistler. To them, introduced by Rossetti, there entered a foreign-looking young man, with a flamboyant manner and

126

wearing across his shirt front a broad red ribbon, which he asserted was a decoration bestowed on him by a continental potentate. His name was Howell. His attractions were not physical. One witness said he had a face like a whipped cab horse; and another that he was the color of a vegetable marrow. But his conversation was entertaining and surprising. He had, he said, been diving off the coast of Portugal in search of gold from a sunk Spanish galleon. This and other sensational reminiscences enthralled the company especially Rossetti and Ruskin. For Burne-Jones and Howell it was the start of a friendship.

This did not prove lasting. For Howell turned out to be an adventurer, a crook, and a liar. The truth of his history is not known, beyond the fact that he was the son of an English drawing master and a Portuguese mother; and that, after a shady and adventurous youth abroad, he had come at the age of twenty-six to seek his fortune in London. Here, he managed to make a position for himself in artistic circles, partly by amusing the artists by his talk, and partly by selling their pictures for them. He was good at selling, and the artists noticed it. If they also noticed that he took a rake-off for himself, they turned their eyes away. Rossetti indeed, who had a streak of moral anarchist in him, was rather amused than otherwise by Howell's dishonesty. He delighted in his preposterous fantasies; and did not take it very seriously if he caught him going off from his house with a drawing or an object of art concealed about his person.

Burne-Jones took to him too. Howell had the power of cheering him up when depressed. Ruskin discovered this. In 1866, therefore, when Burne-Jones was going through a bad fit of melancholy, Ruskin paid Howell two hundred pounds to go and live near him, in order to be available for keeping up his spirits. Burne-Jones was very pleased. Soon, he was frequently writing Howell little notes, asking him to come over; beginning "My dear little Owl"—for so he nicknamed Howell—and ending "Your loving Ned." Alas, this happy relationship was not to last. Even while it endured, Burne-Jones was not always cheerful. His basic tendency to sad moods remained; and sooner or later, in spite of Howell's company, they recurred.

The second cause of Burne-Jones's sadness was less subjective. After his art, he depended for happiness on his personal relationships. These were turning out in some degree disappointing. In particular, his marriage had disappointed. Burne-Jones had matured into a man intensely susceptible to feminine charm, to whom a romantic connection with some woman was the breath of life. As such, he was unlikely to be satisfied with a relation with one woman only, and especially if that woman happened to be Georgiana Burne-Jones. The affinity between husband and wife was incomplete. He, for all his genuine idealism, was a hedonist, who lived for delight; she, for all her artistic tastes, was a moralist, who lived for duty. Between the hedonist and the moralist, a great gulf is fixed. Should they come together, each becomes aware of this gulf. The moralist cannot help disapproving and the hedonist grows nervous lest he should incur the moralist's disapproval. This fear encouraged Burne-Jones to turn to other women not only for entertainment, but also for reassurance. How soon this happened we do not know. Certainly there was trouble by 1868. In that year we find Burne-Jones already entangled with a member of a foreign artistic colony in London, the daughter of a Greek called Cassavetti, and married to a Signor Zambaco. Maria Zambaco, to judge by her portraits, was not the usual Burne-Jones type, but a black-eyed, black-browed, Mediterranean type of beauty, with an air of brooding and voluptuous intensity. It is interesting that she bears a noticeable resemblance to his picture of Circe the Enchantress. She seems to have enchanted him pretty thoroughly. Such information as is left to us suggests that the affair was full-blooded enough to have provoked open scandal. There is an unconfirmed story that he left home in 1869 to live with Madame Zambaco for several months. It was also rumored that the romance ended in an unsuccessful suicide pact. The lovers agreed to end all by drowning themselves in the Serpentine. After they had advanced a few steps into it, however, they decided that it was too cold and came out again.

This is a pleasing story, and I wish I could believe it was true. But, alas, Rossetti, writing to Madox Brown in the same year, suggests a more probable, though less comical version of the same incident. "... Poor old

Ned's affairs," he says, "have come to a smash altogether, and he and Topsy, after the most dreadful to-do, started for Rome suddenly, leaving the Greek damsel beating up the quarters of all his friends for him and howling like Cassandra. I hear today however that Top and Ned got no further than Dover, Ned being now so dreadfully ill that they will probably have to return to London. Of course the dodge will be not to let a single hint of their movements become known to anybody, or the Greek (whom I believe he is really bent on cutting) will catch him again. She provided herself with laudanum for two at least, and insisted on their winding up matters in Lord Holland's Lane. Ned didn't see it, when she tried to drown herself in the water in front of Browning's house &c.—bobbies collaring Ned who was rolling with her on the stones to prevent it, and God knows what else."

It is unlikely that such an incident could be kept from Burne-Jones's wife. But, if another unconfirmed story be true, poor Georgiana had learnt of her husband's infidelity earlier than this. The Dear Little Owl had proved a traitor. Out of pure mischief, it seems, and though he was in Burne-Jones's confidence about the affair, he brought Madame Zambaco to call on the ignorant Georgiana when her husband was out. Burne-Jones returned home, and opening the door saw the back of an unknown woman talking to his wife. She turned; he recognized Madame Zambaco, and fainted dead away, hitting his head on the mantelpiece. Presumably after this, Georgiana discovered the truth. To her credit, her anger was especially directed towards Howell. In her Life of Burne-Jones, written over thirty years later, though never mentioning Madame Zambaco, she alludes to Howell in a tone of extreme severity as "one who had come amongst us in friend's clothing, but inwardly he was a stranger to all that our life meant." Burne-Jones was equally indignant; he never had anything to do with Howell again, and tried his best to see that Ruskin and Rossetti did not either. Meanwhile, Madame Zambaco seems to have disappeared from his life. Her name is never mentioned again in connection with him. Life at The Grange, Fulham, resumed its tranquil course.

But the relation between its owners was not the same as it had been.

Georgiana was still bound to Ned by the conviction that he was a genius whom it was her privilege as well as her duty to serve: and the bond was strengthened by the fact that they both loved their children. But it is significant that from this time on they did not have any more. They were not as intimate with each other as in the past. People noticed that after 1869 each seemed tacitly to have agreed to live his or her own life.

Unfairly this came harder on the sinned-against Georgiana than on the sinning Ned. She occupied herself with her family and with causes, generally of a radical and progressive kind. She also got comfort from the friendship of William Morris. His marriage too was going through a troubled phase. Rossetti was now deeply in love with Jane Morris and it is likely that in some degree she responded to him. Rossetti's spell acted powerfully on women, while Morris's inhibitions combined with his absorption in his work to make him an unsatisfying husband. This did not prevent his minding when his wife appeared to lose interest in him. He felt lonely and in need of sympathy just as Georgiana did. Their friendship grew closer. They saw each other often; when they did not, they wrote to each other.

But it was always Burne-Jones that Georgiana loved: no friendship, however firm or high-minded, could make up for losing him. Nor were her conjugal troubles over. Burne-Jones learnt his lesson, he was careful to avoid scandal. But he was still susceptible; and relationships with women continued to play a major part in his life. We know little about most of these relationships—hardly more than the ladies' names; Mrs. Norton, Mrs. Gaskill, May Morris are some of them. We know that he called on them often, wrote to them, addressed them in affectionate terms; so affectionate indeed that each of them tended to think she was the most important woman in his life. Did he ever encourage this view by going any further? Some people think he did; it was remarkable, they said, that Georgiana was ready to forgive him so often. Even if this were true however, it did not necessarily mean he was unfaithful to her in the full sense of the term. Sentimental friendship between man and woman was an accepted custom of the period; a relation avowedly romantic and sometimes enduring for years, but kept carefully within the bounds of

propriety. All the same, sentimental friendship, if pursued with persistence, would be likely to displease a wife—especially if, like Georgiana, she was "pure and penetrating" and brought up in the Nonconformist tradition. After 1869, The Grange, Fulham, was not the home of untroubled domestic bliss that it might appear to an ignorant visitor.

Disillusioned with marriage, Burne-Jones was also in some degree disillusioned with his chief male friendships. None of his heroes had remained the source of inspiration and delight that he had been. Most painful was the change in his friendship with Gabriel. The basic division in Rossetti's nature had in the end proved fatal to his stability of spirit. The Latin/Bohemian in him warred incessantly with the guilt-ridden English Protestant, and with disastrous results. Moody, inconstant, and undomestic, he was profoundly unsuited to be a husband. Within two years of marriage, Elizabeth Siddal, worn out with suffering and jealousy, died of an overdose of laudanum—purposely or not, no one has ever known. In any case, Rossetti was overcome with agonizing remorse at the way he had treated her; so much so that he impulsively buried the only manuscript of his recent poems in her coffin. After a few years of mingled dissipation and self-reproach, he recovered enough to fall in love again, and more intensely, with William Morris's wife, Janey. Inspired by this passion, his poetic genius revived to do some of its best work. His spirits improved in consequence, and it began to strike him as a pity that his earlier poems should be wasted. He had them dug up, and printed in a new volume. This more hopeful mood did not last. Circumstances were against it. In the first place, Mrs. Morris was bound firmly, if not joyously, to Morris. Secondly, the book of poems, when published, was viciously attacked as immoral by a jealous fellow poet called Buchanan. The attack made a sensation, which the arrogant-seeming Rossetti might have been expected to treat with contempt. But sorrow, sense of guilt, and frustrated love had undermined his faith in himself. He had a breakdown and tried to commit suicide. Once more, he recovered; but forever after, he was a changed man. He lived for nearly ten years more, still managing to work. But his morale was gone, so far as his personal life went. Shut away in his house in Cheyne Walk,

131

Chelsea, and often dazed with laudanum, he shuffled around house and garden gazing dully out at the misty Thames, an obsessed paranoiac, who shrank from seeing anyone who had known him in his golden prime. Among these was Burne-Jones. For some years after his marriage, they remained on the old affectionate terms. But after Rossetti's collapse, everything changed. The event had come to Burne-Jones as an appalling shock. ". . . It has been the saddest sight I have had in my days," he said, "and seems to tinge everything with melancholy and foreboding. There is more than any tenderness of friendship in what I feel for him— he is the beginning of everything in me that I care for, and it is quite dreadful." Once Gabriel showed signs of getting better, Burne-Jones rushed affectionately to see him. Rossetti utterly rejected this gesture of friendship. Again and again Burne-Jones repeated it; but Rossetti remained unresponsive. In the past the two had been bound together by an intense interest in each other's art; yet now, Gabriel never asked Burne-Jones about his pictures, nor showed him any of his own. In vain Burne-Jones wrote protesting. The relationship was dead. Though Burne-Jones, for the sake of old affection, called now and again at Cheyne Walk, he felt bitterly that, for all Gabriel cared, he might as well have stayed at home. Rossetti's death in 1881 came to Burne-Jones as a relief. For then at last he was able to forget the immediate past and remember him as he once had been. Bitterness was washed away in tears of grief. Bitterness, but not sadness: Burne-Jones was left sorrowfully disillusioned about human life, where the strongest love cannot be trusted to last, where the richest promise may prove unfulfilled.

His friendship with Morris was not disillusioning; but it was less of a pleasure than it had been. Though they still often met, they had less in common than in the past. For Morris's nature was beginning to seek fulfillment in a direction where Burne-Jones could not follow him. During these years, Morris had gradually become convinced that his campaign to beautify contemporary England was a failure. His products —furniture, wall-papers, etc.—were bought only by a rich and idle minority and meant nothing to the mass of the people, who could not afford them. They were, in fact, something Morris deeply disapproved

132

of, namely elegant luxuries; and he was coming to the conclusion that they never could be anything else, so long as England was a competitive and capitalist society, run for profit. If his ideal was ever to be realized, he thought England must suffer a socialist and revolutionary change. With Morris, to think was to act. He bought some books on politics and economics and devoted most of the next twelve years of his life to active work for socialism. He wrote pamphlets rather than poems, and thought less of designing wall-papers than of addressing working men at street corners. He felt proud when, on one occasion, he was actually arrested by the police for so doing.

Burne-Jones saw no cause for pride in any of this. It was not that he thought Morris's opinions wrong. In so far as he had political views, they were vaguely and romantically radical. He hated business men and empire-builders: he was all for rebels and underdogs. But politics bored him and he had the sense to realize that he did not understand them. Besides, he thought that the artist's first duty, even as a citizen, was to practice his art. Surely, Topsy would do more for society by writing poetry, which he did well, than by addressing mobs, which he did badly. For Morris was not a success as a politician. He quarreled with his fellow workers in the socialist cause and failed to get on easy terms with working men. Amused and exasperated, Burne-Jones noticed these facts. "Morris," he said, "is the biggest and unwisest of creatures. I think better and better of him and less and less of his judgement as time goes on." It is to be doubted if he really did think better of him. In later years, he talked about his faults in a way he had not done in his youth. Was not there an inhuman strain in Morris? "The streak of the north wind in him," Burne-Jones called it. If there was a softer strain lying hidden and frustrated in the depths of Morris's nature, he did not know it. Did Topsy really love anyone, Burne-Jones asked himself. Perhaps his little daughter Jenny, he thought; but no one else.

As for his third hero, Ruskin, he had gradually faded from Burne-Jones's life. His marriage indeed had at first strengthened the friendship; for Ruskin liked Georgiana very much: he described her as "a little country violet with blue eyes and long eye lashes, as good and sweet as

can be." He took the couple abroad with him in 1863 and he went on seeing them when they came back. For the time being this made Burne-Jones fonder of Ruskin than ever. In caressing affectionate words he offered to design him a tapestry as a token of his gratitude. "Shall you like it, dear?" he wrote, "and will it ever make a little amends for sorrow? . . . It is so detestable for me to be happy and you not—I can't bear that sometimes." Alas, his affection proved to be as short-lived as it was demonstrative. It was Ruskin's fault that it cooled. Incurably a governess, he could not help giving Burne-Jones unasked for advice about his work and scolding him if it did not please him. When Burne-Jones showed him his picture *The Mirror of Venus*, Ruskin's only comment was "I mourn for its dullness." Burne-Jones could not be expected to like this. He also found himself depressed by Ruskin's lack of humor. One day he read him the story of the barber from the *Arabian Nights*; he thought it would amuse him. He turned out to be mistaken about this. Ruefully he described the scene. "His mother was by and said she was always interested in the Egyptians because of their connection with God's chosen people. I thought that funnier even than the story of the barber. It was a difficult evening and I wished I hadn't begun to read." Further he disagreed violently with much of what Ruskin said in his later books. By 1870, the two men were so much on each other's nerves that, whenever they met, they argued. Within a few years, they hardly met at all. As long as he stayed apart from him, Burne-Jones kept a soft spot for Ruskin in his heart. He tried to remember all he had done for art in general, and for his own art in particular.

In 1878, these worthy sentiments were to cause him some trouble. For it was in this year that Whistler brought his famous libel action against Ruskin for calling him a coxcomb who had flung a pot of paint into the public's face. Ruskin asked Burne-Jones to witness on his behalf. It was the last thing Burne-Jones wanted to do. He hated rows; he hated appearing in public: and he was not at all sure that Ruskin was in the right. However, it seemed ungrateful and disloyal to refuse. Reluctantly, he went into the witness box and said nervously that, though he considered Whistler a painter of great talent, he did think that he

sometimes exhibited his pictures in an inexcusably unfinished state. The upshot of the case pleased nobody. Ruskin lost: but Whistler was only awarded a farthing's damages—this meant that the jury thought he deserved no sympathy. He turned against Burne-Jones for life. Burne-Jones wrote to Rossetti, "The whole thing was a hateful affair, and nothing in a small way ever annoyed me more." Officially he and Ruskin remained on good terms: but after this Burne-Jones had no doubt whatever that the friendship was more trouble than pleasure to him.

Burne-Jones's later life, then, was not so smoothly serene as its outer circumstances suggested. But it had its compensations. He was happy in his work, for one thing. For another, to make up for the failure of earlier relationships, he had formed some delightful new ones. There were those with his children; high-strung voluble Phil and quiet pretty Margaret. Burne-Jones had a childish streak in him that made him enjoy playing with children. He was always drawing for them; either comic pictures, often of pigs, or horrific scenes of ghosts and monsters, with titles like "The Mist Walkers" and "The Heath Horror." These last were alarming enough for other people to tell him that they were unfit for children. The children themselves disagreed. Burne-Jones's horrific drawings gave them thrills of delicious fear just as his comic drawings threw them into delicious paroxysms of laughter. The pleasures of home centered round their father with his jokes and rumbling voice and soft golden beard.

He, on his side, found peculiar satisfaction in their company. His games with Phil and Margaret gave him a chance to indulge a part of himself that found too little outlet in grown-up society. He could express in his drawings for them what he could not express in his serious pictures. Indeed, playing with children became so important a pleasure to him that after his own children grew up, he made friends with other people's, notably Katie, the little daughter of Mr. and Mrs. Lewis, well-known art patrons of the day. Burne-Jones corresponded regularly with Katie: his letters were signed "Mr. Beak" and were elaborately illustrated.

To him as to Samuel Palmer, the love of his children brought pain as well as pleasure. He was filled with apprehensions for their safety and entered only too much into their distresses. When he heard that Margaret had been taken ill on a visit to Ireland he immediately took it for granted she was at death's door; Phil's unhappiness during his first term at Marlborough plunged his father into a wretchedness equal to his own. Considering how fond he was of Phil and how little he cared for convention, it seems odd that Burne-Jones should have sent him to a boarding school at all. Georgiana, writing in later years, implies that he only decided to do so with doubt and hesitation. As it was, the decision led to general unhappiness. Phil, brought up in an atmosphere of gentle affection, found school life Spartan and brutal. Burne-Jones, besides missing him dreadfully, entered painfully into his sufferings. He poured out his feelings to him in letters which blended sympathy and extravagant endearments with advice about how to deal with hostile schoolfellows. ". . . At any rate don't yield at all to them, but take your own way and never change it—only in that way will you win either now or afterwards in life. It will always be so, dear, there will be always people telling you how you shall think and act and dress, and what you are to say and how you are to live, down to the tiniest trifle, meaning that you are to think and act and dress as they do; and some sort of penalty you must pay all your life for differing from them, and their tyranny is excessive and relentless, and they would mostly like to destroy what they cannot convert to their own likeness. With all this have nothing to do. Neither despise them for differing from you, for this is to be the same unjust thing yourself, but get away from it whether in mind or body— the first is always possible. And think as little of all that side of life as you can—at the worst it is like the teasing of flies on a summer day—and there is left to think of sun and moon and seasons and earth and seas and monuments and images, and the lives of the great—all these may be your life if you will. . . ." "Remember always you are free, and nothing need change your plan for one moment. The world of men is just the same: if afterwards one gets any great enthusiasm, people only mock; if one drops it to please them, they will still mock; if one were to die for it they

would have no other way of expressing themselves—and still don't mean any evil, but are only thoughtless and pitiable. Every way I had at College that was not quite like the ways of men about me was only derision to them, but I did learn out of it all to free myself, and you see, as far as is good for me, I live quite free."

As well as sympathizing with Phil in his sorrow, Burne-Jones talked to him about sorrows of his own, especially the sense of change and decay that swept over him from time to time now he was growing older. He wrote from Oxford: "I came down yesterday in time to take a long walk round the spots I most liked when I was here. That was twenty years ago and more, and it feels half sad and half happy to come down sometimes and think over the life between, and how different it is to anything I could have dreamt of—how much happier than I ever hoped in some things and more calamitous than I ever dreaded in others. The bells are constantly chiming as they used to do and make me ready to cry." In one letter his sense of lost youth embodied itself in a bitter-sweet half-comical fable. "I have gone down this week in painting—but hope to get up next week, my new master Dr. Senectus says there is no time to lose. I wrote to my old tutor Mr. Juventus to say good-bye to him, and told him how I was getting on. In reply he said that I should never see him again, for which I am very sorry, for I always liked him though he set me very hard tasks sometimes, and I don't like never seeing people again. And old Senectus is such a dreary old chap—knows a lot but doesn't make it amusing, and there are no holidays, not even half-holidays." Here the school metaphor and schoolboy language has clearly been chosen in order to appeal to a schoolboy. But the sentiment they express is wholly and only to be understood by the middle-aged. One wonders what the fourteen-year-old Phil can have made of it!

Meanwhile Burne-Jones realized his mistake. He told a friend never to send his son to a boarding school. The son, he said, would suffer from lack of love and the parent from the loss of an irreplaceable companion.

III

THESE later years also saw the start of two important friendships. The first was with Dr. Sebastian Evans, a gifted scholar and poet, though not much of a worldly success as either. Burne-Jones got to know him in 1885. The friendship helped to fill the gap made by the death of Rossetti and Morris's dedication to politics. It was never close as these friendships had been: nor was there any question of Evans influencing Burne-Jones. For Evans's philosophy of life was a civilized, cynical affair—like that of a charming, but wicked Cardinal, thought Burne-Jones. But Evans was a wonderfully agreeable talker. The two would dine alone together and then for hours discuss and amicably dispute about the purpose of existence and the nature of art. Evans was humorous. Perhaps almost too humorous; Burne-Jones admitted to finding his company so sparkling as to be tiring if he saw him often. Still, it was a pleasure to find a friend who liked fun so much; and all the more because he did not mind if it was unrefined. For Burne-Jones still felt an occasional need to take a holiday from good taste and refinement. The two friends had much enjoyed themselves, visiting a famous tattooed lady, then on show in London. On her right arm were the Stars and Stripes: on her left, the Union Jack; while on her bare and ample back, and rippling with the movement of its muscles, was spread an exact reproduction of Leonardo da Vinci's picture of the Last Supper. "I wanted you to see it," cried Burne-Jones exultantly, as they left the exhibition. "Nobody could believe in the beauty and grandeur of such an apocalypse without seeing it with his own very eyes."

Ned's delight at the spectacle bewildered the fastidious Georgiana. But as a matter of fact it was in character. The bohemian Burne-Jones was not yet quite dead, the Burne-Jones who had rioted with Rossetti and drawn shocking drawings to amuse his fellow art students. In his lighter moods he still did comic drawings, less shocking, but equally unlike his serious works: caricatures of his friends, especially Morris, and also of imaginary figures, generally men totally bald and stark naked women as fat as those of Rowlandson. Yet the name of Rowlandson indi-

cates a difference. Burne-Jones could not change his artistic personality completely. His fat women lack Rowlandson's vigor and also Rowlandson's coarseness. They are drawn with the same delicacy of line as are his angels and wood nymphs. So that, intentionally or not, the impression they make is also delicate, though a little weak. Still they remain surprising productions for those who only know Burne-Jones's pictures of angels and wood nymphs; and they tell us something significant about him. Like his sketches for children, they represent a reaction against the pressure exerted on him by his principles and his period. The view of art to which he subscribed did force him to repress an essential part of his own personality. The result was that now and again this part rebelled: Burne-Jones would be seized with a desire to take a holiday from good taste and the ideal. After drawing so many beautiful thin people solemnly, it was refreshing frivolously to draw some ugly fat ones.

His other new friendship was of a different and intenser kind. Dining with his patron, Graham, Burne-Jones used to meet his daughter, Frances. By 1878, she was old enough for him to take notice of her. She was well worth noticing: a characteristically Pre-Raphaelite beauty, with wide-apart eyes and a full-lipped mouth. In herself, she combined a delicate sensibility to beauty with a robust positive temperament that enabled her to get all the enjoyment out of life that she could. Burne-Jones found her personality exhilarating. On her side, she was flattered by his attention and enchanted by his talk. They became intimate friends. He dined at her father's house two or three times a week; she sat to him for her portrait. In 1883, the relationship was interrupted. Frances Graham married John Horner, and for a year or two saw less of Burne-Jones. Then the friendship revived, stronger than ever. For Burne-Jones, it was more than a friendship. Indeed, his relationship with her became, after his art, his chief source of happiness. Frances Horner was the type of woman to please him most. She had the sensibility to appreciate his imaginative side—no one could be a close friend of Burne-Jones who could not do this—yet her confident appetite for life supplied an antidote to his nervous anxiety. And of course he was delighted by her beauty: "How blessed it must be to look in the glass and

see you!" he said to her. When he died, a close friend of hers wrote to her: "Up to the end you above all others lightened and enriched his difficult life." We do not know whether Frances Horner, like some of his women friends, thought she meant more to Burne-Jones than did the others. But if she did, she was right.

From 1885 on, he saw her whenever he could: when he could not, he wrote to her; remarkable letters, from which we can catch the flavor of his mature personality. It is an elusive, complex flavor. An observer described him as partly monk and partly Puck. The monk showed in his appearance, an aesthetic kind of monk, slight and very pale with a dreamy gaze, and dressed usually in a high coat of priestly cut and a dark blue shirt with tie to match drawn through a jeweled ring. Then, suddenly and unexpectedly, an impish smile would steal over his features, and he would make an odd comical remark, or break into a deep infectious laugh. His conversation was unpredictable, shifting from grave to wildly gay, from serious discussion to intimate confidences, from outbursts of Edward Lear-like nonsense to a flight of poetic fantasy. Yet though its moods shifted, they did not jar with one another. They were made harmonious by the pervading shimmer of Burne-Jones's personality, wayward, light-footed, unashamedly charming. It is a Victorian kind of charm, tender and whimsical. But, once one has accustomed oneself to its idiom, it still casts its spell. And it is saved from over-sweetness by the salt of its humor. Burne-Jones professed not to rate humor high as a characteristic. He saw none, he reflected ruefully, in the works of Dante or Malory. Not only did he keep it out of his own serious art, he actually went so far as to beseech his son Philip, who drew excellent caricatures, never to exhibit them publicly— on the ground that they were too low a form of art. But in fact, do what he would, humor colored Burne-Jones's whole mind, flickering over every phase of his talk; so much so that some people thought of it as his outstanding personal characteristic. Burne-Jones, the man, they said, was primarily a humorist. Certainly the individual flavor of his conversation and his letters comes from the blend of his especial kind of humor with his especial kind of poetry. Here he is in January, 1890, telling

Frances Horner about Browning's funeral: "... to Browning's funeral at Westminster Abbey—under protest—for I hate that beautiful heaven to be turned into a stonemason's yard for anybody—no one is good enough to spoil that divine citadel—and I am sick of dead bodies and want them burnt and scattered to the winds. It wasn't impressive, no, not a bit—people said to me 'How impressive.' I said, 'Yes, indeed'—one has to in the world, but it wasn't, it was stupid, no candles, no incense, no copes, no nothing that was nice. My dear, now they have got these churches they don't know what to do with them—placards all about say, 'Seats for the Press,' 'Mourners,' and the procession poor and sorry—a Canon four feet high, next one of six feet high—surplice, red hood like trousers down the back—you know them all. I would have given something for a banner or two—and much I would have given if a chorister had come out of the triforium and rent the air with a trumpet—how flat those English are—most people are. . . .

"And when a coffin, covered with a pall, is carried on the shoulders of six men it looks like a big beetle—and what Paul said was partly so glorious that it is the last word that need be said, and partly so poor, and flat, that I wondered that any one took the pains to say it; but I spent the time looking at the roof and its groining, and the diapered work, and wanted a service in praise of the church, and wondered who had built it, and why his name was forgotten. Why couldn't they leave him in Royal Venice?"

Here he is writing to her when she is away yachting: "In London it is the softest, most mellow day, and autumn is the time of year for the declining ones—as I am. Delusive spring over with its false promises over—and violent maddening summer over—another delusion of the poets. But autumn is quite true—doesn't promise to be warm, but often is—nor promise to be fine—nor does it make any promise, but fulfills the promises that the bankrupt others made—so bless it, say I. But tell me if you are better and why you were ill—was it a cold caught really in a nasty yacht?—the very word looks like the way of spelling a sneeze."

Are not these quotations delightful? As letters should, they give the

effect of talk: we seem to hear the inflections and hesitations and pauses and emphases of the speaking voice. But the words are chosen with more skill and economy than most talkers find possible. Burne-Jones's letters are works of art. So, we are told, was his conversation; and, now and again, he broke off to enrich it with a piece of ornament, in the shape of an anecdote, or a fable which he had invented or adapted. This practice of his was not so unusual then as it would be now. Other famous talkers of the time did it, notably Oscar Wilde. Here are two brief examples of Burne-Jones's spoken tales, taken down by a listener:

"Lucifer is where Lucifer was and is just as proud. That was his fault, no other—desperate pride. It is the fault of them still, the fallen ones. The other day in Avignon a priest was confessing sinners and saw in the congregation a splendid-looking youth, broad-shouldered, stout-necked, golden-haired and fierce, very tall, whose turn came at last to confess. He confessed so many things that the priest's hair stood on end and he said: 'But have you lived hundreds of years to have done so much evil?' 'I have lived thousands of years,' said the youth; 'I fell from Heaven at the beginning of the world—I want to get back there.' The priest, who belonged to a glorious, ample, wide-eyed, wide-hearted religion, none of your nasty mean Lutheran, Protestant, Methodist travelling-van impudences—said it could be done. He didn't even ask him to be sorry, being wise and knowing the story. He said: 'Say after me these words, God only is great and perfect—' The curly-headed splendour of a man strode away desolate and still damned—that happened only the other day."

Here is another, briefer example: "There was a Samoan chief once whom a missionary was bullying. Said the missionary: 'But have you, my dear sir, no conception of a deity?' Said the Samoan chief: 'We know that at night-time someone goes by amongst the trees, but we never speak of it.' They dined on the missionary that same day, but he tasted so nasty that they gave up eating people ever after, so he did some good after all. . . ."

A deeper significance is implicit in this last flippant anecdote. For all his jokes, Burne-Jones did not make a frivolous or shallow impres-

sion. The monk in him was as much in evidence as was the elf. There were still traces to be discerned of the boy who had wanted to be a priest and also of the youthful friend of Ruskin and Morris, out to battle for a better world. He had changed in that he lacked the faith of his earlier years. Experience had not helped him to come to a clear conclusion as to what he still basically believed in; and he was beginning to resign himself to the fact that it never would. About religion, for instance: Burne-Jones disliked professional skeptics, and himself professed to believe in God. But, when asked what he meant by God, he used to repeat the words of the Samoan chief in his story. "We know that at night-time someone goes by amongst the trees, but we never speak of it." Though he called himself in some sense a Christian, the central crucial doctrines of Christianity did not mean much to him. Unlike Palmer, he never speaks of the Fall or the Atonement; and he had no special sentiment for the person of Christ. The two aspects of Christianity that did appeal to him were poetic, not dogmatic; the mystical Holy Grail aspect, and what he called the "Christmas Carol" part of the gospel story: the tales of the wise men and the shepherds and the star in the East. And these he loved more for their beauty than for their truth: when asked if he believed in the Star of Bethlehem, he said, "It is too beautiful not to be true."

He was less interested in politics and therefore even vaguer about them. To the end of his life, he remained officially progressive: anti-imperialist, pro-Parnell and the Irish rebels, even theoretically sympathetic to socialism. But he professed no definite political creed, all the more because he was irritated by Morris's uncompromising political dogmatism. He burst out in a letter, "I have no politics, and no party, and no particular hope: only this is true, that beauty is very beautiful, and softens, and comforts, and inspires, and rouses, and lifts up, and never fails."

This last sentence represents his one basic instinctive unquestioned conviction. But he was still affected enough by his age and upbringing to feel it needed moral justification. He could not be a pure and shameless aesthete. When a lady admirer told him that she envied artists like

him because they lived in a world of beauty, remote from the troubles of mankind, Burne-Jones was seriously upset: to him, it was an insult to be thought indifferent to human suffering. How then did he justify himself for turning away from the harsh ugliness of life and dedicating himself to the enjoyable activity of painting? He thought about this and one night gave his reasons to Sebastian Evans. The artist's duty, he said, was to make the most of his talent. By doing so, he created an image of beauty; and because beauty is an ennobling thing, this image did good to those of his fellow men who looked at it. He did not approve of "realistic" art, like that of the impressionists, because it did not, in his view, present man with an image of anything nobler or more beautiful than what he saw around him; and so could not elevate him.

I V

BURNE-JONES'S especial feeling for beauty was the inspiration of his art. As such, it is a single link uniting his two lives; the man's life and the artist's. Otherwise the two never touched. His art was the expression of that inner life of the imagination which he had kept distinct from his outer life ever since he was a schoolboy. He once described the spiritual region, in which it was spent, as "that strange land that is more true than real." He went on to say that he sometimes felt he was living in it, even when he was not working. Certainly when he went into the studio and shut the door, it was the only world that existed for him. His pictures are pictures of it.

They are our only record of his inner life. The nature of his secret hopes, raptures, aspirations, must be deduced from them: it is in these, his painted poems, that we must look for the history of Burne-Jones's spirit. Though history is not the right word; for it narrates no sequence of events. The first thing that strikes one when studying Burne-Jones's art is that, once he had fully discovered his characteristic manner, his art never changed. He lived for nearly forty years after 1860. But, during that period, his art neither develops nor

declines. He painted in the same manner and with the same skill. Sometimes he even painted the same picture. For he did not finish one before going on to another: he always had several in hand, sometimes a picture took ten years to finish. Often he made several versions of it. All are marked by a common and unmistakable character. Most purport to be illustrations, to represent some scene from myth or fairy tale or scripture or *Morte d'Arthur*. But in fact, and whatever their title, they are pictures of Burne-Jones's private daydream; visions of the never-never land he had created for his own delight. Further, these two subjects—what may be called the titular subject on the one hand, and on the other the true subject—seldom coincide. Indeed, considered strictly as an illustrator, Burne-Jones is seldom successful. His daydream is not like the story which is its pretext; rarely does it recall the Bible, or *Morte d'Arthur*, or Greek myth.

For these are all, in their different ways, simple, vital and strong. They express the powerful and primitive imagination of the folk, at once intensely earthy and intensely spiritual. None of these words describes Burne-Jones's inner world, which was rather an expression of his special sense of beauty; the characteristic sense of a highly cultured, refined spirit, living a sheltered life at the end of a long tradition of civilization. Ghostly, fastidious, and cloistered, it approaches everything, as it were, at second hand. Its imaginings are not the result of a direct spiritual experience. Still less are they stimulated by what he saw round him in the contemporary world. Their inspiration comes rather from certain phases of feeling as he found them expressed in the literature and art of former ages; an art that appealed to him just because it was far away from what he saw with his own eyes and was concerned instead with fauns and dryads, knights-errant and witch maidens, with the Star in the East borne aloft by winged angels and the Sleeping Beauty in her wood of briar rose. Burne-Jones drew the material of his imagined world from fantasy rather than reality, from the past rather than the present, from art rather than life.

Raw, unadulterated nature appealed to him no more as a man than it had as a boy. On a country walk he never expressed pleasure at anything

he saw unless it reminded him of something in a picture. Staying in the country for any length of time depressed him. It seems as if the sight of visible beauty distracted his mind from the contemplation of imaginary beauty; so that for all his professed dislike of the modern world, he preferred the buses and gas light of Victorian London to the fields of rural England. Nor did the spectacle of real scenery give him ideas for the scenery in his pictures. That was derived from the pictures of others and from his own fantasy.

So were the figures who peopled it. For the most part they are adaptations of those painted by Botticelli or Michelangelo, but infused with Burne-Jones's very different spirit. His characteristic type is pale, slender, weightless, nervous-looking and of indeterminate sex. On the whole it leans to the feminine rather than to the masculine. When he invents his own subjects—in *The Golden Stairs* and *The Mill*—the figures are girls. Such men as do appear in his pictures do not look very male. Like their female companions, they are languid, fragile creatures with beardless faces and clustering hair and usually clothed in long robes. If for once he attempts a more virile type, as in *The Wheel of Fortune*, the result is unconvincing: Michelangelo youths without Michelangelo's energy. This ambiguity of sexual type is the consequence of Burne-Jones's brand of aestheticism. His figures look more female than male because he wanted to make them all as beautiful as possible: and the physical qualities he thought beautiful—delicacy, refinement, tender grace—are more commonly found in women than in men. But this same taste for refinement meant that he also portrayed women with their more obvious and animal sexual characteristics softened and subdued. For Burne-Jones, as for many other Victorians, sexuality and refinement were incompatible. In consequence there is nothing fleshly about his ladies. On the contrary, the spirit in them is stressed at the expense of the flesh. In his world, all the inhabitants resemble angels—beautiful, unearthly, and sexless. The Venus that is the Goddess of his devotion is not Venus the Goddess of amorous passion, the Venus who slew Hippolytus and compassed the rape of Helen; but Venus the ethereal Goddess of Ideal Beauty.

As such, though, she is the vitalizing spirit of his art. It is in his ideal

of beauty that his creative individuality shows itself. This extends from people to things. His distinctive and original sensibility appears in setting and costume, in the delicate, decorative detail of carven cornice and engraved armor and fluted drapery. To enter Burne-Jones's world is to enter a place where everything is beautiful to look at. Conversely, he plays down anything that could look ugly. Old age, for example: now and again his subject involves his portraying an old man, Merlin, or the Wise Men from the East. He makes them as slim and as upright as are his youths and usually as beardless. If one does wear a beard, it looks false. Burne-Jones's old men and women look like young people in a pageant, wearing masks that formally symbolize old age. He treated other kinds of ugliness in the same way; with odd consequences. The ruins in *Love Among the Ruins*, for instance, are very pretty ruins. But as a result, we do not feel the required contrast between young love bravely blooming and the decay and wreckage amid which it blooms. Again, in *King Cophetua and the Beggar Maid*, Burne-Jones was concerned, so he said, to represent the beggar maid as convincingly poverty-stricken without introducing the ugliness of poverty. Certainly, he avoids this danger. There is nothing sordid or shabby in the beggar maid's appearance. She is dressed simply in a plain well-fitting garment, made apparently of silvery gauze. It suits her; but she does not look much of a beggar maid. Burne-Jones's legendary monsters, too, are represented with the horror of deformity removed from them. Saint George's dragon and the Serpent attacking Andromeda are translated by the artist's hand into mild heraldic creatures, not more formidable than the Gryphon in *Alice in Wonderland*. Nor could anyone be struck with panic at the sight of the Great God Pan as portrayed by Burne-Jones. He has become a gentle nature spirit, with the usual delicate feminine features, playing pensively on his pipes to a pair of happy lovers, or bending in sympathy over the suffering Psyche.

Moral ugliness Burne-Jones assimilates to the general mood of his pictures. The only evil figures he makes much of are sorceresses like Circe or Nimue; and these are far from ugly. Like La Belle Dame sans Merci, they corrupt by alluring. Burne-Jones conceives their appearance in such a way as to suggest their baleful intentions, but also to stress the

beauty by which they put them into effect. Evil, so far from lessening this beauty, is made to add a sinister glamor to it. Once or twice Burne-Jones embarks on a more adventurous project and paints the King of Evil himself: Satan enthroned or falling from Heaven. But he conceives him as he conceives everyone else. Satan, like Burne-Jones's other male figures, is beautiful and devitalized and a little feminine.

He also looks sad. Here we come to another distinguishing characteristic of Burne-Jones's world. Sadness pervades it; apparent in its grave cool colors, in the cadaverous light in which it is bathed, above all in the faces of its inhabitants. He said he did not mean these to be sad, but merely expressionless like those of Greek statues. "The moment you give what people call expression," he explained, "you destroy the typical character of heads and degrade them into portraits which stand for nothing. . . ." He follows the principle here enunciated, in so far as his faces are not distorted into smiles and scowls. But they are far from expressionless. On the contrary, one and all they gaze out at the world with wistful melancholy. Angels or devils, warriors or nymphs, dancers or mourners, they all look as though they were yearning, without hope, for some lost bliss.

Certainly the spirit animating the Burne-Jones world is incongruous with many of the subjects he has chosen to paint. It is odd to find fierce knights, stern prophets, and savage gods transformed into frail sleep-walkers, moving with nerveless limbs through the streets and gardens of a toylike Never-Never Land. We are disconcerted to see Saint George and Sir Lancelot, and even the Prince of Darkness himself, presented before us looking girlish, preoccupied, and not in the best of health. What makes the incongruity especially strange is that Burne-Jones cannot have thought of them like this. He was fully appreciative of their real spirit. Indeed he liked the Greek stories and *Morte d'Arthur* largely because they took him away from the sick and complex nineteenth century into a world robust, heroic, and extroverted. It is possible that he intended to communicate his sense of these qualities in his pictures. But if he did he was too true an artist to be successful in his aim. For, when he began to work, he was unable to subdue his creative individuality. His pictures, intentionally or not, become an

image of his personal vision, a personal vision not at all like that of Homer or Malory, but rather that of a highly civilized aesthete, born in an uncongenial period of material progress, philistine taste, and religious doubt. He lived for beauty, but saw it as something alien, remote, out of reach. Spiritually undernourished, his visions are marked by a spiritual languor.

His notion of beauty is further limited by the moral climate in which he had grown up. This led him to equate the beautiful with the good; and the good was, of its nature, something pure and unearthly, incompatible with the earthy and the coarse. Burne-Jones himself could enjoy the earthy and the coarse very much. But he could not feel his enjoyment consistent with his ideal of the good and the beautiful. Nor was this ideal compatible with the comic or the macabre. As we know, Burne-Jones had a strong taste for both of these; but he never indulged it in his serious pictures. It only got a chance to show itself in the sketches he scribbled for friends and children. Nowhere else: in his cathedrals no gargoyle was permitted to raise its grotesque head. The beautiful, because it was the same as the good, must always be grave, sweet, and noble. He managed to make it all these things in his pictures; but at the cost of making them bloodless.

Grave, sweet, noble; not serene. The melancholy which reveals itself, though involuntarily, in the countenances depicted by Burne-Jones was evidence of a troubled spirit. Troubled because uncertain; passionately he had said that he believed in beauty as an ultimate value. But he had no sure grounds for this belief. It remained a mystery. Burne-Jones did not object to this in itself: he accepted and even approved of mystery. He admired Michelangelo, because, more than any other painter, he expressed the essential mystery of life. "Intellectually," he says, "I suppose nothing grander has ever been done than Michael Angelo's Prophets and Sibyls and Angels in the Sistine Chapel. What is the burden of them? The burden of Michael Angelo that he wrote very large upon the walls of the temple of God: 'Of all earthly things those that are nighest to God are Beauty and Strength and Majesty and the Thought of a wise man, and all these things are a Mystery.' . . ." But the name of Michelangelo suggests a difference. In his profoundly religious spirit, the sense

of mystery was born of faith, it was rooted in his awareness of God's greatness and power, so far beyond man's understanding. Burne-Jones had no such firm faith. He longed for it. But his longing remained unfulfilled. It is the realization of this which produces the sadness reflected in his pictures; the sadness of one who is never sure that the beauty he worships is not a piece of wish-fulfillment, the figment of a wistful daydream.

Its daydream quality is the outstanding distinguishing feature of Burne-Jones's imaginary world. This it is which makes his art basically different from Palmer's or Blake's. Their art expressed not a daydream but a vision, not a wish but an experience; directly presented by Blake, by Palmer represented as incarnate in the visible world. But the visible world meant little to Burne-Jones: nor had God vouchsafed him a vision. He therefore had to make up his ideal region out of his own longings and the visions of other men. He is a painter of fairy tales, that is to say of stories that pleased his fancy, but which he did not seriously believe in. And indeed he is fully convincing only when a fairy tale is actually his subject; when he is depicting the Sleeping Beauty rather than The Annunciation. For his version of the Sleeping Beauty is confessedly just a flight of fancy, whereas his version of The Annunciation is a vain attempt to simulate the genuine religious faith of Botticelli or Fra Angelico.

V

BURNE-JONES lived till 1898, painting the same pictures over and over again, with the same success. Professionally, his success even increased; in 1885, he was made an Associate of the Royal Academy.* In 1894, Queen Victoria created him a baronet. Morris, a republican and professional rebel, was shocked at the last event; so

* Eight years later, in 1893, he resigned from the Royal Academy. He found he did not feel at home in its atmosphere. "I am particularly made by nature not to like Academies," he said. "I went to one when I was a little boy and didn't like it then."

much so that Burne-Jones, a little frightened of the aggressive Topsy, implored people not to mention the fact of the baronetcy in his presence, for fear of provoking an outburst. His relations and other friends, however, approved of his title; and the public flocked in crowds to look at his pictures.

Burne-Jones's personal life also pursued the same course as before, in The Grange and at Rottingdean, with his family and old friends. He still spent agreeable evenings discussing life with Sebastian Evans, still flirted wistfully with Frances Horner. His family life did change a little: not always for the better, thought Burne-Jones. Lovely Margaret remained lovely, but she married the scholarly Mr. Mackail and left home. And Phil—well, Phil, though lively and with some talent as an artist, was otherwise something of a disappointment. There was nothing idealistic and Pre-Raphaelite about him. He seems to have reacted against so much good taste and other-worldliness, and set up as an Edwardian man about town, with a taste for smart society and Monte Carlo. Moreover, his love-life was of a kind to worry his father. Instead of marrying and settling down with a nice wife, he preferred to dangle after celebrated married beauties, who were often not nice at all. Certainly Mrs. Patrick Campbell was not nice; she was the glamorous and tempestuous storm center of the English theatrical world. For a time Phil was a favorite of hers; then, according to him, she dropped him abruptly. In revenge, it was thought, he exhibited a picture of a female Vampire, taken to be a portrait of Mrs. Patrick Campbell, triumphant over a prostrate male victim. She was furious and said so. A noisy scandal resounded, of a kind that poor Burne-Jones found distressingly vulgar. All the same, he was still very fond of Phil. Indeed, it was to please Phil, and to gratify Phil's wish to inherit the title, that he had braved the disapproval of Morris and accepted a baronetcy.

If he was not so happy as he had been about his son, he was happier with his wife. His taste for society and other women grew less with advancing years. He found he preferred to stay at home and spend the evenings at The Grange. Georgiana was ready to welcome him. She was growing older too. Both appreciated the security, the stability of married

life: both became growingly aware that they were bound together by experiences and memories that they shared with no one else. For the rest, Georgiana thought it right to avert her mind from any unpleasant memories. She spoke of her husband in terms of enthusiastic veneration, as of one with whom it had always been a privilege and glory to live. Her less idealistic relatives mocked at her for this. But she was wise. All truth, says the French proverb, is not fit to be told. Nor, we may add, to be remembered. By insisting on looking at her marriage through rose-colored spectacles, it is likely that Georgiana Burne-Jones succeeded in making it genuinely rosier.

Burne-Jones's later years were also brightened by a revival of Morris's friendship. Morris's political career had proved such a disappointment that in the end he gave it up. He retained his socialist convictions, but resigned from political activities and devoted his energies, which were still formidable, to printing beautiful books and writing long romances, couched in a strange mock-archaic lingo of his own invention, describing a life as remote as possible from that of his own day. He also took up again with Burne-Jones, whom he wanted to illustrate some of the printed books. Burne-Jones still felt that there was something inhuman about Morris. "If I died," he said, "I suppose he would miss me; but not so much out of his heart as out of his mind—not knowing where else to turn for another of my kind." However, for his part, he still loved Morris dearly and found it delightful to have him back on a Sunday morning; dogmatic as ever, but dogmatizing about Sir Galahad, not about Karl Marx. "Look here, Ned, that's all gammon, you know," he would say, if they happened to disagree about the interpretation of a piece in *Morte d'Arthur*. After arguing, they relaxed to enjoy the illustrations in a comic paper of the period called *Ally Sloper's Weekly*. It seemed as if the old days at Oxford were back again. Then, in October, 1896, Morris died. For the moment, Burne-Jones was overcome. He knelt by Morris's dead body in tears and sobbing. Another friend of Morris's, kneeling beside him, turned to him in sympathy. Burne-Jones impulsively kissed him and resumed his sobbing. And to Georgiana afterwards, "I am quite alone now," he kept repeating.

He was grieving for more than the loss of Morris. After his sixtieth birthday, his sad moods recurred more often. He had begun to realize only too vividly the transience of things human, to be possessed by the sense, especially poignant to a man with his capacity for delight and admiration, that, however much people might pretend to ignore it, everything passes and decays and disappears; youth and beauty and hope and love itself. Moreover, he felt that the world was changing and that he was no longer at home in it. He hated the new developments in politics, in art, and in letters. The romantic liberal in him was outraged by Cecil Rhodes, the Ruskinian idealist shrank in horror from the novels of Zola. Wherever he looked, all was growing brutal, soulless, and hideous: it was as if the beauty he worshiped was being driven from the world. "To love beauty nowadays is to be in torment!" he exclaimed: "The world now very much wants to go back into barbarism. It is sick and tired of all the arts; it is tired of beauty. . . ."

If this was so, then—so he had sadly come to recognize—the hopes of his youth had proved to be illusions. He remembered how Ruskin and Morris and Gabriel and himself had set out to do battle with the forces of materialism and ugliness. Now, all that had happened was that, forty years later, these forces were stronger than ever. And who was left to fight them? Not Gabriel; he was dead. Nor Ruskin; he was mad. Now Morris was gone too. The battle was lost. For who was he to fight it alone? "The world is out of joint," he quoted in anguish, "O cursed spite, that ever I was born to set it right! Rossetti could not set it right and Morris could not set it right—and who the devil am I, who the devil am I!" He felt drained and useless and in an uncomprehending universe. "A pity it is I was not born in the Middle Ages. People would then have known how to use me—now they don't know what on earth to do with me." Thus his grief at the loss of Morris was sharpened and embittered by a more general sense of defeat; defeat of the sacred cause to which he and his friends had sought to dedicate their lives.

He recovered from the shock of Morris's death to live for nearly two more years in apparent tranquillity. Resigning himself to the fact that the world was going the wrong way and that he could do nothing to stop it,

he turned away his eyes from the painful spectacle to concentrate on the still and lovely region of his inner dream. That at least could not be spoilt. "I need nothing but my hands and my brain," he asserted, "to fashion myself a world to live in that nothing can disturb. In my own land I am King of it." He spent most of his days in his studio. When he emerged from it, people noticed that, though his manner was as courteous as ever, he seemed curiously detached and withdrawn—like one whose spirit was centered elsewhere. With no full-blooded conviction, though: for, with Morris, something had died in Burne-Jones, some will to prevail, some vital spark needed to fire his creative vitality. Nor, in his insubstantial land of daydream was he able to forget for long his sense of an ultimate disillusionment. On the evening of June 15th, 1898, a friend of his called Hallé dined at The Grange. After dinner, Burne-Jones began talking about his work. He had always loved it, he said, and had, by its means, hoped to do good to others. The hope had proved vain. "No, no!" protested Hallé. Burne-Jones's countenance glimmered pale in the gathering dusk: "It is true," he said sadly; "don't you see that people who say they like my work also profess equally to admire other work, and of a kind that I hold in abomination?"

The following evening, he was seized by a violent attack of angina pectoris. He died in a few hours.

EPILOGUE

I HAVE finished my two stories. Before I say good-bye, may I offer my readers two brief reflections arising from them. The first concerns my two heroes. Though, on the face of it, Burne-Jones's story is happier than Palmer's, somehow it leaves a sadder aftertaste. It ends more sadly, for one thing. After all his troubles, Palmer died serene and hopeful, whereas Burne-Jones ended his pleasanter life in a minor-key mood; resigned, but disillusioned. Moreover Palmer has turned out to have achieved more. He is a recognized master. Burne-Jones, on the other hand, though he has left some beautiful and individual work, especially in applied forms of art, such as designs for tapestry, book illustrations, stained glass, no longer seems the great painter that Ruskin and Henry James thought him.

The chief reason for this no doubt was simply that he had less natural genius than Palmer. But it was also due to the fact that his art was not inspired, as Palmer's was, by direct experience. Daydreams and a taste for Botticelli are not so vitalizing to an artist as are joy in the English countryside and a vision of God. Of the two men, Palmer was the nearer alike to spiritual and to earthly reality. It is better for an artist to be a visionary than a dreamer. This is my first reflection.

My second relates not to the individual artists, but to the movement they took part in. For, from the distance of a hundred years, we can see that they represent the same trend. The Ancients and the Pre-Raphaelites were soldiers in different armies, but they battled for the same cause; the cause which Palmer called "Ideal Art," and whose aim was to portray a more perfect beauty than can be found in this imperfect world. Up to the middle of the last century, this was held to be the right aim for an artist by most thinkers on the subject, Christian and pagan alike. As they saw it, the Soul was born instinctively desiring beauty, permanence, harmony, but found herself in a world transient, ugly, and discordant. It was the function of the artist to present man with an image of that perfection that the Soul desires, an incarnation in earthly terms of that celestial beauty for which she longs. Burne-Jones and Palmer still held this traditional view of art's purpose; for them art had value only if, in Palmer's phrase, it helped to unveil the heavenly face of beauty.

157

The point of view implied in this phrase was, however, on the way out. Rationalist skepticism, reinforced by the new vision of the material world opened up by science, was undermining man's belief, not just in orthodox religion but in any ideal interpretation of the nature of reality. More and more thinkers held that the spiritual world was a figment of man's imagination, and that his delight in the beautiful was evidence of nothing but itself. To Palmer and Burne-Jones, such notions were blasphemous and nihilistic. Moreover, the industrialized mechanized civilization that they saw rising around them struck them as hatefully ugly and soulless. Nor did they like the new sorts of art and literature— realistic and impressionist—which were coming into being to mirror man's new view of the world. Impelled then by a common horror of the present, Palmer and Burne-Jones both turned away from the age they lived in to find inspiration for their work in the past; Palmer in the past world of rural simplicity and uncorrupted nature, Burne-Jones in the world of beauty imagined by artists who had the luck to live in bygone ages of poetry and faith. Further, each hoped by this means to lead men back to ideal art and to the state of mind that inspired it.

So far as their own art was concerned, the event justified their action; they did some admirable work. In their more general aim, however, they failed. The new world of science and skepticism grew ever stronger: the realist movement in art steadily gained ground. Moreover, we can now see that—partly because it had the impetus of the age behind it—it was more powerfully creative than its rivals. The strongest painters of the nineteenth century were those who, like the French impressionists, had no truck with "ideal" art, but avowedly set out to paint just what they saw. Palmer and Burne-Jones, then, were beaten in the immediate battle; their desire that art should return to the past turned out in prac- tice to be impossible. Yet, in another sense, time has vindicated the cause for which they fought. For it has shown that it was they, and not the advocates of "realism," whose doctrine interpreted aesthetic experience most truly. Seen from a distance of eighty years, the new art that they shrank from shows itself as no different in kind from the old art they revered, and—whatever its practitioners might claim—hardly more real-

istic. Good art is inevitably ideal art: for good art always modifies reality in search of a higher perfection. Manet's barmaid of the Folies-Bergère is as little a straight record of unidealized fact as any pale Briar Rose Princess of Burne-Jones. On the confusion of the real scene, her creator has imposed an order: and he has translated its discordant hues into terms of his own delicate and harmonious color sense. We admire his picture less for the accuracy with which it represents reality than because in it he has, to repeat Palmer's words, unveiled the heavenly face of beauty. It does not matter that Manet's subject-matter was not in itself beautiful. By the alchemy of his art, he has converted even its ugly features into the component and necessary parts of an image of beauty. For Blake was right. The satisfaction given us by art is a sacramental satisfaction; the vision of an ideal perfection incarnate for a fleeting precious moment in material form.

BIBLIOGRAPHICAL NOTE

BIBLIOGRAPHICAL NOTE

SAMUEL PALMER

Unpublished correspondence in the possession of:
 Miss Joan Linnell Ivimy
 Mr. John Samuels
 Mr. Theodore Hofman
 Mrs. F. L. Griggs
 Sir Arthur Richmond
 The Victoria and Albert Museum

Alexander, Russell George. *A Catalogue of the Etchings of Samuel Palmer.* Print Collectors' Club, Publication No. 16. London, 1937.

Binyon, Lawrence. *The Followers of William Blake: Edward Calvert, Samuel Palmer, George Richmond and Their Circle.* London and New York, 1925.

Blunt, Anthony. *The Art of William Blake.* New York, 1959.

Calvert, Samuel. *A Memoir of Edward Calvert.* By his Third Son. London, 1893.

Finch, Eliza. *Memorials of the Late Francis Oliver Finch.* London, 1865.

Gaunt, William. *Arrows of Desire: A Study of William Blake and His Romantic World.* London, 1956.

Gilchrist, Alexander. *Life of William Blake.* 2 vols. London and Cambridge, 1863. Revised and enlarged edition, 2 vols., London, 1880. Everyman's Library edition, edited by Ruthven Todd, London and New York, 1942.

Grigson, Geoffrey. *Samuel Palmer: The Visionary Years.* London, 1947.

——, ed. *Samuel Palmer's Valley of Vision.* London, 1960.

Hamerton, Philip Gilbert. *Etching and Etchers.* London, 1868.

Hardie, Martin. "Samuel Palmer," *Old Water Colour Society's Club,* IV (1926–1927).

——, *Samuel Palmer.* Print Collectors' Club, Publication No. 7. London, 1928.

——, *Water-colour Painting in Britain.* Vol. II, *The Romantic Period.* London, 1967. (Chapter X: "Samuel Palmer.")

Keynes, Geoffrey. *The Illustrations of William Blake for Thornton's Virgil.* London, 1938.

——, ed. *William Blake: Letters.* London, 1956.

Lister, Raymond. *Edward Calvert.* London, 1962.

————. "Francis Oliver Finch," in *Studies in the Arts.* Proceedings of the St. Peter's College Literary Society. Oxford, 1968.

Malins, Edward. *Samuel Palmer's Italian Honeymoon.* Oxford, 1968.

Melville, Robert. *Samuel Palmer.* London, n.d.

Palmer, A. H. *Catalogue of an Exhibition of Drawings, Etchings and Wood-cuts by Samuel Palmer and Other Disciples of William Blake.* Victoria and Albert Museum. London, 1926.

————. *The Life and Letters of Samuel Palmer.* London, 1892.

————. *Samuel Palmer: A Memoir.* London, 1882.

————. "The Story of an Imaginative Painter," *The Portfolio*, 1884, pp. 145–151.

Palmer, Samuel. *An English Version of the Eclogues of Virgil.* London, 1883.

————. Letter to F. G. Stephens, Esq., in "Examples of Modern Etching, IX, Samuel Palmer," *The Portfolio*, 1872, pp. 161–169, especially 163–164.

————. *The Shorter Poems of John Milton.* With twelve Illustrations. London, 1889.

————. *Sketch-Book, 1824.* Facsimile published for the William Blake Trust. London, 1962.

Robinson, Henry Crabb. *Diary, Reminiscences and Correspondence.* Selected by Thomas Sadler. 2nd edition, London, 1869.

————. *The Diary of Henry Crabb Robinson; an abridgment.* With introduction by Derek Hudson. London and New York, 1967.

Sickert, Walter Richard. *A Free House! or The Artist as craftsman.* Edited by Osbert Sitwell. London, 1947.

Sterling, A.M.W. *The Richmond Papers.* London, 1926.

Story, Alfred T. *The Life of John Linnell.* London, 1892.

Wilson, Mona. *The Life of William Blake.* London, 1927; revised edition, London and New York, 1948.

EDWARD BURNE-JONES

Unpublished correspondence in the possession of:
The Fitzwilliam Museum, Cambridge
The Hon. Mrs. Raymond Asquith

Alexandre, Arsène. *Sir Edward Burne-Jones.* (Second Series.) Newnes' Art Library. London, 1907.

Angeli, Helen Rossetti. *Dante Gabriel Rossetti.* London, 1949.

————. *Pre-Raphaelite Twilight: The Story of Charles Augustus Howell.* London, 1954.

Baldwin, A. W. *The Macdonald Sisters.* London, 1960.

Bell, Malcolm. *Edward Burne-Jones. A Record and Review.* (First Series.) London, 1892.

————. *Sir Edward Burne-Jones.* Newnes' Art Library. London, 1907.

Burne-Jones, Edward. *The Flower Book.* Reproductions of thirty-eight water-colour designs by Edward Burne-Jones. Reproduced by Henri Piazza et cie. for the Fine Art Society. Limited edition, London, 1905.

————. *Letters to Katie.* London, 1925.

————. *The Work of Edward Burne-Jones.* Ninety-one photogravures directly reproduced from the original paintings. Limited edition, Berlin Photographic Co., London, 1900.

Burne-Jones, Georgiana. *Memorials of Edward Burne-Jones.* 2 vols., London, 1904.

Cartwright, Julia (Mrs. Henry Ady). *The Life and Work of Sir Edward Burne-Jones. Art Annual*, 1894, Christmas number of the *Art Journal.* London, 1894.

Clark, Kenneth McKenzie. *Ruskin Today.* London, 1964.

Crow, Gerald H. *William Morris, Designer.* Special winter number of *The Studio.* London, 1934.

De Lisle, Fortunée. *Burne-Jones.* London, 1904.

Doughty, Oswald. *A Victorian Romantic, Dante Gabriel Rossetti.* London and New Haven, 1949.

————, and J. R. Wahl, eds. *Letters of Dante Gabriel Rossetti.* 4 vols., Oxford and New York, 1965–68.

Gregory, Horace. *The World of James McNeill Whistler.* Edinburgh and New York, 1959.

Grylls, Rosalie Glynn. *Portrait of Rossetti.* London, 1964.

Henderson, Philip. *William Morris: His Life, Work and Friends.* London, 1967.

————, ed. *The Letters of William Morris to His Family and Friends.* London, 1950.

Horner, Frances. *Time Remembered.* London, 1933.

Hunt, Violet. *The Wife of Rossetti, Her Life and Death.* London, 1932.

Ironside, Robin. *Pre-Raphaelite Painters,* with a descriptive catalogue by John Gere. British Artists' Series, London and New York, 1948.

Mackail, J. W. *Life of William Morris.* 2 vols., London and New York, 1899, 1922.

BIBLIOGRAPHICAL NOTE

Pearson, Hesketh. *The Man Whistler*. New York, 1952.

Quennell, Peter. *John Ruskin*. London, 1956.

Robertson, W. Graham. *Time Was*. London, 1931.

Ruskin, John. *The Art of England*. Lectures given in Oxford by John Ruskin during his second tenure of the Slade professorship. Orpington, 1884. (Lecture II: Mythic Schools of Painting: E. Burne-Jones and G. F. Watts.)

Schleinitz, O. von. *Burne-Jones*. Leipzig, 1901.

Thirkell, Angela. *Three Houses*. London, 1931.

Vallance, Aymer. *The Art of William Morris*. London, 1897.

————. *The Decorative Art of Sir Edward Burne-Jones*, baronet. *Easter Art Annual*, extra number of the *Art Journal*. London, 1900.

Whistler, James McNeill. *The Gentle Art of Making Enemies*. London and New York, 1890.

Wood, Esther. *Dante Rossetti and the Pre-Raphaelite Movement*. London, 1894.

Wood, T. Martin. *Drawings of Sir Edward Burne-Jones*. London and New York, 1907.

INDEX

INDEX

A plate number preceded by an asterisk indicates a color plate.

Samuel Palmer

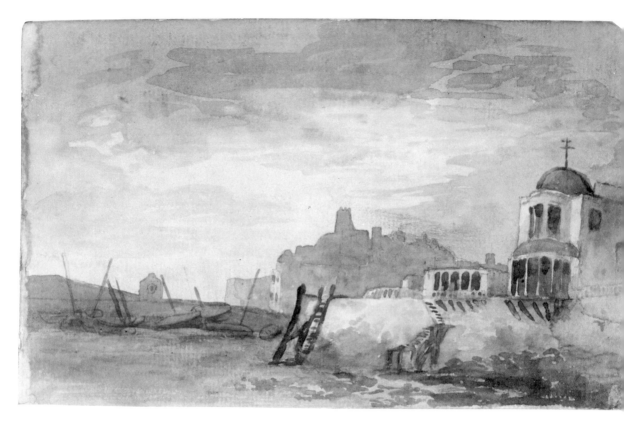

15 Samuel Palmer. *Margate, with Part of the Pier and Harbour after Sunset.* 1819. Water color, 4$\frac{7}{16}$ x 7″

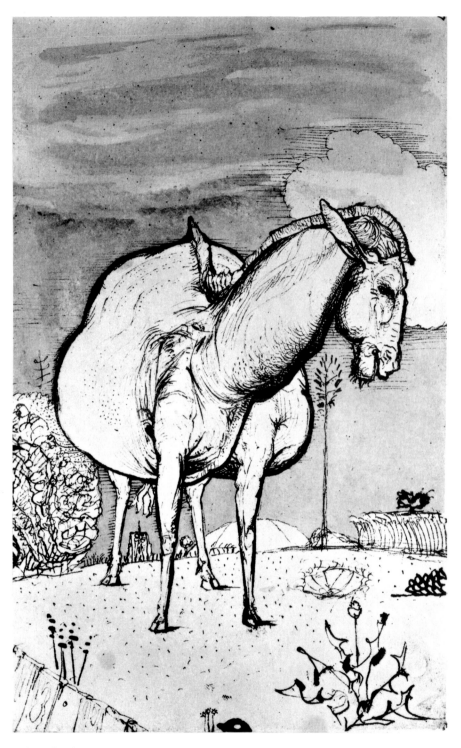

16 *Animal* (page of the "Ivimy" Sketchbook). 1824. Pencil underdrawing, India ink with blue water color, 4⁹⁄₁₆ x 7⁷⁄₁₆"

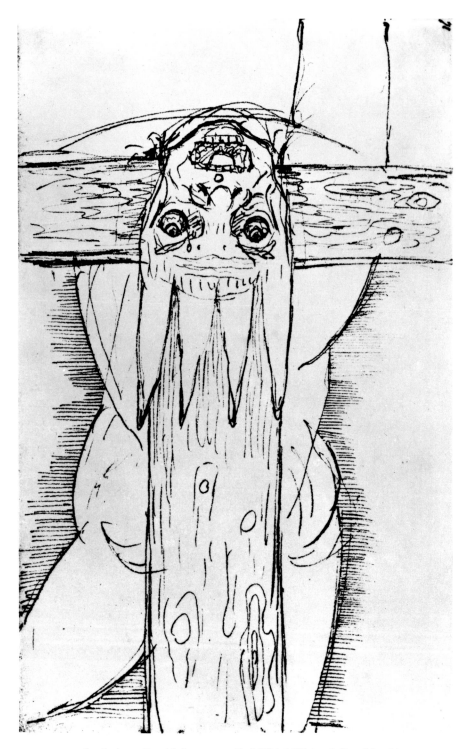

17 *Study for a Crucifixion scene: Bad Thief* ("Ivimy" Sketchbook).
1824. India ink, 4⁹⁄₁₆ x 7⁷⁄₁₆"

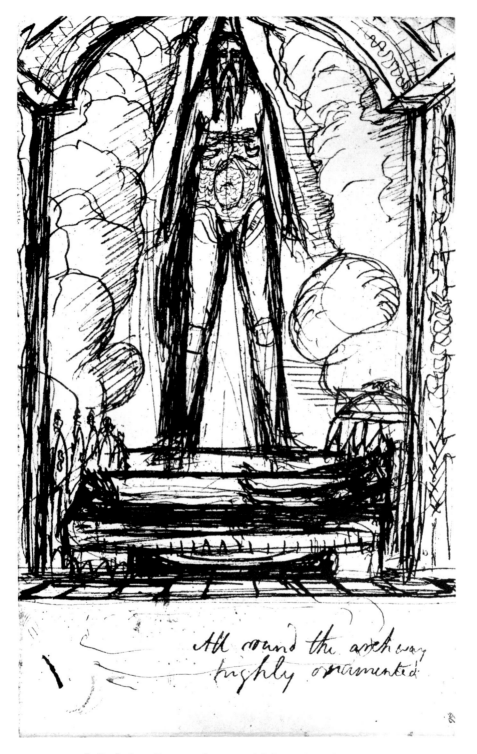

All round the archway
highly ornamented

18 *Study for a Resurrection scene* ("Ivimy" Sketchbook). 1824.
India ink, 4⁹⁄₁₆ x 7⁷⁄₁₆"

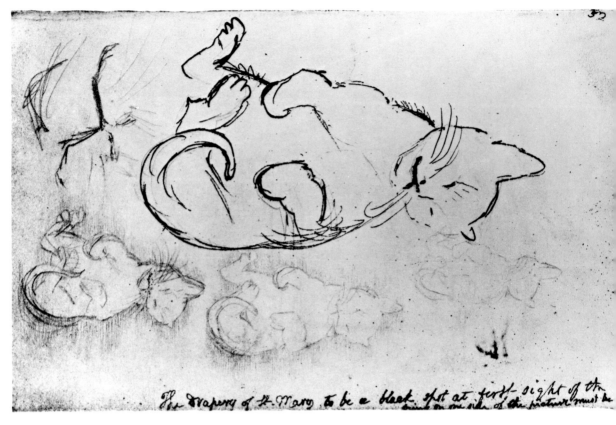

19 *Cats* ("Ivimy" Sketchbook). 1824. Pencil (small cats), pen and India ink (large cat), 4⁹⁄₁₆ x 7⁷⁄₁₆"

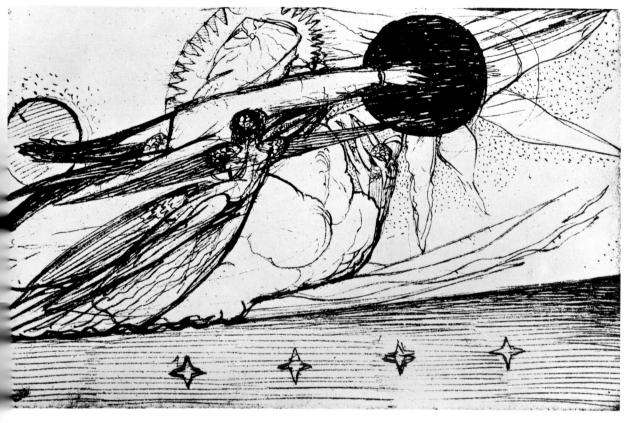

20 *Study for a large Creation scene* ("Ivimy" Sketchbook), 1824. India ink, 4⁹⁄₁₆ x 7⁷⁄₁₆"

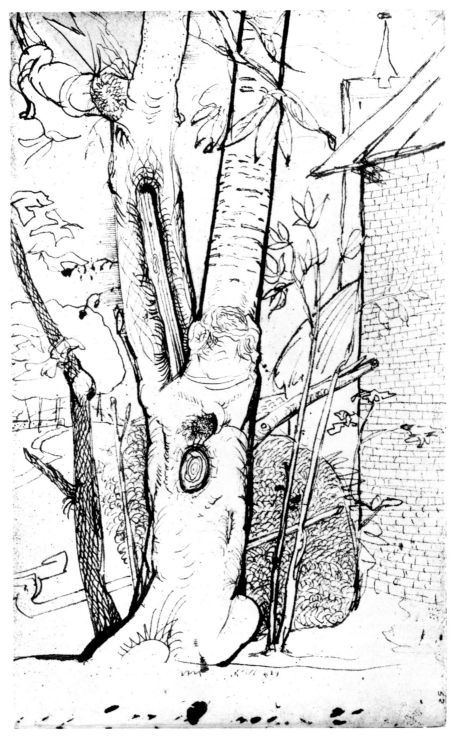

21 *Study of a tree trunk* ("Ivimy" Sketchbook). 1824. Pen and India ink
with blue water color, 4⁹⁄₁₆ x 7⁷⁄₁₆"

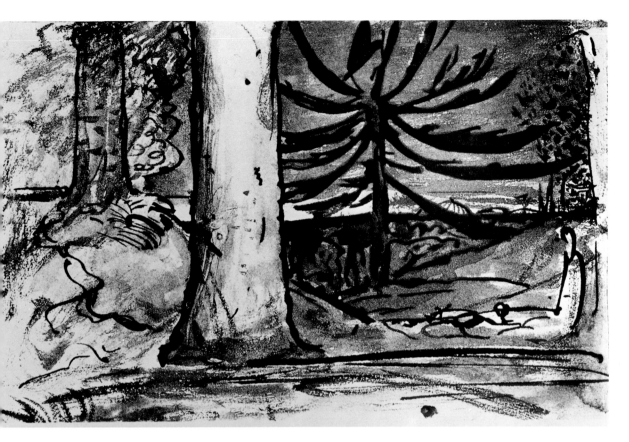

22 *Moonlit scene* ("Ivimy" Sketchbook). 1824. Sepia, 4⁹⁄₁₆ x 7⁷⁄₁₆″

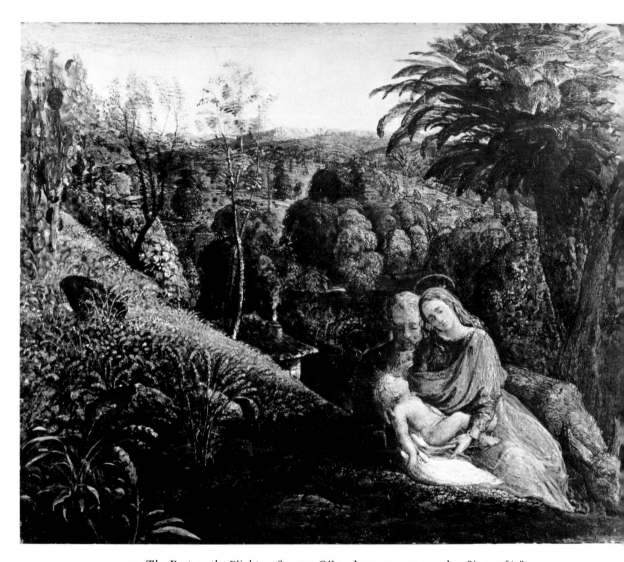

23 *The Rest on the Flight.* c.1824–25. Oil and tempera on panel, 12³⁄₁₆ x 15⁵⁄₁₆″

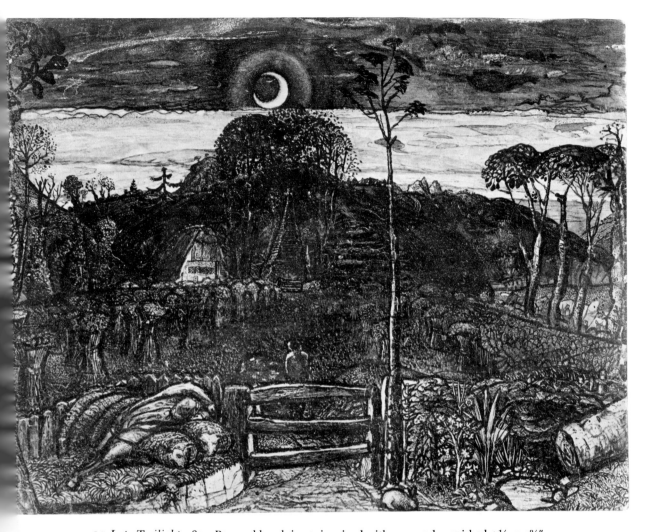

24 *Late Twilight.* 1825. Pen and brush in sepia mixed with gum and varnished, 7¹⁄₁₆ x 9⅜″

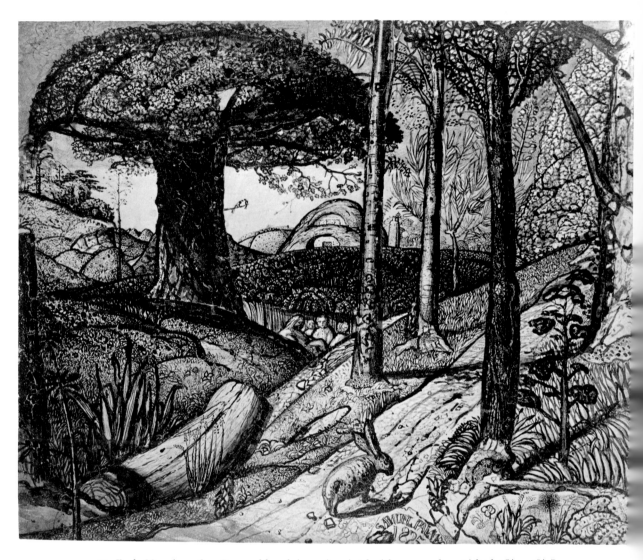

25 *Early Morning*. 1825. Pen and brush in sepia mixed with gum and varnished, 7⁷⁄₁₆ x 9³⁄₁₆″

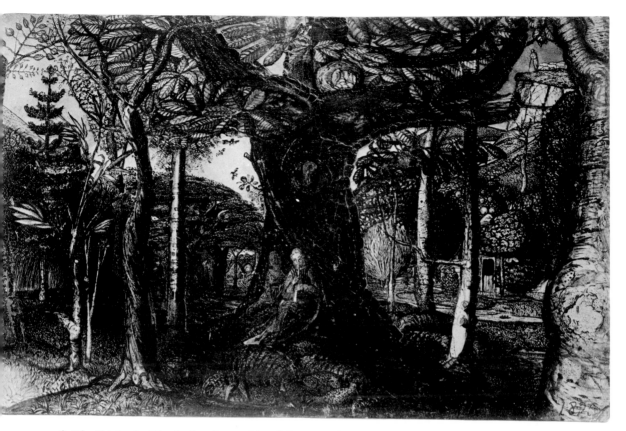

26 *The Skirts of a Wood.* 1825. Pen and brush in sepia mixed with gum and varnished, 6¹³⁄₁₆ x 10⅞″

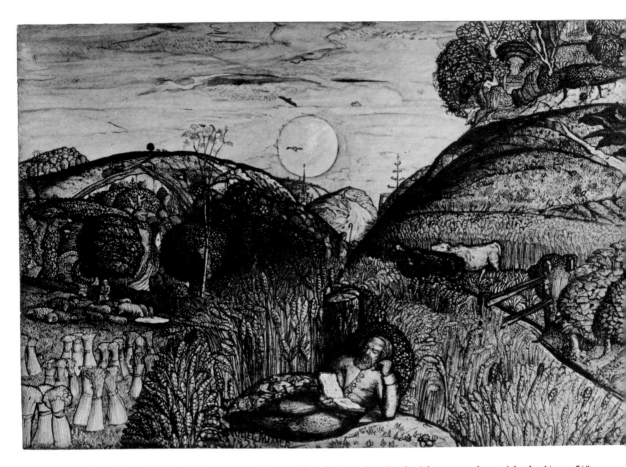

27 *The Valley Thick with Corn.* 1825. Pen and brush in sepia mixed with gum and varnished, 7⅛ x 10⅞″

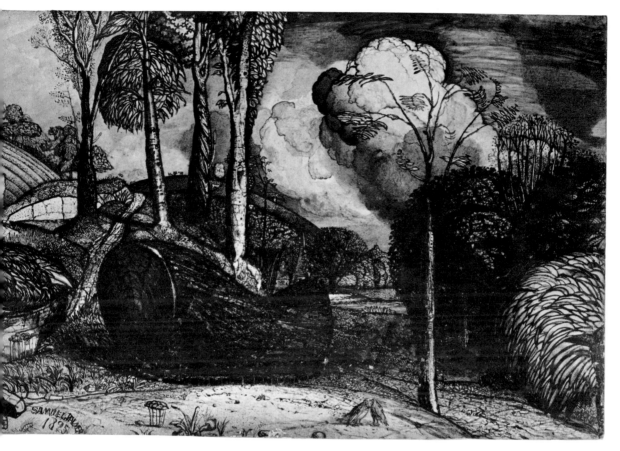

28 *The Valley with a Bright Cloud.* 1825. Pen and brush in sepia mixed with gum and varnished, 7⅛ x 10¹⁵⁄₁₆″

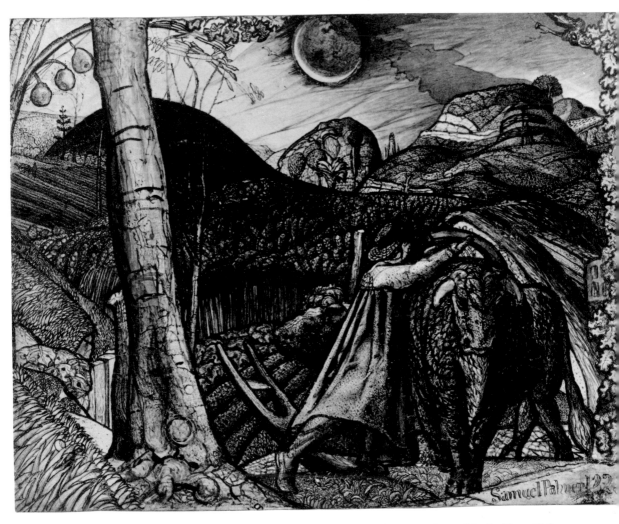

29 *A Rustic Scene*. 1825. Pen and brush in sepia mixed with gum and varnished, 7¹⁄₁₆ x 9⁵⁄₁₆″

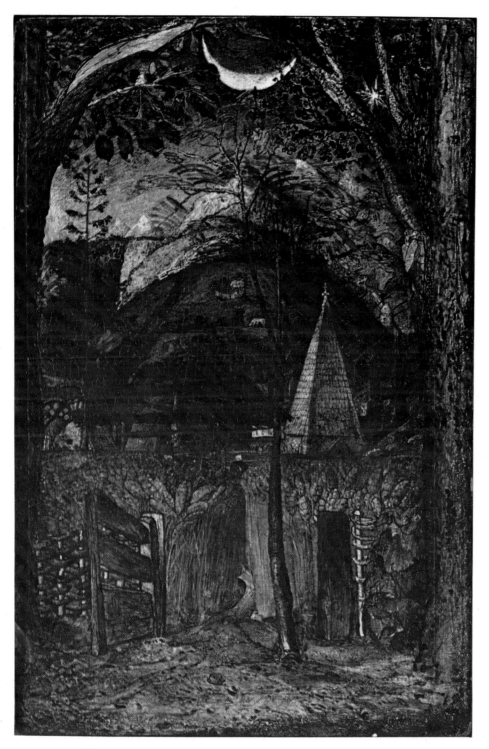

30 *A Hilly Scene.* c. 1826. Water color, pen, and tempera on panel, 8¹⁄₁₆ x 5⁹⁄₃₂″

31 *Ancient Trees, Lullingstone Park.* 1828. Pencil, 10 x 14″

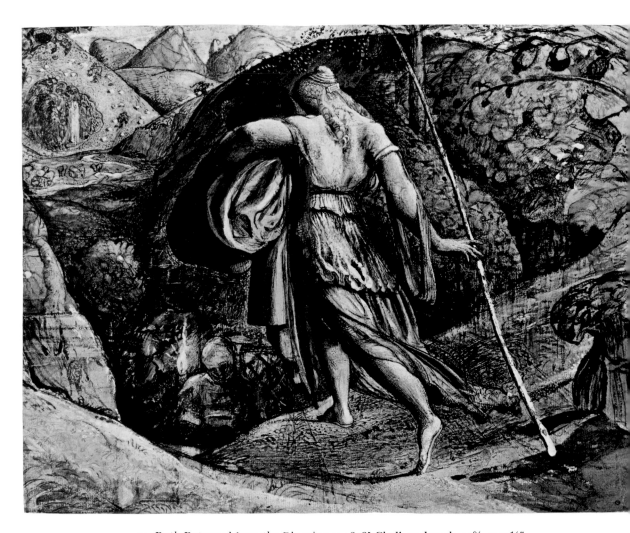

32 *Ruth Returned from the Gleaning.* c. 1828? Chalk and wash, 11⅟16 x 11½"

33 *Barn in a Valley.* 1828. Pen and brush in bistre, India ink, and gouache over pencil on brownish paper, 11 1/16 x 17 5/16″

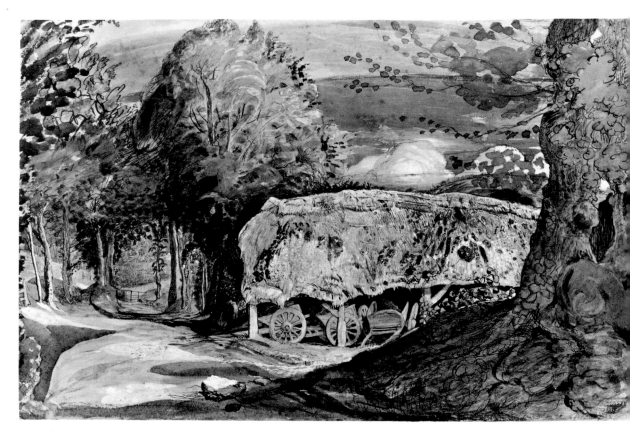

34 *Cart-Shed and Lane.* 1828. Pen and ink, water color, and gouache, 10$\frac{15}{16}$ x 17$\frac{11}{16}$″

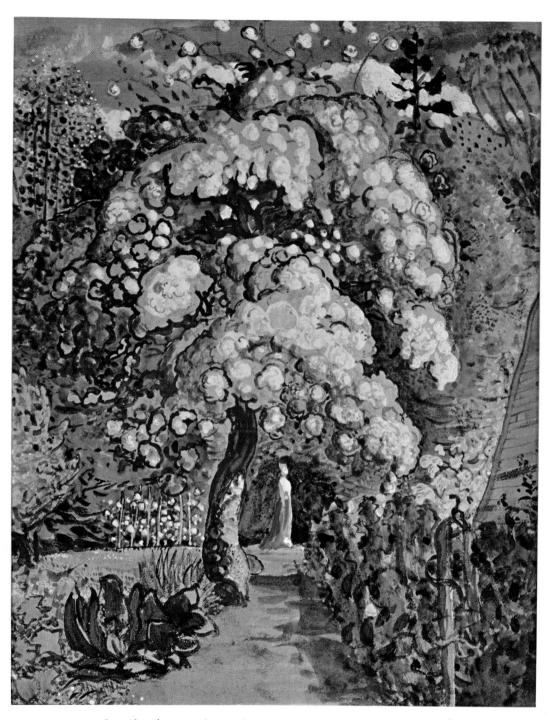

35 *In a Shoreham Garden.* c. 1829. Water color and gouache, 11¹¹⁄₁₆ x 8¾″

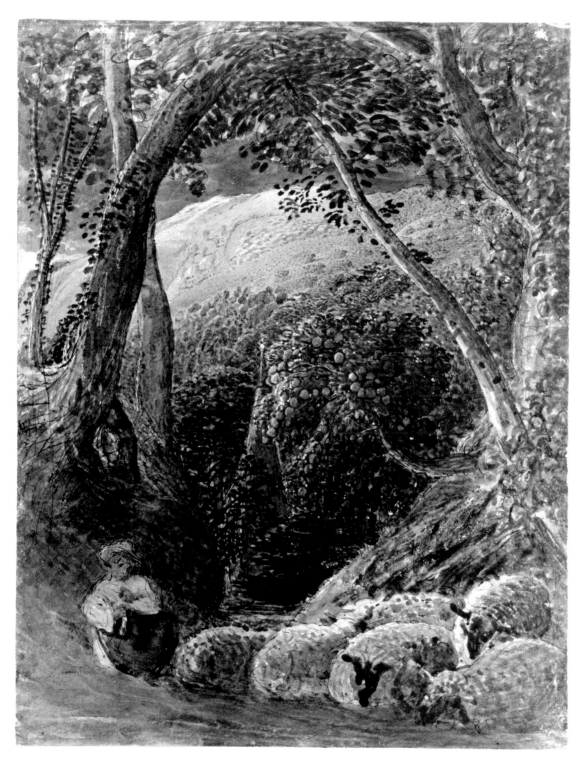

36 *The Magic Apple Tree*. 1830. Water color and pen, 13¾ x 10¼″

37 *Shepherds Under a Full Moon.* c. 1830. Brush in India ink, sepia, and body color, 4⅝ x 5⅝″

38 *Coming from Evening Church*. 1830. Oil and tempera on canvas, 12 x 7¾"

39 *Study for "The White Cloud."* c. 1831–32. Brush and India ink, sepia, and body color, 5¹¹⁄₁₆ x 6⅜"

40 *Young Man Yoking an Ox*. 1831–32. Brush in India ink, 5¹³⁄₁₆ x 7⁵⁄₁₆″

41 *Pastoral with Horse Chestnut.* c. 1831–32. Water color and body color, 13⅝ x 10½″

42 *Old House (Ivy Cottage), Shoreham.* c. 1831–32. Water color and body color
over pen and ink, 15$\frac{11}{16}$ x 12$\frac{1}{2}$″

43 *The Flock and the Star.* c. 1831–32. Brush in India ink with a little brown penwork, 5⅞ x 7″

44 *The Shearers.* c. 1833–34. Oil and tempera, 20¼ x 28″

45 *The Sleeping Shepherd.* c. 1833–34. Oil and tempera, 15 x 20¼"

46 *A Man with a Faggot*. c. 1832–33. Sepia, 4 x 3⅜″

47 *Study of a Garden at Tintern.* August 1835. Pen and ink, black chalk, water color, and body color on brownish paper, 14^{10}⁄$_{16}$ x 18^{11}⁄$_{16}$"

48 *View from the Villa d'Este at Tivoli.* 1839. Water color and body color over pencil, reinforced
with pen and ink and heightened with gold, on buff paper, 13¾6 x 19¹³⁄₁₆″

49 *The Vintage*. 1846. Brush and sepia, heightened
with white body color, 5⅜ x 3″

50 *At Redhill.* 1848. Water color and body color over black chalk on buff paper, 10³⁄₁₆ x 14¾″

51 *Tintagel Castel, Approaching Rain.* c. 1848. Body color over pencil, 11⅞ x 17⁵⁄₁₆″

52 *The Waves.* c. 1850–55. Water color on gray paper, 5¾ x 8⅞″

53 *Pastoral Scene.* c. 1865. Water color, 7⅞ x 17″

54 *Hope, or The Lifting of the Cloud.* 1865. Water color, 8⅛ x 14⅝"

55 *The Travellers.* 1875. Water color, 10¼ x 17¼"

56 *The Herdsman's Cottage; or, Sunset.* 1850,
published 1880. Etching, 3⅞ x 3″

57 *The Sleeping Shepherd, Early Morning.* 1857.
Etching, 3¾ x 3¹⁄₁₆″

58 *The Morning of Life*. Begun 1860, published 1872. Etching, 5⅜ x 8³⁄₁₀″

59 *The Early Ploughman*. Begun 1861, published 1868. Etching, 5¼ x 7¾"

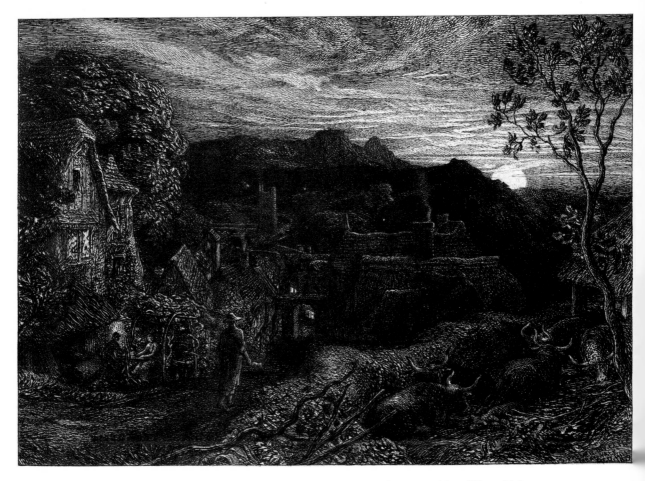

60 *The Bellman* (for *Il Penseroso*). 1879, published 1889. Etching, 6⁹⁄₁₆ x 9³⁄₁₆″

Where glowing Embers through the room
Teach light to counterfeit a gloom,
Far from all resort of mirth,
Save the Cricket on the hearth,
Or the Belmans drousie charm,
To bless the dores from nightly harm:

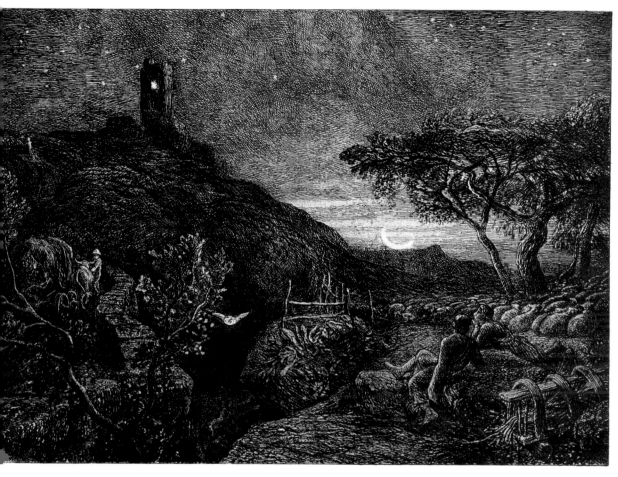

61 *The Lonely Tower* (for *Il Penseroso*). 1879, published 1889. Etching, 6⅝ x 9³⁄₁₆″

Or let my Lamp at midnight hour,
Be seen in som high lonely Towr,
Where I may oft out-watch the Bear,
With thrice great Hermes . . .

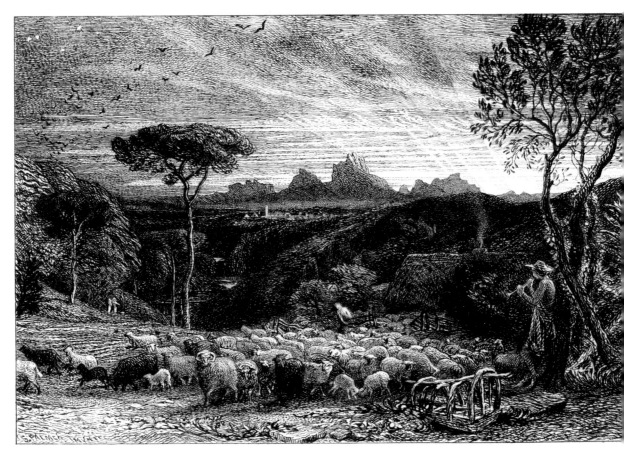

62 *Opening the Fold; or, Early Morning* (for Virgil's *Eclogues*). 1880, published 1883. Etching, 4⅝ x 6¹⁵⁄₁₆″

And folded flocks were loose to browse anew
O'er mountain thyme or trefoil wet with dew.

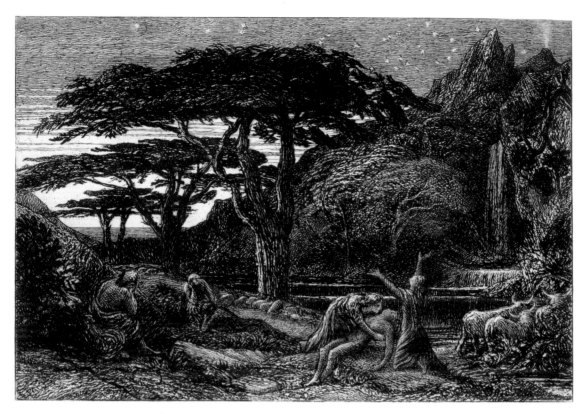

63 *The Cypress Grove* (for Virgil's *Eclogues*). 1883. Etching, 4 x 6″

Untimely lost, and by a cruel death,
The Nymphs their Daphnis mourn'd with falt'ring breath.

Edward Burne-Jones

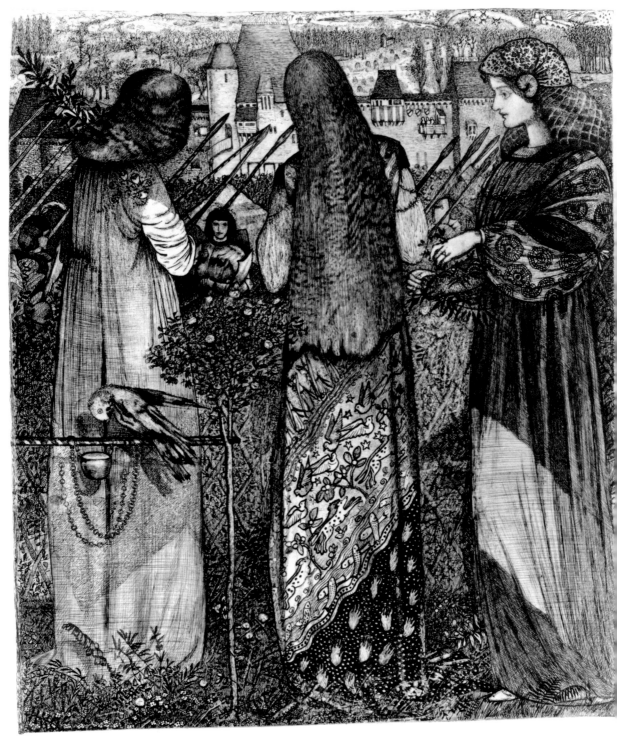

64 Edward Burne-Jones. *Going into Battle*. 1859. Pen and ink on vellum, 8⅞ x 7¹¹⁄₁₆″

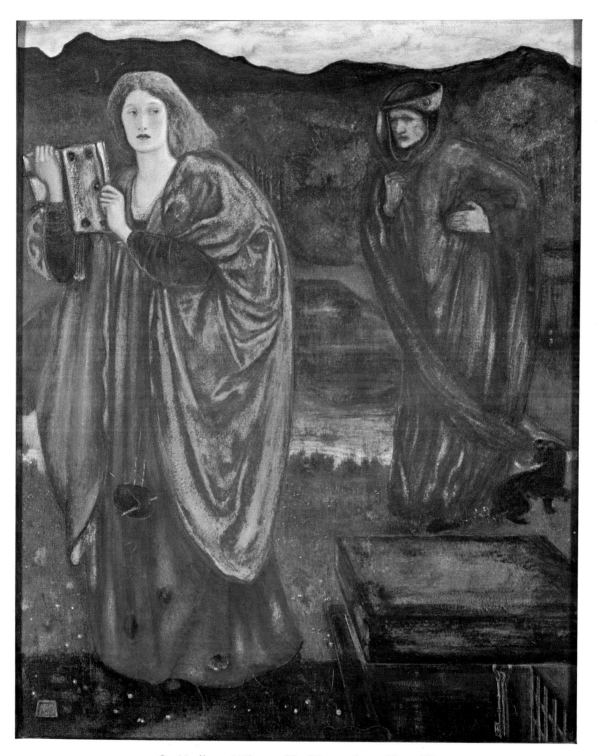

65 *Merlin and Nimue.* 1861. Water color, 25¼ x 20½"

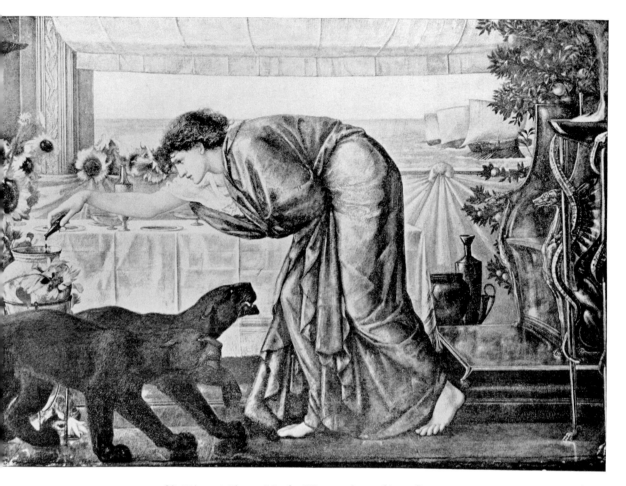

66 *Wine of Circe*. 1863–69. Water color, 27½ x 40"

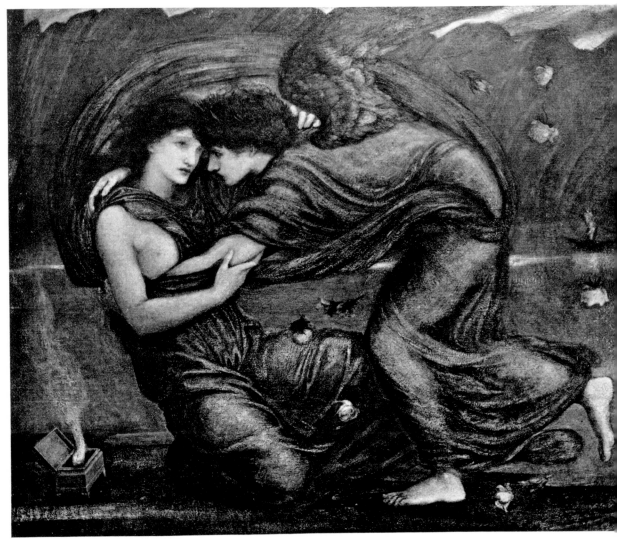

67 *Cupid Delivering Psyche*. 1867. Water color, 31½ x 36″

And kneeling down he whispered in her ear,
Rise, Psyche, and be mine for evermore,
For evil is long tarrying on this shore.
 —Morris, *The Earthly Paradise*

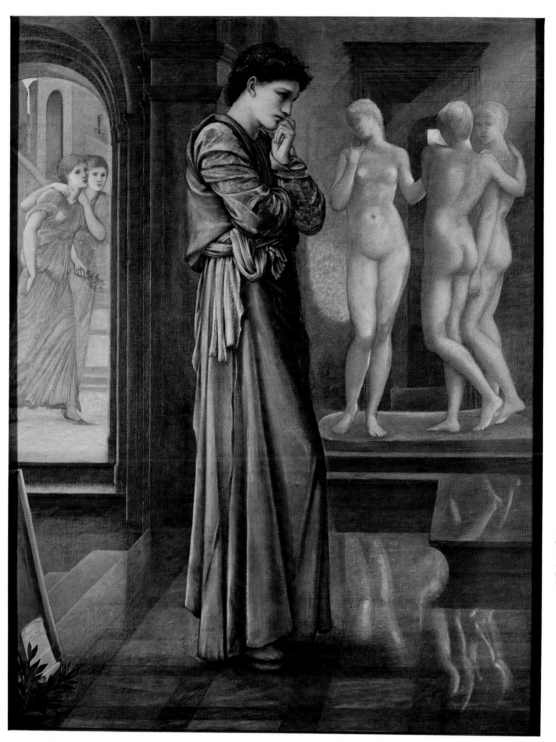

68 *Pygmalion and the Image: The Heart Desires*. 1868–70. Oil on canvas, 38½ x 29½"

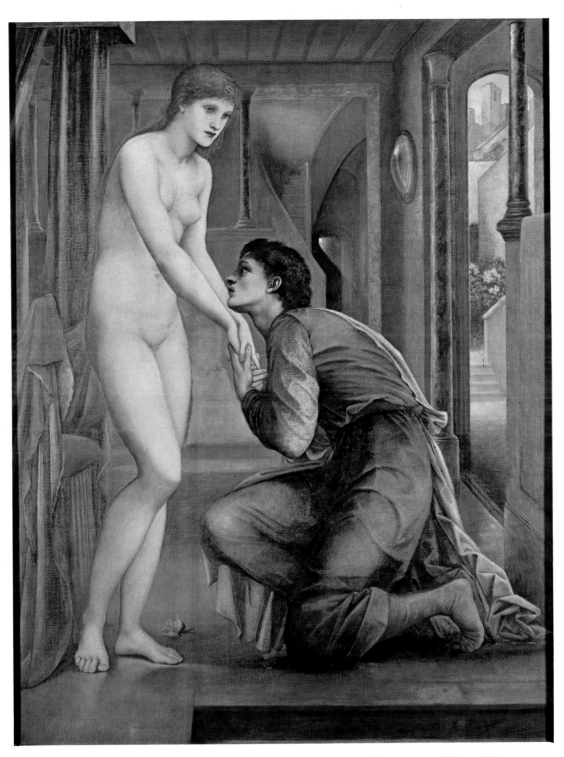

69 *Pygmalion and the Image: The Soul Attains.* 1868–79. Oil on canvas, 38½ x 29½"

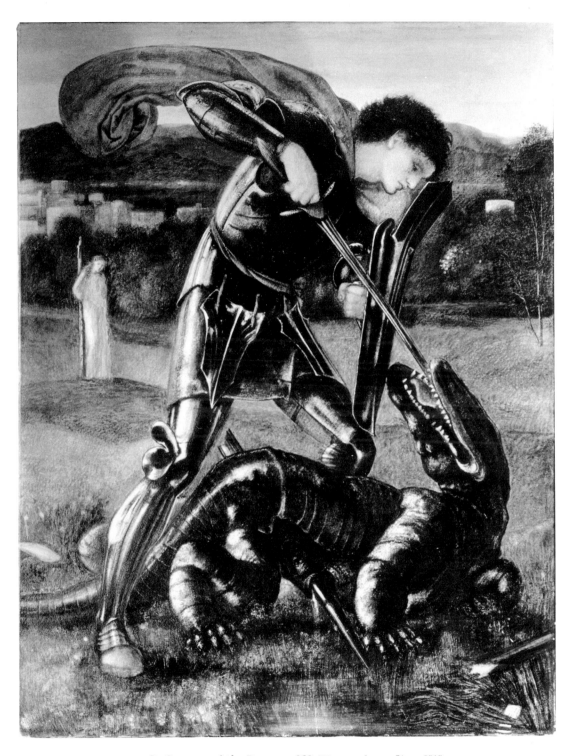

70 *St. George and the Dragon.* 1868. Water color, 23⅞ x 18⅝″

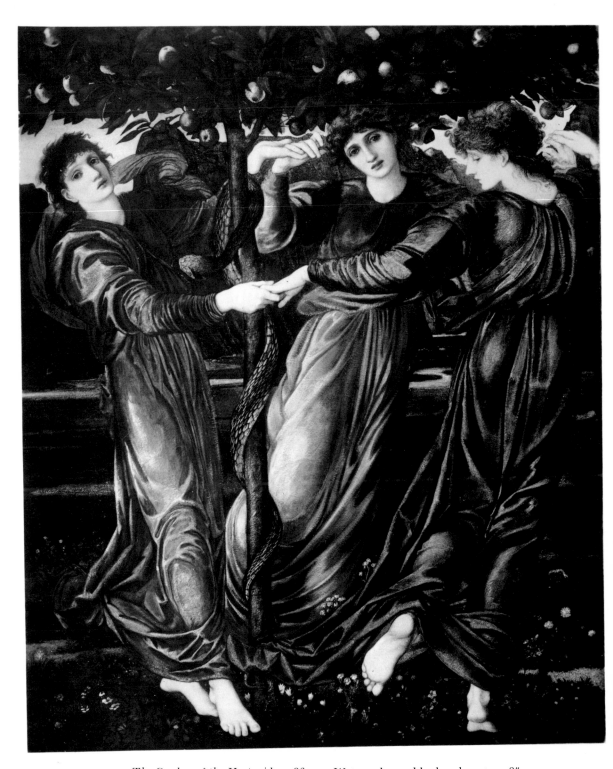

71 *The Garden of the Hesperides*. 1869–72. Water color and body color, 47 x 38″

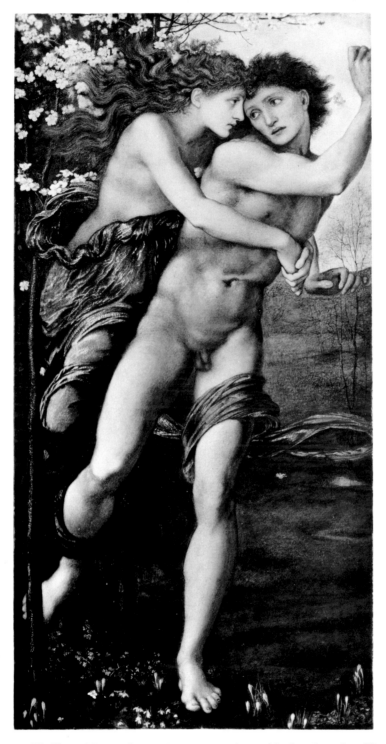

72 *Phyllis and Demophoön.* 1870. Water color and body color, 36 x 18″

Dic mihi quid feci, nisi non sapienter amavi?
(Tell me, what have I done, except not wisely love?)
—Ovid, *Heroides*

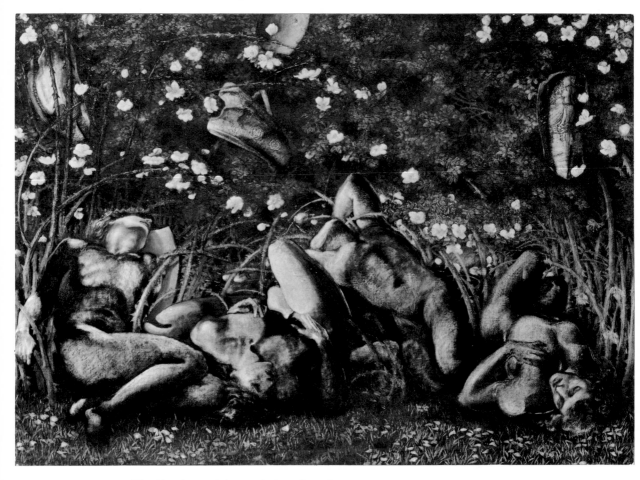

73 *The Sleeping Knights*, study for *The Briar Wood*. c. 1870. Oil on canvas, 24 x 32½″

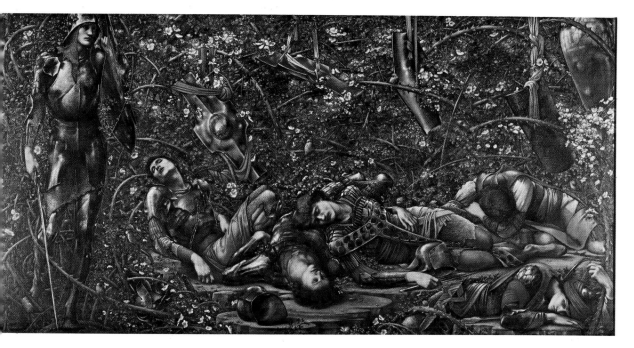

74 *The Briar Rose Series: The Briar Wood.* 1871–90. Oil on canvas, 48 x 98″

The fateful slumber floats and flows
About the tangle of the rose;
But lo! the fated hand and heart
To rend the slumberous curse apart!

75 *The Briar Rose Series: The Council Room.* 1871–90. Oil on canvas, 48 x 98″

The threat of war, the hope of peace,
The Kingdom's peril and increase
Sleep on, and bide the latter day,
When fate shall take her chain away.

76 *The Briar Rose Series: The Garden Court.* 1871–90. Oil on canvas, 48 x 90″

The maiden pleasance of the land
Knoweth no stir of voice or hand,
No cup the sleeping waters fill.
The restless shuttle lieth still.

77 *The Briar Rose Series: The Rose Bower*. 1871–90. Oil on canvas, 48 x 90″

There lies the hoarded love, the key
To all the treasure that shall be;
Come fated hand the gift to take
And smite this sleeping world awake.

78 *The Briar Rose Series: The Kitchen* (intervening panel).
1871–90. Oil on canvas

79 *The Briar Rose Series: The Briar Wood* (intervening panel).
1871–90. Oil on canvas

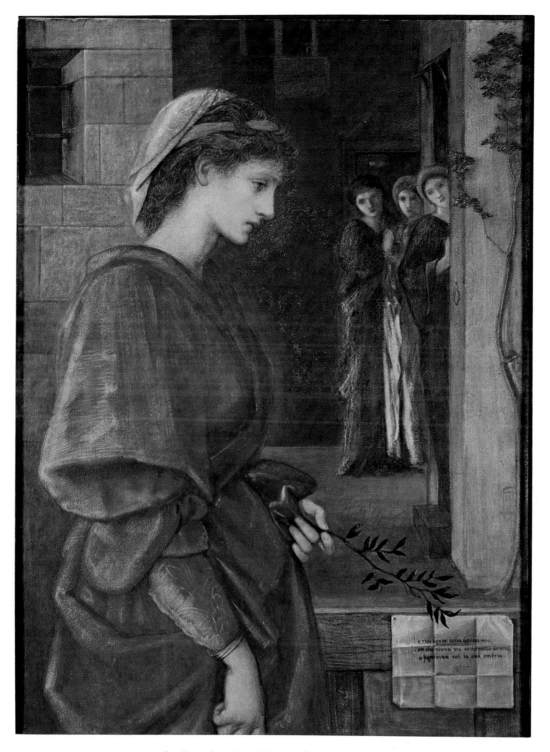

80 *Beatrice*. 1870. Water color, 26¼ x 19¼"

With other women I beheld my love;
 Not that the rest were women to mine eyes,
Who only as her shadows seem'd to move.
 —Rossetti, after Cavalcanti

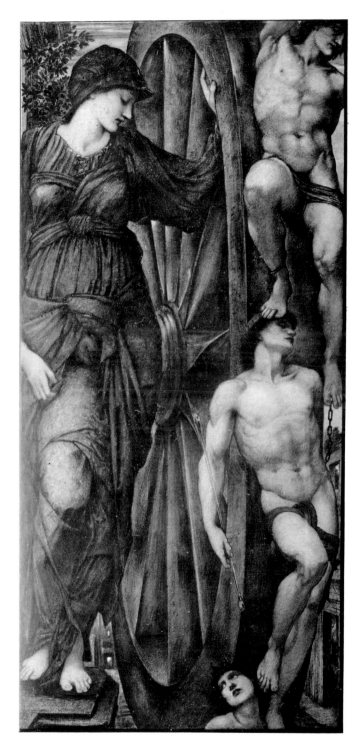

81 *The Wheel of Fortune*
1871–86. Water color, 45 x 21″

82 *A Dream, The Muses on Mount Helicon.* 1871. Water color on canvas, 9 x 12″

83 *Dorigen of Bretaigne Looking for the Safe Return of Her Husband.* 1871. Water color, 10½ x 14¾"

But whan she saugh the grisly rokkes blake,
For verray feere so wolde hir herte quake
That on hire feet she myghte hire noght sustene.
Thenne wolde she sitte adoun upon the greene,
And pitously into the sea byholde.
 —Chaucer, "The Franklin's Tale"

84 *Pan and Psyche.* 1872–74. Oil on canvas, 25⅝ x 21⅜″

85 *Danaë and the Brazen Tower*. 1872. Oil on panel, 15 x 7½"

86 *The Feast of Peleus*. 1872–81. Oil on panel, 14¾ x 43″

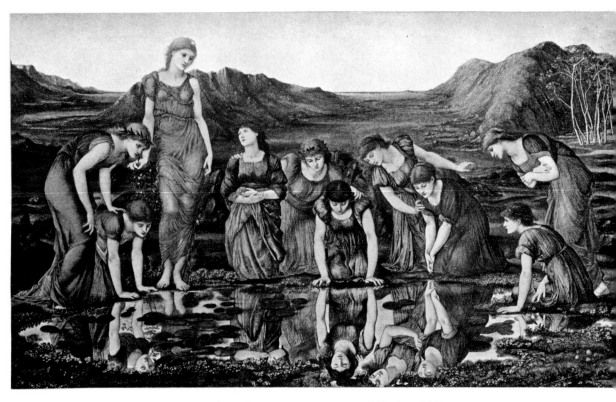

87 *The Mirror of Venus.* 1873–77. Oil, 48 x 78½″

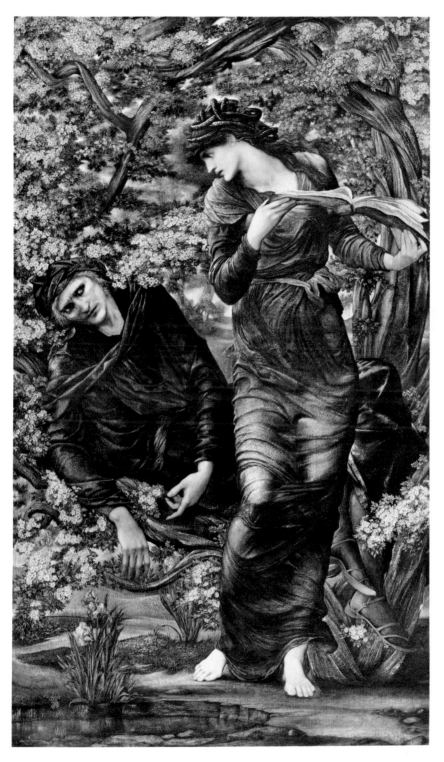

88 *The Beguiling of Merlin.* 1874. Oil on canvas, 72 x 43"

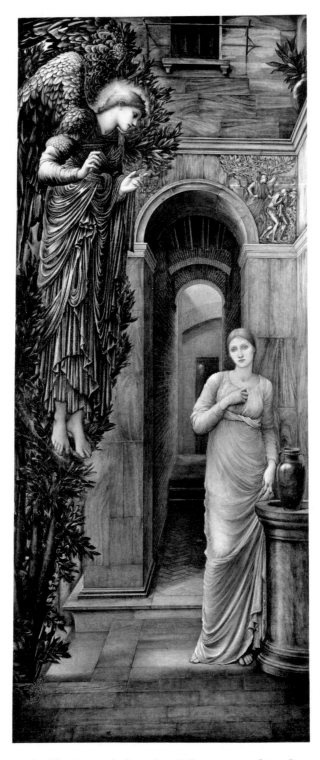

89 *The Annunciation*. 1874. Oil on canvas, 98 x 41"

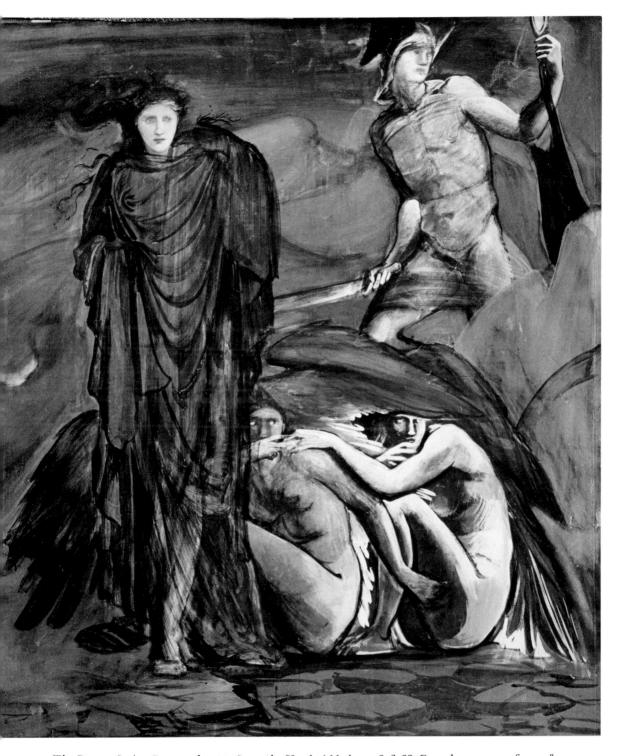

90 *The Perseus Series: Perseus about to Sever the Head of Medusa.* 1876–88. Gouache on paper, 60 x 54"

91 *The Perseus Series: The Escape of Perseus.* 1876–88. Gouache on paper, 59½ x 53½″

92 *The Perseus Series: Perseus Slaying the Serpent.* 1876–88. Gouache on paper, 60½ x 54½″

93 *The Golden Stairs.* 1880. Oil on canvas, 106 x 46″

94 *The Magic Circle.* c. 1880. Water color, 27¼ x 20½"

95 From *The Flower Book*: *Golden Thread*, 1882–98.
Water color, 6½″ diameter

96 From *The Flower Book*: *Traveller's Joy*, 1882–98.
Water color, 6½″ diameter

97 From *The Flower Book: Comes He Not?*, 1882–98.
Water color, 6½″ diameter

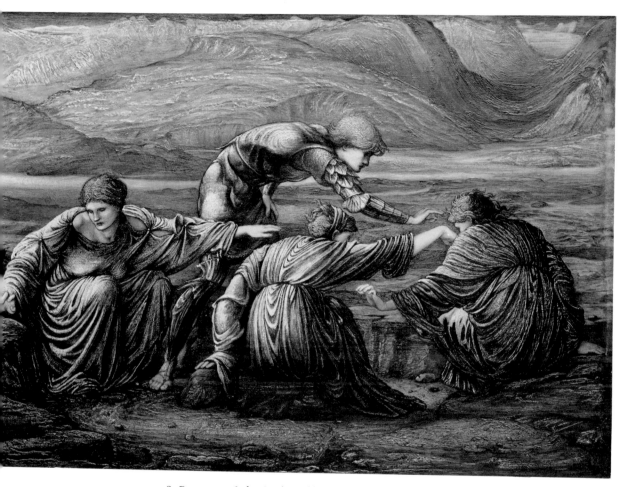

98 *Perseus and the Graiae*. 1883. Oil on panel, 15 x 20"

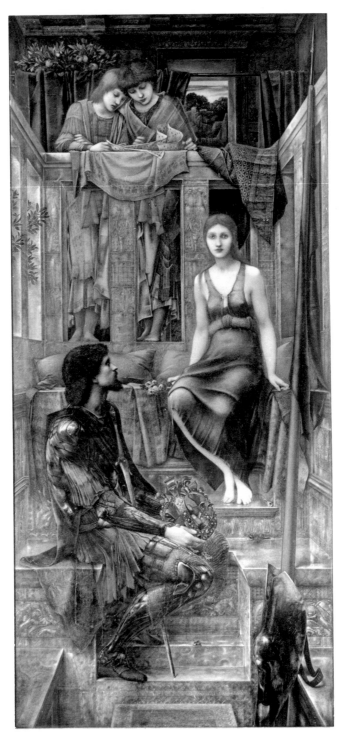

99 *King Cophetua and the Beggar Maid.* 1884.
Oil on canvas, 115½ x 53½"

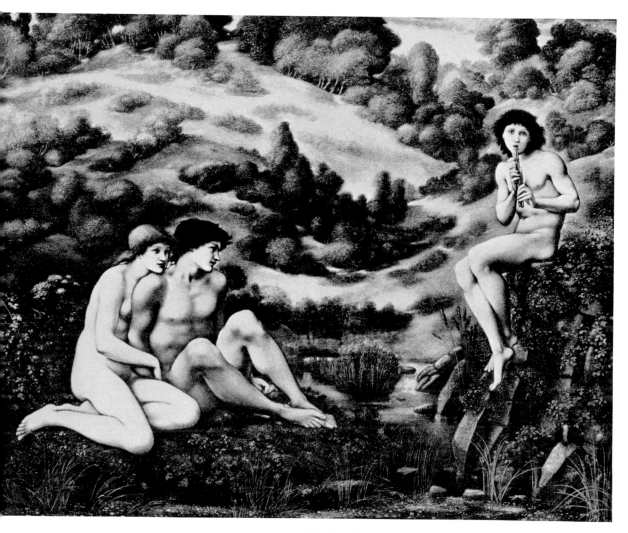

100 *Garden of Pan.* 1886–87. Oil, 60 x 74″

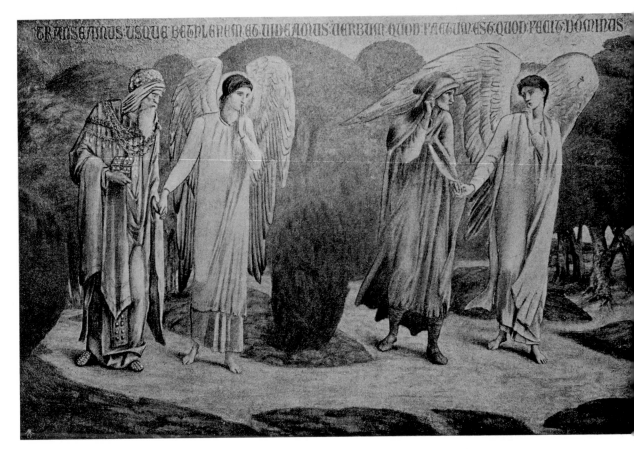

101 *King and Shepherd with Angels*. 1888. Mural decoration in oil, 84 x 120″. St. John's Church, Torquay

Let us now go even unto Bethlehem, and see this thing which is come
to pass, which the Lord hath made known unto us. (Luke 2:15)

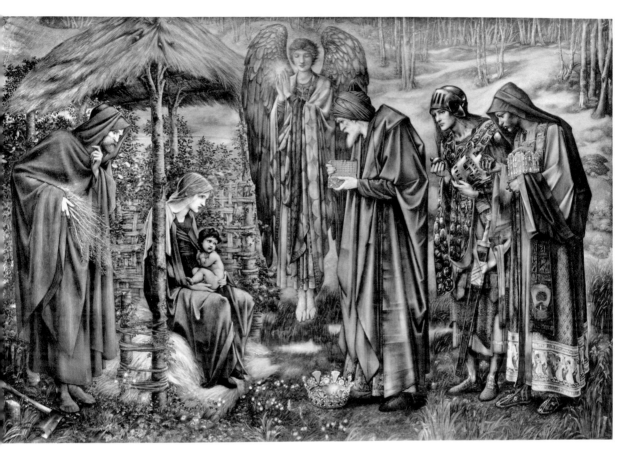

102 *The Star of Bethlehem.* 1888–91. Water color and body color, 101 x 152″

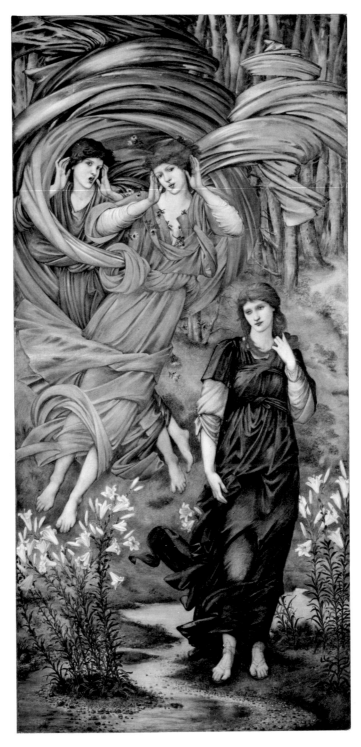

103 *Sponsa de Libano*. 1891. Water color, 127 x 61"

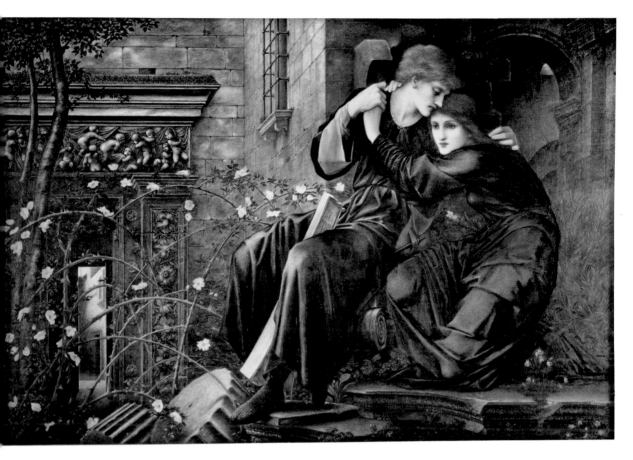

104 *Love Among the Ruins.* 1894. Oil on canvas, 37½ x 63½"

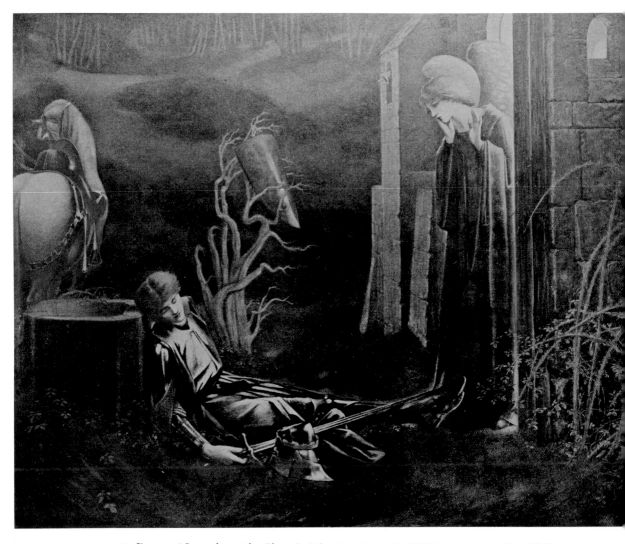

105 *Dream of Lancelot at the Chapel of the San Grael.* 1896. Oil on canvas, 53½ x 66½"

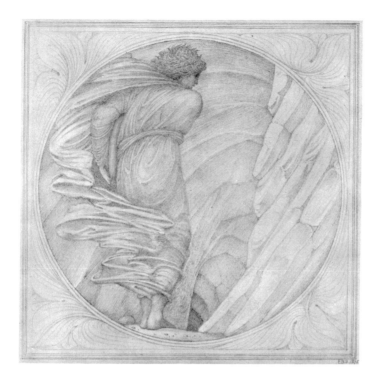

a *Descent into Hades.*
8¾ x 8¾″

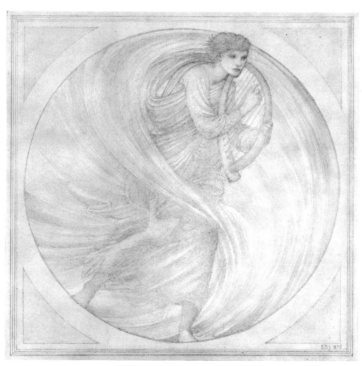

b *Through the Flames.*
8¾ x 8¾″

106 *Orpheus Series.* 1875. Pencil

107 *Angels of Death*. After 1885. Chalk drawing

108 *Lancelot and the Grail*. After 1885. Chalk drawing, 9½ x 7¼"

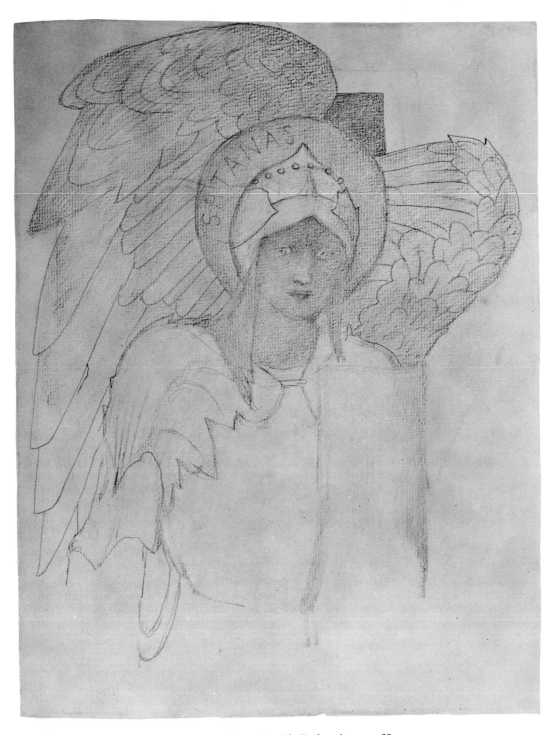

109 *Satan*. After 1885. Chalk drawing, 7 x 6″

110 *Waves.* After 1885. Pencil, 6¾ x 5″ and 6⅞ x 5¼″

111a *Baby and Cat: for Katie Lewis.* c. 1883–85.
Pencil, 4 x 4½"

111b *William Morris: Two caricatures.* Mid 1860's. Drawings, 5¾ x 7½" over all

112a *Fat Ladies: Up the Ladder* and *"The Tide! The Tide!"* Mid 1880's.
Drawings, 7 x 4½″ and 6 x 4½″

112b *Ladies of Fashion*. Mid 1880's. Drawings, 5 x 4½″

113 From *The Distracted Artist*. c. 1885. 4¼ x 7″

114 From *The Distracted Artist*

115 *Missing the Train*. Mid 1880's. Drawing, 6¾ x 8⅝"